# COLOrs

ANNE VARICHON

# COLOrS

WHAT THEY MEAN AND HOW TO MAKE THEM

TRANSLATED FROM THE FRENCH BY TOULA BALLAS

abrams, new york

PHYS

TO ALL THOSE WHO HAVE HELPED ME CREATE
THIS WORK, I OFFER MY WARMEST THANKS:

Christine and Jean-Luc
Agussol, Marie Angelvy,
Isabelle Arnold, Cécile
Aupic, Farid Belkahia,
Barbara Barrois, Marc
Beynié, Bérangère Bois,
Mohamed Bolbol, Carline
Borel, Annie Boullay,
Isabelle Boulnois, Félician
Carli, Leah de Caupelle,
Nathalie and Gérard Cazé,
Marion Chataing, Hadj
Charof, Hana Chidiac,
Patrice Coopman, Thamqi
Chouikh, Karyn Delaunay,
M. and Mme. Fassi Fehri,
Michel Garcia, Chantal
Garnier, Silvain Fire,
Henri Giriat, Adamo
Gusella, Joséphine and
Jean-Paul Hernandez,
Yann Hernandez, Mme.
Houssein, Laurence
Jean-Bart and Denis Raulet,
Mohamed Karimi, Séverine
Lejeune, Lucie, Patrick
Michel-Dansac, Odile and
Patrick Maffone, Cathy
Magnan, Stéphane Meysson,
Mohsine Ngadi, Christiane
Naffah, Erika Pasimeni,
Anne and Dominique Payot,
Brigitte Perkins, Mohamed
Rachidi, Céline Rajac,
Virginie Rault, Armelle and
Lucas Ritter, Laurence and
Carlo Roccella, Mariangela
and Silvan Schmid,
Armelle and Dominique
Sennelier, Cécile, Béatrice,
Anne-Marie, François
and Philippe Varichon.

Thank you to Thierry
Heuninck for his
contribution to the
earlier edition.

And, lastly, my thanks
to Claude Hénard and
Florence Lécuyer, and
to their departments at
Éditions du Seuil, who all
believed in my dreams.

This book has greatly benefited
from the assistance of the
Conservatoire des Ocres et
Pigments Appliqués (the
Conservatory for Applied Ochers
and Pigments, also known as
the OKHRA Association).

Created in 1994, the OKHRA
Association conceived and
developed the Conservatoire des
Ocres et Pigments Appliqués in
the former Mathieu ocher factory
in Roussillon in the Luberon
region of Provence, France.

This organization protects
the heritage and develops the
technical culture associated
with the manufacture of colors
for every level of the art, from
the individual craftsman to
industrial applications. Every
year, they hold exhibitions and
thematic displays (on pigments,
colorants, paints, plasters, dyes,
and the science of color), which
also help augment the library,
the materials collection, the
workshops, services, sales desk,
and the specialized bookstore.

The Mathieu factory, in fact,
provides ochers, numerous
pigments, binders, and tinctorial
substances in addition to an
abundant choice of works.

The OKHRA Association,
the former Mathieu factory,
and the Conservatoire des
Ocres et Pigments Appliqués
84220 Roussillon, Provence
info@okhra.com
www.okhra.com
tel. +33 (4) 90 05 66 69

And this color here, Christian, where
there's green and blue and violet
and black, what do you call it?

This color, that's Viaggio gray.
It sprang from love.

# preface

I invite you on a butterfly's journey.

Imagine you are flying over the Earth. From time to time, attracted by some color, you land on a vast continent or a tiny island. You witness the birth of red ocher in a tomb in Nazareth, and the disappearance of purple from the shores of the Mediterranean. You accompany yellow ocher on its path from Australia fifty thousand years ago to the Siberian tundra or, more recently, to a community of Inuit, who coat their ritual masks with it after first licking them to make the pigment adhere properly. You flit around India, where they pour charcoal into milk and milk into turmeric. Farther away, you can see men and women placing copper plaques in tubs of marc to make verdigris, or gathering stigmas from saffron pistils. You discover why the Igbo of Nigeria drink kaolin, and how, in the Maghreb, they make ink with lamb's wool.

Your journey ends with the discovery of synthetic pigments and dyes.

You can create, if you wish, your own paints and dyes with the help of the recipes that appear in this book. They complement the history of pigments and plant dyestuffs, along with tales and anecdotes about their subject matter. Then, maybe, when you next put on your indigo-dyed jacket, the songs of the women of the island of Sumba will accompany you.

*The white canvas—it's like a layer of dust that covers up the real painting. It's just a matter of cleaning it. I have a little brush to clear away the blue, another for the red, and another brush for the green. And when I've finished cleaning, the picture is all there.*

Georges Braque (1882–1963)

# WHITE

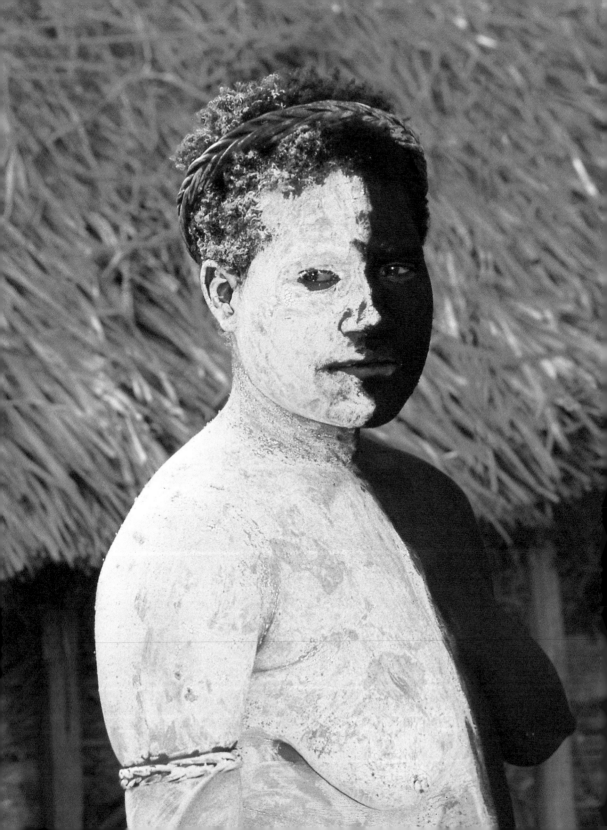

In 1669, Isaac Newton (1642–1727) demonstrated that the color white results from the synthesis of the six colored rays that compose the spectrum. In other words, a surface "is" white when it reflects the light and all the colors in the visible spectrum.

The human eye is sensitive to infinite nuances of whiteness. The Inuit, for example, perceive seven varieties of white, and in India, Sanskrit texts distinguish between a shiny white, the whiteness of a tooth, the whiteness of sandalwood, the whiteness of an autumnal moon and of autumnal clouds, the whiteness of silver and of cow's milk, the whiteness of a pearl, a ray of light, a shell, a star, and so on. As for the Japanese, they use six distinct terms to evoke whiteness, differentiated not only by brilliance or matteness, but also according to the

*The white chalk and black charcoal decoration that divides the body of this young Papuan woman into two sections is probably part of the important ceremonial cycles practiced by many New Guinea tribes. In these rich and complex rites, the juxtaposed pigments represent the structure of the cosmos and maintain or restore the equilibrium of the world. White chalk is also applied all over the body in funeral ceremonies, and widows from a lake-dwelling Sepik tribe put on a multitude of necklaces made of white shells. They wear this jewelry, which can weigh up to sixty-six pounds, during the six months of their mourning period.*

energy of the color. There are also inert whites and dynamic whites. Cultural vocabularies that reflect all these subtleties are becoming rare today, but the symbolism associated with the color continues to be rich and meaningful. White plays an integral role in a variety of rituals and cults and is generally invested with positive values. And even if black and white are not recognized as "colors" by physicists, they contribute a certain formality to our palette.

*In the fourteenth century B.C., the pharaoh Amenhotep IV, better known as Akhenaten, founded the city of Tell-El-Amarna in Middle Egypt as his capital in celebration of the cult of the sun god Aten. The city was inhabited for only twenty years. Archaeological excavations have uncovered several tombs, including those of Akhenaten and other notables. This fresco decorates the hypogeum, or underground burial chamber, of Ramose, Akhenaten's general, and represents a group of women in mourning. For the white shade of the dresses, the artist used calcite white (chalk) bound with glue drawn from the acacia gum. The ancient Greek historian Herodotus stated that the priests of ancient Egypt could only wear vestments of the purest linen, as wool and leather were forbidden to them.*

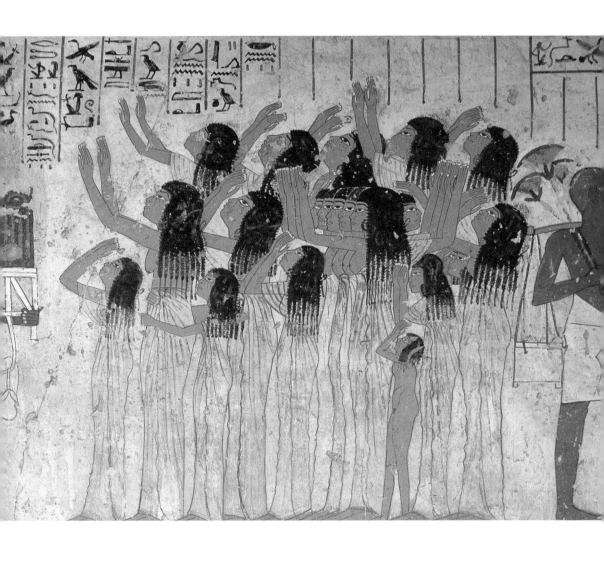

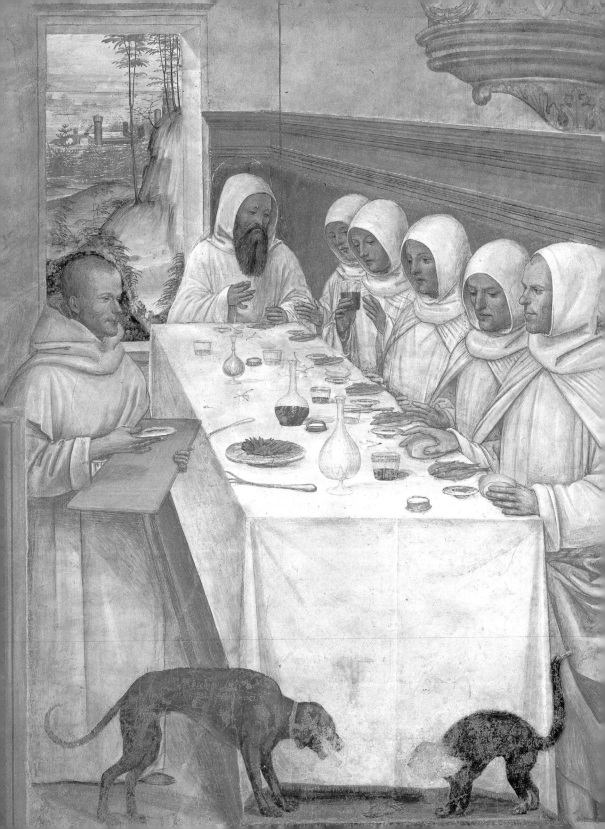

# CREATION MYTHS

For the artist and theoretician Wassily Kandinsky (1866–1944), a great silence emanates from white, but this silence is not dead; rather, it is full of possibilities. White is the oblivion before the beginning, before birth. In Greek mythology, the world began in the absolute emptiness of space: Chaos. In this immense turmoil, this obscure nothingness, this place of suspense, vertigo, and confusion, the blank and bottomless abyss was cracked open, giving birth to the light, the blossoming flower that was the first act of creation. Along with the light, the darkness surged forward, and this colossal couple gave birth to the clarity of the day and the color white, as well as the night and the color black.

This chromatic duality does not belong only to the Greeks. It is universal. Primitive peoples took their first infant steps toward creating universal principles blending shadows and light and founded cosmogonies where white and black contrasted and completed each other. The color white lights up the dawn of many cultures.

For example, in the folklore of many northwest African societies, the universe emerged from an egg that contained everything waiting to be born. Its white color is reminiscent of the supreme deity, who is often pale-skinned, and also the dry part of the world. White represents the warmth that allows life to blossom.

On the other side of the globe, the Aztecs honored the discovery of the lagoon on which they built the city of Tenochtitlán in present-day Mexico. According to legend, the first thing the founders of the future empire saw was a magnificent white bush growing at the edge of a curving stream. All around stood pure white willows, cattails, and reeds, with not a single green leaf in sight. White frogs, white fish, and spotless serpents began to emerge from the water. The Aztecs believed that these were the signs prophesied by their creator-god, Quetzcoatl.

*The Lombard artist Giovanni Antonio Bazzi, known as Sodoma (1477–1549), created this fresco, Saint Benedict and His Monks in the Monastery Refectory, between 1505 and 1508 to decorate the cloister of the Abbey of Monte Oliveto Maggiore near Siena, Italy. The diverse white tonalities were achieved by a base of lead white more or less broken up by the yellow shades (ocher, orpiment, and lacquer derived from weld, curcuma, and saffron.) In Sodoma's time, painters—or their assistants—prepared all colors themselves by grinding pigments before blending them thoroughly with the appropriate binder. It was not until the end of the seventeenth century that artists were able to purchase ready-made blends from merchants.*

# A CELESTIAL WHITENESS

The color white is the essence of luminosity and has been associated with celestial power since the beginning of the human adventure. White also represents the immaculate—absolute purity. Members of ancient cults often draped themselves in white fabric to glorify the divine.

## PHARAONIC EGYPT AND ANTIQUITY

The ancient Egyptians used flax, the creation of which they attributed to the goddess Isis. Its fibers could be woven into the whitest material, and linen therefore was judged the most propitious to honor divine purity. The priests of Isis could only wear white linen robes, and linen bandages were used in mummification practices.

In Rome, the priestesses of Vesta, charged with maintaining the sacred flame and with guarding the *penates* of the Roman people, also dressed in white linen as a sign of purity and loyalty, and as a symbol of the vows of chastity they had taken.

## THE OLD TESTAMENT

*The Islamic religion is present on every continent, and the Muslim community consists of about a billion followers, the majority of whom live in Asia. The faithful everywhere must obey the five Koranic commandments. Prayer is an essential duty. Here Muslims gather together in Java, Indonesia. The white color of their clothing evokes the absolute uniqueness of God, the fundamental dogma of Islam.*

In the Bible, white represents the color of light and is an emblem of the divine. The book of Job recounts how God created the angels before creating the stars. When the heavens lit up, the angels, clad in linen of a perfect whiteness, were already present to praise God. When Moses performed his miracles in the Old Testament, his hand was turned white as a sign of power and strength.

On Yom Kippur, the Day of Atonement in the Jewish faith, the Grand Rabbi dresses himself in white linen to restore an amicable relationship with God and with all people.

## CATHOLICISM AND THE REFORMATION

In Catholicism, white symbolizes the color of the transfigured God and is intimately linked with Christ. Like a lamb, the Messiah's innocence

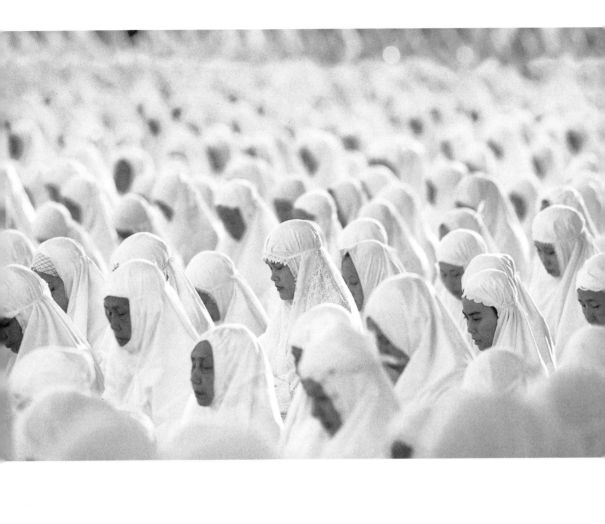

would lead him to the sacrifice through which he would accomplish the divine will. When the Virgin Mary presented her child to the Temple forty days after his birth, Simeon, an old man to whom the Holy Spirit had revealed that he would see the Savior before his death, uttered a song of praise and called Christ, "a light to illuminate the nations." In honor of this day, tradition demands the use of white tapers for Candlemas celebrations; in baptisms, they welcome the new member of the faith and enjoin him to live like a child of the light.

Christian iconography grants the color white a special status. In a miniature from the *Acts of the Apostles,* an illuminated Russian manuscript executed in a Rostov atelier in 1220, the delicate, almost transparent white filaments affixed to the apostles' clothing symbolize the light. They suffuse the composition with a brightness and serenity, a calm luminosity that seems to come from inside the small painting. Since early Christianity, the color white has also been associated with feast days celebrating the Virgin Mary even though, iconographically, she is usually dressed in somber shades, bearing witness to her mourning. This imagery remained the standard until near the end of the nineteenth century when Pope Pius IX (1792–1878) recognized the dogma of the Immaculate Conception. The Virgin then began to be portrayed in white, the symbol of purity, and, for the first time in the history of Western Christianity, the liturgical and iconographic colors symbolizing the Virgin were the same.

For the medieval Catholic Church, and later for the Reformed Church, virtue was translated into clothing made of natural (that is, undyed), raw fabric corresponding to ideals of humility, purity, and simplicity. White became the color worn by men and women of many monastic orders, missionaries, priests, and, since the end of the sixteenth century, by the pope.

## ISLam

In the Arabo-Islamic civilization, heirs to Greek philosophy, white is at the top of a scale that descends toward black. Colors are arranged according to their proportion of fire (light) and earth (dark). White,

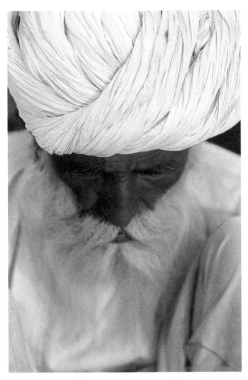

therefore, can move toward black through a succession of darker and darker grays, browner and browner reds, and even through green or indigo. In classical Arabic, the term that designates the color white reflects notions of clarity, luminosity, and loyalty; white incarnates the unity and even the very image of divinity, and it is beloved by Allah. All things that descend from heaven bearing good news are of an immaculate whiteness, notably the corporeal form of the archangel Gabriel and the white bird that announces good tidings. They also use the term "new white" to refer to a message of joy. In the Islamic world, white has also been synonymous with power and strength. When the Fatimids ended the Abbasid dynasty in the tenth century, they replaced the color black, which had been the emblem of the vanquished, with white in order to make manifest their divine luminosity, inalterable and pure. The Ayyubid dynasty that followed ordered that all white fabric be dyed.

## ASIAN RELIGIONS

In the ancient texts of India, reality is divided iconographically into distinct qualities linked to specific colors. The uncolored, and particularly the white, designate the state of purity and divinity. The color white, therefore, is associated with the highest Hindu caste, the Brahmins. According to traditional aesthetic codes, white is associated with detachment and serenity; the color white can also signify a humorous expression.

*According to certain theories, the divisions of Hindu society into four principal castes were at first based on the relative darkness of skin color. Therefore, the superior caste and the color white set apart the conquerors of India, while the "Untouchables," with their black skin, were the descendants of the aboriginal peoples. However, it seems that the role of color was purely emblematic, and did not, in fact, correspond to segregation by racial type.*

In the Mongol pantheon, Buddha is represented in white, the color that symbolizes transcendental wisdom. White also identifies lamas in Tibet. In days gone by, Buddhist monasteries would gather together hundreds of tents made of black yak hides, against which the white wool tents of the dignitaries would stand out.

White also occupies a predominant place in the Shinto rites of Japan. Before ceremonies, the priest carefully cuts geometric shapes out of white paper before arranging them on the branches of sacred trees and around altars. These pristine sheets of paper evoke the purity of the gods and intercede in purification rites. The color white plays an equally important role in Zen gardens, places of contemplation and silence, where white gravel and pebbles punctuate the stroller's meditation and lead him or her toward illumination.

## THE PILGRIM'S WHITE HABIT

White fabric was worn not only by those who served religion, but also by those who wished to become closer to God. The color white underscores the pilgrim's purity and signals that he has devoted himself for a time to contemplation.

One of the five pillars of Islam, the pilgrimage to Mecca assures the faithful of the absolution of their sins. For this event, the pilgrim wears an ihram, a seamless white garment that symbolizes his state

of consecration and completely effaces all distinctions of nationality and social class. Each year at the beginning of pilgrimage season, the great black cloth draped over the Kaaba is replaced. A white veil covers the building temporarily until a new black fabric is put in place. This white veil is then cut up and distributed among the pilgrims as a token of good luck.

Japanese pilgrims devoted to purification rites, such as immersion into sacred rivers, wear white as a symbol of spotlessness and rebirth. In the mountains in the center of the country, peasants set aside natural hemp cloth to prepare clothing to be used in ceremonies needing ritual purity. These same clothes were worn by itinerant porters who tended sanctuaries during the annual holidays of the tutelary divinities.

# MILK WHITE

The color white plays an equally important role in the history of humanity through milk, that sweet elemental sustenance. The gods of Olympus themselves could not do without it, and Zeus suckled at the breast of the nymph Amalthea. Along with wine, honey, and dew, milk is one of the four substances considered sacred by the Talmud. And, in the Koran, it is said, "Here is the description of the garden promised to those who believe in God. There will be rivers of milk whose taste never changes." Even today, in Muslim Egypt, they refer to milk to describe a beautiful day.

## PASTORAL PEOPLES

In pastoral societies, a particularly powerful emotional tie connects the color white to milk, as the liquid represents their first alimentary source. For Bedouins who travel the length and breadth of the Negev Desert with their flocks, the color white has become an implicit benediction. It is the color of gratitude, of esteem, of joy, of luck, and of fertility, but also of protection against the evil eye. And when they seek a saint's protection through prayer, the Bedouins dress themselves in white.

*The djellaba is a long-sleeved hooded robe worn by the men and women of Morocco. The most beautiful examples are woven from the wool of sheep selected for their whiteness.*

# THE WHITENESS OF MILK
# AND SPERM IN AFRICA

In many African societies, white is perceived as the original color. From very earliest times, it has been associated with mother's milk and even with the pale skin of a newborn child, but it is also linked to the existence preceding birth. Through the act of fertilization, the whiteness of the paternal seed connects the life of the ancestors to the future child. The color white, therefore, relates to both genesis and death and, as we will see, also accentuates the key stages of life.

Milk attests to a woman's fertility, and its positive virtues are transferred to all things white. Among the divinities in the pantheon of the Hausa people of Nigeria, the white gods are the most favorable. The color white also plays a role in a number of ceremonies by communicating a "white heart" (that is to say, peace) or a "white belly" (happiness) to the participants. The Hausa spill milk on altars as offerings to the gods, and sacrifices and shamanic medicinal rituals take place on sand drawn from rivers and chosen for its whiteness. Likewise, white cotton patches are set on the bellies of newborns to protect them against demons. Similar practices are found throughout Africa. In Sudan, the sick wear bands of white fabric to hasten their recovery, and children are dressed in white at fall of night as protection against the dangerous forces of darkness. The Kongo of central Africa alternate strips of fabric woven in black and white as part of their attire. The white bands are worn when a calamity introduces a great disorder into the community.

Milk is sometimes represented by another white liquid. The Ndembu people of northwestern Zambia harvest a white resin from a particular type of tree, which the women call the "mother and child tree" or the "milk tree." It is a symbol of fertility and, therefore, represents the survival and the social cohesion of the group.

# Passages

In *Songlines,* Bruce Chatwin (1940–1989) describes an Aboriginal painting: "So many Aboriginal artists used strident color schemes. Here, simply, were six white to creamy-white circles, painted in meticulous 'pointilist' dots, on a background which varied from white to blueish white to the palest ochre. In the space between the circles there were a few snake-like squiggles in an equally pale lilac grey…"

In many cultures, the color white marks the important passages an individual must cross in the course of her existence.

## SNOW WHITE

In "Snow White," the folk tale popularized by the Brothers Grimm, the color white is associated not only with innocence, but also with the heroine's required period of latency in her tomb. Snow White owes her name to the pallor of her skin. An Italian version of the tale also exists: "La Ragazza di Latte et Sangue" ("The Girl of Milk and Blood"). With snow relatively unusual in much of Italy, the three drops of blood spilled by the queen fall on milk and white cheese in this account. But, in France as in Italy, the name "Snow White" also calls to mind the whiteness and purity of a strong light, and perhaps the tale has its roots in some ancient pre-Christian rite celebrating the sun. According to Bruno Bettelheim (1903–1990) in *The Uses of Enchantment,* the problems the fairy tale must resolve have been posed since the beginning of history: innocence and the white purity of our conscience in contrast with sexual desire and the red chaos of our unfettered emotions, here symbolized by blood. White confronts red, the color strongly associated with menstruation. The duality found in the heroine—asexual in her whiteness, eroticized by the redness—is echoed in the fateful apple offered by her stepmother. The stepmother keeps the white half and gives the red portion to the one she wants to kill. Snow White succumbs to the temptation, choosing the color that marks the beginning of her sexual maturity, and dies prematurely by the innocence of childhood. Not until the prince's kiss awakens her

from her long lethargy is Snow White ready to welcome love. Bettelheim concludes that "we can only attain adulthood when the red and the white can coexist harmoniously."

## INITIATIONS

In Kenya, Maasai initiations are part of a cycle that lasts more than twenty-five years. The crossing of each stage—from the all-important circumcision initiation to the Eunoto ceremony (shown opposite)—is marked by a body painting made with white chalk. Every seven years, the Eunoto brings together almost four hundred warriors in sacred chalk quarries. The initiates concoct a paste with the pigment, then decorate their bodies with designs recalling the exploits accomplished since their last initiation. The ritual is known by the name "the white dance." The color white represents their transformation into senior warriors, and marks their ability to assume responsibility, henceforth, for a wife, children, and a herd. It also symbolizes a new phase in a man's existence, centered on the idea of protection, the duties owed his family, and the benefits he will reap from it. In effect, evil will befall anyone who would dare attack a man bearing white images.

If darkness and the color black signify, respectively, the site of initiations and the state of the profane, white represents the color of the initiate, the one who has been symbolically reborn.

White, the color of ritual purity, accents the lives of the Tamang people of Nepal. When a child is weaned, his mother dresses him in white for his first meal of solid food. His maternal uncle, who performs the child's first haircut, presents the little boy with an article of white clothing and a white headband for the occasion. White clothes are worn as well in initiations. The male head of the family dresses himself in white to celebrate the clan gods, and he attracts prosperity to the household by decorating it with effigies of bamboo stalks topped with white cotton squares. Marriages are celebrated under white canopies, recalling the long white sheets of fabric used in funeral ceremonies. Known as the "white path," this material symbolizes the route the soul of the deceased must travel in order to reach his home in paradise, the place of rebirth.

In many African tribes, the bodies of young boys who have just been circumcised and turned into new men are painted white. Among the Kissi of Guinea, initiates are whitened completely, like ghosts. For the nomadic Bambara of the Sahara, the white clay covering the bodies of newly circumcised young men and women marks the passage by transforming from the color of death and lunar light into a sign of life and the sun. In Sudan, the Nuba face each other in initiatory ritual combats, shielding themselves with white ashes formed by burning the branches of a certain type of shrub. White as snow, the powder is both sacred and practical for them. It signifies the fulfillment of an exploit, dispenses strength and health, cleans and embellishes the skin, and protects the wearer from insects and parasites. Also, milk whipped into cream can be used to trace decorative designs on the body.

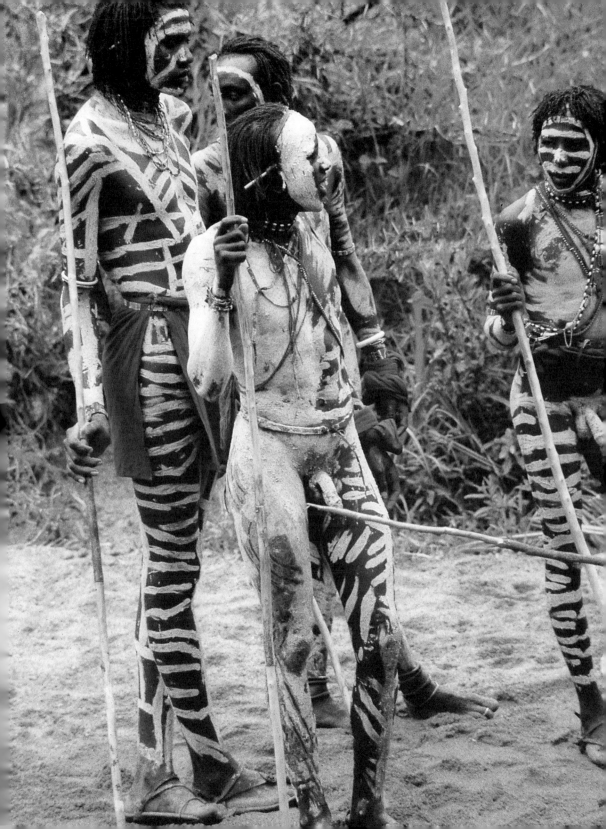

When a young man kills his first enemy and ascends to the warrior class, the Iatmul people of New Guinea celebrate the event by decorating his body with white chalk.

In Western cultures, white also represents the spiritual enlightenment brought about by the symbolic rebirth of the initiate. Moreover, the word "candidate" comes from the Latin *candidus*, meaning "white," from the white togas worn by candidates for office in ancient Rome. Until recently, a new communicant in the Catholic faith wore a white alb to the solemn first communion ceremony—the admission into the sacrament of the Eucharist—as a symbol of humility and purity of heart. In Islam, both mother and child wear white outfits on the day of circumcision.

## VIRGINAL WHITE

As part of the celebrations on St. John's Eve (June 23), young girls in Shropshire, England, would hang a white sheet under an oak tree to discover what marriage had in store for them. The next morning, they would find a little dust on the material and place a pinch of it under their pillows. In the course of their dreams the following night, the dust would reveal the face of the man to whom they were destined.

In many cultures, marriage is looked on as an initiatory rite and underscored as such by the white outfit worn by the future bride. The traditional costume for the Japanese bride includes a white kimono, an acknowledgment of the state of purity that she must bring to her new home and a symbol of her new existence.

The nomadic shepherds of Afghanistan set aside immaculately white sheep's wool to construct the yurts of newly married couples. Until the end of the eighteenth century, however, wedding gowns in the West were made of the most dazzling red material. It was only during the course of the nineteenth century that the white gown began to establish itself. For many years, a couple in the countryside would don traditional costumes, which were also worn on feast days, while among the leisure classes in the cities and towns, the beautiful dress made especially for the marriage ceremony was worn again on

important occasions. Eventually, the white wedding gown became a jewel used only once. This idea corresponded to the growing importance of virginity.

In contemporary France, the expression "white wedding" indicates a marriage in name only, purely administrative. The color white here reflects absence from the community and, above all, represents the non-consummation of marriage.

# Gray Hair, the Shroud, and Beyond

## OLD AGE

Gray hair heralds the ineluctable nature of the body's deterioration and of death. In folk tradition, a number of magical practices were used to erase such warning signs. In ancient Greece, for example, an old man's head might be rubbed with an omelet made of raven eggs to give him dark hair. To prevent the charm from turning his teeth black, he had to keep a swig of oil in his mouth at the same time.

Reaching old age was considered fortunate in many cultures. Near Peking (present-day Beijing) at the beginning of the twentieth century, they still celebrated the birth of a child by offering visitors white eggs. Each guest would take one and present it to the newborn while wishing him a long life. The death of a great-great-grandfather was not marked by wearing white, the traditional color of bereavement; instead, red was used to reflect the joy experienced by someone who lived to see four generations of descendants.

## WISDOM

In Sudan, they describe a whitened section of land as bare and unfit for cultivation, but add that it is useful for building homes. Old age is the age of sterility and the end of an era. For many cultures, however,

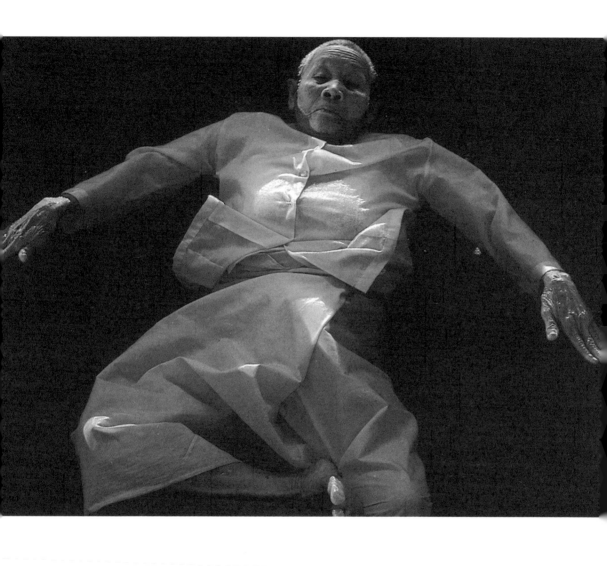

it is also the age of wisdom and of access to a socially important role in the community, often identified by the color white.

Among the Wè of the Ivory Coast, the wisdom of old age is symbolized by a completely white mask, worn with a white outfit. The color plays a major role in rituals. For the Nubas of southeastern Sudan, white is the only color not explicitly intended to embellish the body. When the men cover themselves in white chalk to indicate they are in mourning, the old women use it to whiten their faces as well and thereby signal that they, too, occupy an important ceremonial position within the tribal group.

Just several decades ago among the nomadic Turkmen tribes who roam central Asia, women in the twilight of their lives still wore the white coats reserved for wives whom life had dignified and age had designated as matriarchs.

For centuries, women in Laos could not become Buddhist nuns, but the aged among them could become "ordained grandmothers." They would shave their hair and eyebrows and put on white robes. They obeyed 227 rules and lived apart from monks.

## FRIGHTENING WHITENESS

Sometimes white can have negative connotations. In the Chinese theater, actors wearing white makeup play the role of schemers and are called "tofu faces," in reference to the yellowish-white soy curd.

When used to describe skin, white may indicate illness. This may be the reason why the Dogon of Mali avoid raw cotton fabric. The fear of becoming as pale as the material seems to have impelled them to dye their textiles saffron, the color of the earth, in order to resemble it. White marks could also be caused by leprosy. In ancient India, magic potions tried to make them disappear by recoloring the skin. The diseased area was rubbed until bloody, then a paste made of turmeric, colocynth, and indigo was spread on it because a blend of these plant juices could restore the skin to its original brown complexion.

The color white also denotes a lifeless body. Following a custom of poking fun at religious interments, a cadaverously white character

*The temple of Mongkon Thong in the Kanchanaburi province of Thailand is home to a nun famous for being able to meditate while floating in a bath. There are two conflicting schools of thought in Thai Buddhism concerning the ordination of women, but they agree on admitting novices and female bonzes. The women may have been married and be mothers, and they are often widows or even divorced, but they are always at least fifty years old.*

became a trope of comedies of intrigue performed in the Russian countryside. A man dressed in white clothes conceals his face behind a terrifying mask fabricated of birch bark or covers his face with a thick layer of flour. Pieces of rutabaga stuck in his mouth represent monstrous teeth. The audience shakes with shrieks of terror and peals of laughter. Still alive in the northern provinces of Russia, this tradition is part of a cycle of theatrical parodies that can last over a dozen days.

Whiteness also summons up images of specters. The Ndembu, who live near the headwaters of the Zaire and Zambezi rivers, fear the color white when it is linked to *ignis fatuus*, the swampland will-o'-the-wisp that draws hunters to their deaths.

# wearing white for mourning

### THE WEST AND THE ABSENCE OF COLOR

In ancient times, across most of Europe, the grief brought about by the death of a close relative was translated into the wearing of white clothing. Mourning attire in the Middle Ages, and particularly the clothing worn by widows, was very similar to the dress of monastic orders, whose haircuts were often adopted as well. Like those ascetic garments, these were made of rough fabric as expressions of humility and penitence. The queens of France wore white mourning clothes until the sixteenth century. Anne of Brittany (1477–1514) was the first to wear black for mourning, and was quickly imitated by Catherine de' Medici (1519–1589), then by Marie de' Medici (1573–1642), and Anne of Austria (1601–1666). However, white long remained the color of mourning dress worn by children and young girls in Europe.

Mourning white endured as well as a custom in certain communities, as with the Roma of central Europe. In days gone by, the funeral of a Romany chief assumed a profoundly symbolic nature: the body was placed in a white painted cart that then traced the reverse route of the people's original migration. Obviously, the funeral could have lasted a very long time.

*Mary Stuart (1542–1587), queen of Scotland and widow of François II of France (1544–1560), was one of the last queens to wear white mourning dress. The black clothes worn by Anne of Brittany (1477–1514) when she buried her husband, Charles VIII (1470–1498), were quickly imitated first by the court of Burgundy, then by the Hapsburg court. However, it was years before an aristocratic fashion became solidly anchored in the heart of Western society. Outside the aristocracy, therefore, widows still wore white for bereavement until the end of the seventeenth century. The veil and the bonnet attached under the chin by immaculate linen, or "mousseline barbes," remained characteristic elements of feminine mourning dress. Rather than emulate Anne of Brittany's severe costume, English and French widows adopted the pointed headdress, hence the origin of the term "widow's peak," worn here by Mary Stuart. This portrait of her was painted in France in the sixteenth century. Chateau de Blois.*

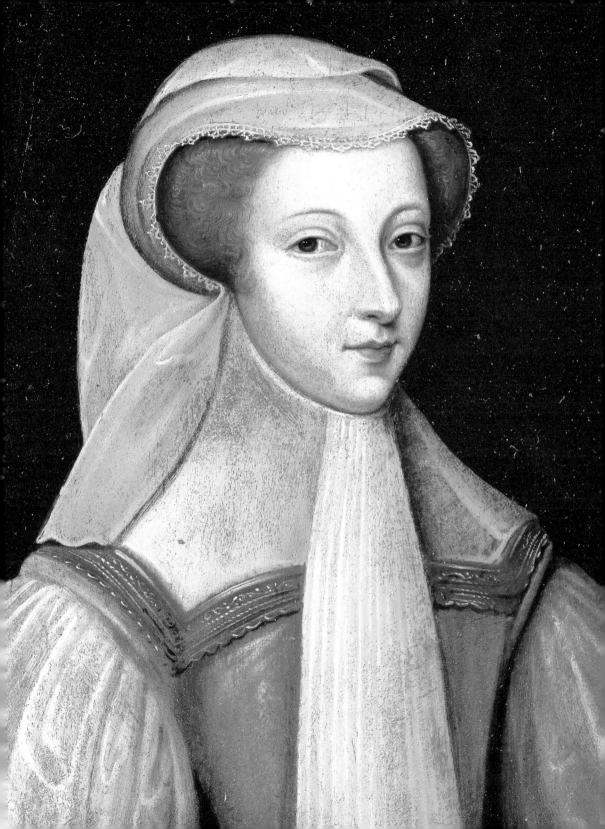

AFRICA AND ANCESTRAL MANES

In Africa, death is linked to white sperm, considered a kind of whitened blood passed down by one's ancestors. As we have seen, the dead return to life in the bowels of their descendant through the intermediary of this substance. The sperm symbolizes the vital union with the ancestors. In this context, the color white provides a meeting place between the living and the dead. Numerous ethnic groups integrate bone dust, crushed chalk, whitewash, and kaolin into their funeral ceremonies or in their communication rituals with the dead. Such pigments are painted on the faces of the participants and are also used to decorate masks, like the ones created by the people of the Ogooué and Congo (formerly the Zaire) river basins. These white masks symbolize the idealized faces of dead young women, and their color represents the spiritual entities incarnated in the ancestral manes, or venerated spirits. Statues used for funerary rites in Mozambique include a hand covered in kaolin, evoking the paternal seed.

THE NATURAL FABRICS OF ASIA

Mourning dress across Asia is made of white or, more correctly, naturally colored fabric. As a general rule, the more distant the bereavement, both in terms of relationship and time, the darker the clothing worn until it returns to the deep blue or black attire typical for men. Under the influence of Western traditions in the course of the 1970s, white also became the color for bridal gowns in a number of Asian countries. But white has been and remains the color for funerals.

Across parts of China, they still place small lime-filled sachets—one packet for each year of life—on the deceased and scatter white paper flowers around the body.

The color white plays an equally large role in the mourning rites of Japan. When death strikes a family, it is customary to send condolences written on white paper, according to a strictly codified tradition, or to send gifts carefully wrapped in white paper to protect their contents from worldly impurities.

*In Chinese culture, the souls of the dead are in close contact with those of the living, and they intercede with the god of heaven for the protection of their descendants. The cult of ancestors is, therefore, intimately integrated into all parts of religious life, and wearing mourning dress is known as "dressing in filial piety." For burials, bereavement rituals are traditionally associated with five distinct types of attire, according to a person's relationship with the deceased. The closer the connection (child, parent, spouse), the coarser the hemp or linen cloth and the simpler the style of dress. Thus, a distant relationship translates into a fine fabric carefully sewn. But whether the chosen material is rough or smooth, whether it is crudely constructed into a sleeveless and seamless coat or meticulously hemmed, it will invariably be left untreated, without ornamentation or embroidery and, above all, devoid of color.*

In rural Thailand, a woman whose husband dies remains in his family, but she can remarry if she wishes. The new marriage contract is prepared not on red paper to connote joy, as with the first marriage, but on white paper, the color of grief, thereby defining her as a widow.

The requirements of white mourning dress gave rise to an astonishing situation in Korea. At the beginning of the nineteenth century, several kings died successively in a short period of time. Tradition demanded that the people wear white for three years upon the death of a king, but the monarchs' fragile health precipitated first unemployment then destitution among dyers. When the last period of mourning was finally over, there was no longer anyone left able to dye fabric. It was only many years later that a member of the court concerned by the situation asked the king to publish a decree officially permitting the public to wear colored, and therefore less dirty, clothing (and, at the same time, shortening the style of long floating sleeves that a preceding king had made obligatory in order to render fighting more difficult).

### REALISM PUSHED TO THE EXTREME

Among Aboriginal peoples of Australia and New Guinea, white, the color of death, assumes a realism unseen in other parts of the world. By painting white stripes on his body, a man transforms himself into a skeleton so that an ancestor can be reincarnated through his descendant.

# THIS OVERWHELMING DESIRE FOR WHITE

Since the dawn of time, humans have always sought out the purest whites to honor their gods or their dead, or to respect the customs of their community. In the course of this quest, they discovered a wide variety of solutions.

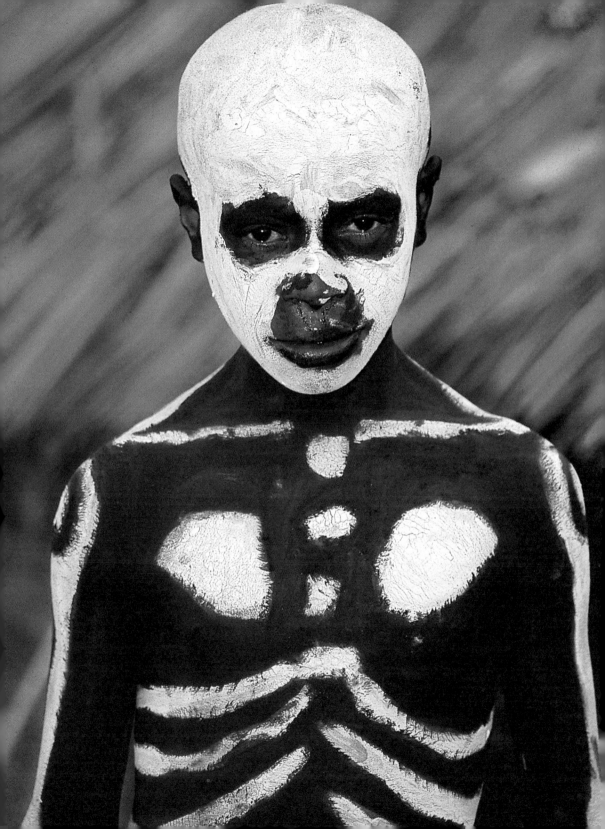

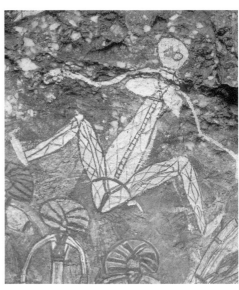

## WHITE PIGMENTS: OF INVENTIVENESS, CHALK, KAOLIN, AND LEAD WHITE

*The "X-ray" style of Aboriginal art dates this rock painting from the Kakadu region of Arnhem Land, Australia, to around 9000 B.C. The white pigment—chalk or kaolin— is bound with orchid sap and spread over the rock face, with eucalyptus fibers or human hair used to help define the most delicate elements.*
*These figures probably served to commemorate the acts of creation by ancestral beings. They came from Dreamtime, the origin of the world and the period when beings—plants, animals, people— emerged from the Australian earth and, moving about its surface, formed its topography, its flora, its fauna, and its humanity. Paintings represent the source of ancestral power. Initiates know how to pass on this dreaming to the present day, and transmit knowledge from generation to generation. And an Aboriginal law says: "To paint the ground no more is to risk seeing it disappear."*

Many white materials have been used for drawing and painting. Every morning, for example, the women of Madras, India, use a fine powder made of rice to trace ephemeral designs on the thresholds of their homes, in honor of the goddess Lakshmi, guardian of the hearth. Elsewhere they resorted to animal droppings or, as in Japan, eggshells and crushed seashells to produce white shades. But as for actual pigments, for many years people only had chalk and kaolin at their disposal; these materials even figure in the prehistoric cave paintings. Over time, artists and artisans discovered other white pigments, which were all characterized by their opacity. The best known was lead white, also known as flake white.

Lead white is a carbonate of lead. You can find it in a natural state, for example, in Iran and in Smyrna (Izmir), Turkey, where they use it to paint boats. But in antiquity, people produced it by exposing slivers of lead to the compound action of vinegar and animal dung, the latter providing both the carbon dioxide and the heat neessary to the chemical process. After several weeks, a white layer of microscopic crystals formed on the lead; this was lead white, also known as ceruse. Since ancient times, lead white had been the pigment most commonly used by artists in Europe and Asia. The portraits of Fayum, Egypt, owe the intensity of their gaze to this substance. The Chinese also created white inks from ceruse. During the Middle Ages, manuscript illuminators in Europe, Armenia, Persia, and India appreciated it for its opacity and coverage, which allowed them to trace designs of great delicacy with a single sweep of the brush. Beginning in the Renaissance, painters coated their canvases with it, thereby introducing a sense of light into

their landscapes. At the start of the twentieth century, the use of this toxic pigment was banned and the reign of lead white ended in the West. Although it was replaced by zinc white, many artists continued to miss it.

# THE unattainable perfect white

Even if white pigments exist, dyeing something white is impossible. Not only do people want white, but it is also the ideal background color for a leather or fabric they wish to tint.

### SEVERAL NATURALLY "WHITE" MATERIALS
The plant world provides flax, which can be woven into (almost) white textiles. Originating in South America, cotton arrived in the Old World at the beginning of the seventeenth century through Hernán Cortés (1485–1547). Its fibers are white, but people only managed to spin and dye it properly starting in the eighteenth century. In the animal world, the principal source for white fibers is white sheep's wool. The Inca selected the whitest wool from llamas, alpacas, guanacos, and vicuñas. In Asia, people exploited natural silk. Also, the hides of white animals were much sought after, for example, by the Kiowa of the Missouri River region, who hunted white buffalo to make teepees from their skins. However, none of these materials is truly white in color. Linen, wool, and leather lean toward ecru, and silk often bears a yellowish, greenish, or orangish tone. For all these reasons, a variety of techniques were developed to eliminate those colored shadings.

### WHITENING A LIGHT MATERIAL
*Scraping and stretching skins*
For many years, the only way to lighten leather was to scrape it laboriously. This technique has been used since Neolithic times by people around the world and applied to a wide variety of hides. Around the St. Lawrence River, native peoples constructed white teepees of patiently abraded bison skins. The Hausa of Nigeria would stretch the lightest skins provided by their sheep and goats for days.

*Ashes, clay, saponins, and sulfur*

In medieval Japan, they bleached silk by boiling it in a solution rendered alkaline by the presence of ashes, particularly those made from the alkaline-rich tea tree. This is how they treated the enormous quantity of raw silk material sent by the provinces to the capital city as payment of taxes. The court's dyeing workshops, with their perfectly mastered techniques and the rarest and most expensive tinctures at their disposal, were then charged with coloring the fabric according to the latest fashions.

Washing powders based on ashes, clay, and other minerals, such as chalk and magnesium, had long been familiar in the ancient Western world, but the techniques for using them had not been sufficiently mastered. They either gave fabrics grayish, greenish, or bluish overtones, or they took away part of their brilliance. Many people preferred to use a clay endowed with real bleaching properties that was common on Sardinia. Roman fullers imported it to whiten light fabrics.

In ancient Gaul, they used saponins, plants containing a particular kind of sap that lathered like soap. People would wash the wool on the backs of the sheep with it, repeating the process on the woven textiles. The saponin not only highlighted the fibers' whiteness but also gave the material a remarkable suppleness.

The bleaching properties of sulfur were also known early on in human history, but the use of this corrosive product needed a light touch. In Gaul fabrics were stretched on a wicker cage set over a stove containing the burning sulfur. During the Middle Ages in the West, they tried to bleach linen by plunging it into a water bath with diluted sulfuric acid. The concentration of acid had to be mastered perfectly; otherwise, the material came out of the bath beautifully white but irreparably damaged. In the Renaissance, the use of sulfur was briefly popular because rich Italians demanded pure white silk, which could be achieved by lightly bluing the raw silk through sulfurization. Creating a luminous white fabric required many such manipulations, the results of which were reflected in both the high price and the prestige of white silk. To prepare them for shipping, these textiles were carefully wrapped so that the residual sulfur in the material did not ruin the dyed fabrics packed alongside them in the transport.

*Antonio del Pollaiuolo (c. 1432–1498), painted this* Portrait of a Young Woman *around 1465. A century later, the French writer Pierre de Bourdeille, seigneur of Brantôme (c. 1538–1614) defined the ideal of feminine beauty in his* Lives of Fair and Gallant Ladies *thusly: "Three white things: skin, teeth, and hands; three black: eyes, eyebrows, and eyelashes." Medieval representations of the Madonna show that, by the twelfth century, her face had to be portrayed as pale and luminous as possible, a requirement that extended to all visible skin surfaces (notably the hands and feet). The compendia of recipes and elixirs that have come down to us reveal that the quest for ingredients with skin-whitening propensities were already a preoccupation in antiquity. Berlin, Staatliche Museen Preussischer Kulturbesitz.*

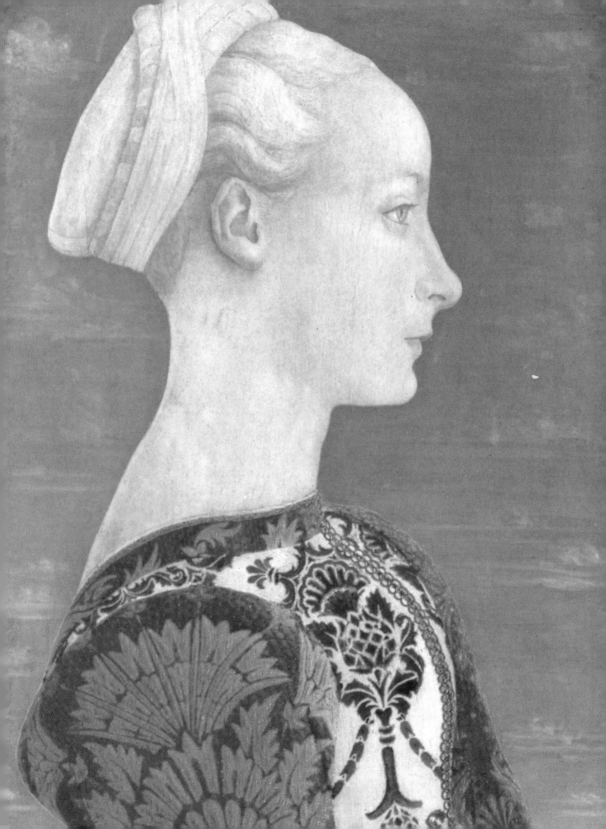

*The bleaching fields*

In Guatemala, fabrics made from various plant fibers were whitened
by exposing them to the sun after washing them in the waters of
Lake Atica.

The West developed bleaching in the fields, a process that con-
sisted of spreading out wool and silk fabrics on the grass so that they
were bathed in dew. The effectiveness of this approach was understood
only empirically at the time, but today we know that this method of
whitening textiles depends upon the release of oxygen from photo-
synthesis. Grass bleaching endured in Europe until the end of the
eighteenth century, and the industry was most successful in Holland
where French and other European textile manufacturers sent entire
shiploads of material to be treated. The sheets had to be moistened
constantly so that they did not dry out. The whitening process mobilized
a large number of seasonal workers and occupied dozens of acres of
fields between May and September. Unfortunately, the bleached fabrics
stayed white for only a short time, before resuming their original tint.
When royalty began to wear white mourning dress in the fourteenth
century, they concealed the material's yellowish tones by pairing it
with violet, gray, or black fabrics. Church dignitaries did the same
with gold textiles.

*New products*

When Claude Berthollet (1748–1822) discovered the bleaching proper-
ties of chlorine in 1791, he revolutionized the whitening of fabric. In
1828, Jean-Baptiste Guimet developed synthetic lapis lazuli, and the
industry went wild selling balls of blue washing detergent. It compen-
sated for the yellow tint in white materials by conferring a slight blue
tone, a visual trick called "optical brightening."

Since the beginning of the twentieth century, the development
of fluorescent whitening agents that absorbed ultraviolet rays and
re-emitted light in the blue part of the spectrum gave the papermak-
ing and detergent industries the ability to improve their whites even
further, making them "whiter than white."

## THE WHITE PLACEBO

Whether it relates to sins, smears, or microbes, the color white has often been proof of the absence of stains. In nineteenth-century Europe, it invaded industrial architecture in an effort to cut back pollution, first in industry and then in the omnipotent culture of the automobile. As a symbol of a hygiene bordering on sterility, white reigned as well in hospital settings, in the color of both the walls and the attire worn by the medical staff. Around the 1970s, the hospital world turned toward an unbridled polychromy as a reaction to the all-white clinic in an attempt to free its mindset and open itself up to other ideas. Today, we see a tendency to re-create a reassuring universe at home through the use of pastel tones. But antiseptic bandages remain white.

## LILY-WHITE

For the Nuba of Sudan, although white identifies a good person, white skin is perceived as ugly. However, in many cultures, skin's lightness has been the predominant aesthetic ideal. Archaeologists have recovered jars of makeup from Ur in Mesopotamia dating from 2500 B.C., as well as from various sites around Egypt, where some whites still bear traces of lead. They were probably used as medications, but also as cosmetics to lighten the skin. We have numerous examples of the use of white makeup in ancient Greece and Rome. Women coated their faces, shoulders, and arms with unguents obtained by diluting tablets of lead carbonate in water. This substance served as a foundation and also concealed small wrinkles. In his comedy *Female Garland Vendors*, Eubulus (c. 360 B.C.) made fun of elegant Athenians: "If you go out during the hot weather, two black streams will run from your eyes and red streaks will stretch from your cheeks to your neck. Your hair, falling down on your forehead, will become sticky with lead white…"

Over the centuries in Europe, white skin, synonymous with freshness, was all the rage among the aristocracy. A dark skin denoted suspect ancestry or peasant labor in the great outdoors. To whiten skin,

women used pomades, some of which were based in lilies or milk, probably in the hope that the whiteness of the ingredients rendered the product more effective. It was only with the rise of paid leave that a white pallor, that sign of class and wealthy idleness, was progressively replaced in the West by a suntanned glow of possibly exotic origin. Henceforth, a tan served as manifest proof of the vacation-goer's good corporal and financial health.

## ALBINISM, OR THE FATAL WHITE

Whiteness pushed to its extreme can prove mortal. Humans and animals (and sometimes plants) may be affected with a malady characterized, among mammals, by the absence of pigments in the eyes, skin, coat, and hair. This is albinism. The principal function of these pigments is protection against radiant light, and creatures that lack these pigments rarely survive. In the animal world, they become easy prey, for they lack the traits that provide camouflage and, therefore, a measure of safety.

# THE USES OF WHITE

# CHALK

CHALK IS A FORM OF CALCIUM CARBONATE (A SEDIMENTARY PRODUCT RESULTING FROM THE FOSSILIZATION OF VARIOUS MICROORGANISMS) THAT CONTAINS A CRYSTALLINE STRUCTURE. THERE ARE MANY SORTS OF CHALK. IN WESTERN PAINTING, THERE IS MEUDON WHITE, CHAMPAGNE WHITE, AND, DURING THE RENAISSANCE WHEN IT WAS USED AS A PREPARATORY GROUND FOR CANVASES, SPANISH WHITE, ALL TERMS THAT IDENTIFY BOTH THE GEOGRAPHICAL SOURCES AND DIFFERENT TYPES OF CHALK. THE FRENCH WORD FOR CHALK, "CRAIE," COMES FROM "CRETE," KNOWN AS "CRETA" IN LATIN; IN ANCIENT TIMES, THE SUBSTANCE WAS IMPORTED FROM THIS MEDITERRANEAN ISLAND. ROMAN WRITERS DESCRIBED IT AS SEA FOAM SOLIDIFED WITH LEMON.

*The seminomadic Fang people of Gabon organize themselves in exogamous clans composed of patrilineal descendants based on the same ancestral clan, the natural-born children of daughters of the clan, and those adopted by the clan. African statuary serves as an intermediary between the living and the entity (the ancestral spirit represented by a mask) acting as guardian of the family reliquaries. The Fang say: "God is above, man is below, God is God, man is man; to each his own, to each his home." Probably used during initiatory brotherhoods, the mask features a concavity formed by the double-arched eyebrows, and its white color refers to the spirit world. Paris, Musée du Quai Branly.*

People everywhere have used chalk. They used it to make sketches like the ones, for example, created by Tibetan Buddhist artists, who would trace a network of fine geometric lines on the background surface of their paintings by means of a thin cord saturated with chalk. With these reference points thus delineated, the painters could then precisely position the figures according to proportions strictly codified by tradition. Chalk also helped to build up white layers. In order to whiten their masks, the Dogon of Mali blended chalk with cooked rice and the excrement of lizards and large snakes. They sometimes added a mixture of sacrificial blood to reinforce the magical efficacy of the mask. On the Vanuatu archipelago, northeast of New Caledonia, chalk was chewed to form a paste that was then slathered over cult objects. When the coating dried, the surface would take on a slightly greenish tinge.

Chalk often lightens pigments or modifies plant dyes, as in Borneo. Conversely, among the Yoruba of Nigeria, the women who draw motifs on the sanctuary walls tint the chalk they use with plant dyes derived from ingredients gathered from their immediate surroundings.

Chalk also plays a role in body painting. Tribes in the Tierra del Fuego trade chalk from the Estancia Segunda. Among the Selk'nam people, for example, it assumes a great importance during cult ceremonies in which the spirit emissaries must represent both the southern sky and snow. Using their fingers, they smear the chalk over their bodies, which are already oiled with animal

fat. To make the designs, they scrape the piece of chalk with their teeth and mix it with their saliva. The paste is then spit out directly from the mouth onto the skin, or collected in the hand and skillfully deposited on the body with the help of a stick, following precise patterns. To obtain a cloudy effect, they clap their powder-covered hands together. As a sign of mourning among the Papuans of Mount Hagen, New Guinea, a man covers his body with chalk blended with ashes to soften the shine. On the other hand, during feasts where men seek wives, he makes sure to polish his body carefully with chalk. Chalk, therefore, becomes his finery, signifying health and strength. It also symbolizes the fat and splendid pig exchanged as money during these ceremonies.

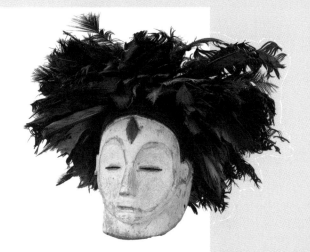

## INSTRUCTIONS

Chalk essentially allows you to modify pigments, especially clay and ocher. You can use it to make whitewash for plaster and wood according to the following formula (the proportions are for six liters of whitewash): dissolve 250 grams of wallpaper glue in 4 liters of warm water until the mixture is perfectly blended. Very carefully add in 2.5 kilos of Meudon white and another liter of water. Stir it very well. In another bucket, dilute 500 grams of clay or ocher with 0.5 liter of water. Little by little pour the chalk preparation into the pigment, blending them together very carefully with the help of a paint stirrer or a pastry whip to avoid the formation of lumps. Then with a brush, roller, or natural sponge, spread the mixture to achieve the desired effect. Most people prefer to whitewash a wall because the mixture dries so quickly.

# kaolin

A SOFT, WHITE-COLORED
ROCK, KAOLIN CAN BE FOUND
IN NUMEROUS DEPOSITS ON
ALMOST EVERY CONTINENT,
AND ITS PIGMENT PRODUCES A
PRONOUNCED MATTE EFFECT.

From the beginning of time (traces go back close to fifty thousand years), Australian Aborigines used kaolin for their paintings on rocks and rock walls. They collected it from deposits or from the banks of waterholes and rivers. For the Aruntas, who live in the center of Australia, kaolin enhances the contours of the charcoal designs drawn on the body for cult ceremonies. They also use it for a very specific ritual during which they construct an enormous structure out of hair, twigs, and branches, balanced on the head of the initiate. Weighing up to twenty-nine pounds, this structure is covered with a coat of kaolin.

Fortunately, the initiate only bears his burden for a few minutes. In Africa, kaolin, a primordial substance linked to communication with one's ancestors, is often collected from depressions flooded during the rainy season, depressions that are also the refuges of ancestral manes. The Urhobo in Nigeria offer it as nourishment to the water spirits, and also whiten the statues used to channel beneficial forces. Kaolin reinforces the expressiveness of the sculpted faces and underscores the scarifications on the bodies, as it is deeply encrusted in the wood grooves. For the feminine ritual masks sculpted by the Songye of the Democratic Republic of the Congo, white is associated with light, the moon, manioc flour, mother's milk, and sperm. These masks represent positive qualities such as health, purity, reproductive vigor, and, therefore, continuity, peace, and beauty. In the neighboring region inhabited by the Luba, oracles and

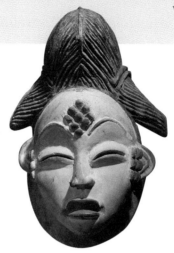

## INSTRUCTIONS

Like other white pigments, kaolin does not mix well with egg yolks, unless you want grayish tones. In water mixtures, it blends best with casein. Casein is the protein compound that forms the basis of cheese. Today, you can find casein sold in powder form. You only have to dilute it (10%) in water and add a little slaked lime (25%) and a drop of preservative before blending in the pigment. Since the preservative is toxic, you must be careful not to ingest it. Casein's binding properties have been known for a long time. In days gone by, they simply used the whey or the fresh cheese directly.

You can also bind kaolin with gum arabic, a mucilaginous substance extracted from the acacia tree, in use for over five thousand years. For this method, use about one volume of binder to two of kaolin. Be aware, however, that paintings made with kaolin have a tendency to flake because the substance does not adhere well to flexible support structures like canvas, and is best used on rigid ones like wood and plaster.

royalty coat their faces and arms with kaolin, signaling their good will and the purity of their intentions to the spirits and to people. Among the Igbo of Nigeria, kaolin, synonymous with purity, is offered as a sign of hospitality and ingested to guarantee success before important negotiations or decisions. They also use its curative properties to cover the bellies of pregnant women and the bodies of newborns. The Yafar of New Guinea collect kaolin from grottos and caverns. It symbolizes the vital principle that organizes their world and, therefore, plays a key role in body decoration and the painting of ritual masks. In Western painting, kaolin is rarely used, except as a mineral preparation that lightens certain pigments such as ocher, charcoal, and azurite.

*The white mask sculptures of the Punu of Gabon all have white coatings based on kaolin, although there are many diverse styles. This one, called a mukuyi mask, symbolically represents the spirit of the dead. We know it plays a mediatory role in the stilt dances during bereavement commemorations, but its precise function is not well understood. Paris, Musée du Quai Branly.*

# EGGSHELL and SEASHELL WHITES

EGGSHELL WHITE COMES FROM THE PULVERIZATION OF EGGSHELLS. SIMILAR PIGMENTS CAN BE OBTAINED BY GRINDING THE WHITES OF OYSTER, CLAM, AND CONCH SHELLS TO FORM SEASHELL WHITE. IN THE CASE OF OYSTER AND CLAM SHELLS, A PRIOR BLEACHING IN THE SUN OVER SEVERAL YEARS IS DESIRABLE.

The white powder obtained by pulverizing crushed seashells and, particularly, conch shells, has been one of the principal sources of white in India since the middle of the eighth century. In frescoes, it lightened the deep tones. And in a calcinated form, it created a whitewash used as the final stratum before the installation of a fresco. Similar techniques were followed in pharaonic Egypt.

In Oceania, the whitewash obtained from the calcination of seashells was also used to bleach hair. Chinese and Japanese artists have made great use of white pigments based on ground oyster shells since the seventeenth century, most notably to render luminous skin. This pigment is still used widely today, as it is not very difficult to produce. Based on a twelfth-century B.C. Chinese text containing a procedure for the preparation of silk dye, it appears that people also employed seashell white to make textiles: the threads must soak in water for seven days before being dried, then resoaked in water mixed with a powder of crushed seashells and wood ash made from a yellow-tinted tree. Seven days and seven nights later, the threads are ready to be dyed. Mostly, eggshell white has been used for body decoration. In the Xingu region of the Amazon, the Kayapo transform themselves into birds during certain key

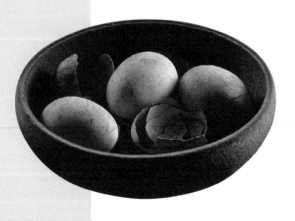

rituals. Their hair is adorned with finery made of multicolored plumage, an eagle's white down is glued on their locks, and smaller parrot feathers are applied to their bodies. Finally, their faces are covered over with a powder made of ground eggshells. The Kayapo people organize themselves around two artistic activities: body decoration made with vegetal paints, which are reserved for women, and for the men, the creation of finery made of feathers and palm leaves, which play a role in countless ceremonies regulating the life of the community. Men are also responsible for making the eggshell powder. In Africa, shells from birds and even from snails have been used to make white, but these are somewhat marginal sources, in the same category as the whitish excrement of sacred lizards and serpents that they gather from burrows and nests.

Eggshell white was also known in the West. Cennino Cennini (c. 1370–1440) provided a recipe in his *Il Libro dell'Arte* (*The Craftsman's Handbook*) for a painting made with colored eggshell fragments to give the impression of a mosaic. Unfortunately, only a part of his proposal has come down to us, and it is difficult to determine exactly how it works.

## INSTRUCTIONS

Boil white chicken or goose eggs until they are hard. Shell them immediately, removing the interior membrane (do not delay; otherwise this will be impossible). Carefully dry the shells, then pulverize them with a marble or metal mortar. You can also use an herb chopper. Be careful that they do not turn to powder, as it is best for eggshell white to be formed by a mosaic of tiny white surfaces. Given that these fragments cannot to be completely blended into the binder, you should coat the support surface abundantly—but in an orderly manner—with gum arabic or, better yet, rabbit-skin glue, before applying the eggshell white.

If the support surface is flat, a weight will help to cohere the whole mass. In this case, separate the eggshell white from the press with a sheet of white paper.

*This little bowl contains petrified eggs recovered from the rubble of the city of Pompeii, buried in 79 A.D. Naples, National Archaeological Museum.*

*I was pleased with myself when I discovered
that sunlight, for example, could not be
reproduced, but that I had to represent
it by some other means...by color.*

Paul Cézanne (1839–1906)

# YELLOW

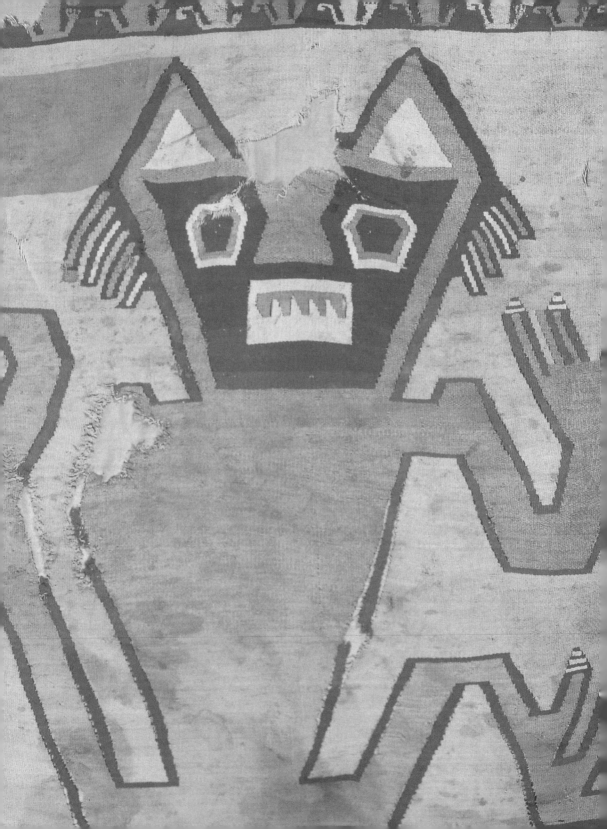

For most cultures, the sun is linked to yellow, which evokes its brilliance and its warmth. The color yellow denotes abundance. Its luminosity suggests the color of flowers reborn in spring, the color of harvest, and the color of gold. Its sense of profusion is expressed even in the wide variety of substances that can create the color: the earth provides numerous yellow pigments, and the plant world teems with them.

But yellow may also be the most paradoxical of colors. When slightly faded, it symbolizes the desert's dryness, the withered autumn, demoniacal sulfur, and bitter bile. And, depending on the people and the times, the color yellow can be an attribute of the gods or a sign of exclusion.

*The Nazca culture flourished between the third and the eighth centuries A.D. in southern Peru. Magnificent textiles have been discovered in Paracas in the tombs of mummies preserved by the desert's dryness. The vibrant yellow color in this example may have come from the annatto (Bixa orellana), a small South American tree. Along with the Inca of Peru, the Maya and the Aztecs of Mexico also took advantage of the coloring properties of its seeds and pulp. Gothenburg. Museum of World Cultures.*

# Numerous Yellow Pigments

The grand history of painting extends its roots deep into several handfuls of yellow ocher and wood charcoal. These pigments traced the first cave painting more than fifty thousand years ago, before Altamira and Lascaux, in a cave found in Arnhem Land in the northern part of Australia. Yellow ocher has been bound with wild orchid sap, with egg yolk, with wax, and with resin. This most ancient of pictorial traditions has survived the millennia and continues still to this day in Aboriginal paintings on eucalyptus bark and in body decoration, where yellow ocher remains the main substance used to draw motifs and totemic images. The color yellow remains so associated with Gotitj Wirrka, an important site in the Northern Territory, that its seam of yellow ocher is regarded as sacred.

While yellow ocher has faithfully outlined the human saga since Neolithic times, it could not illustrate by itself the rich variety of symbolism represented by the color. Very early on, other pigments were found to expand the range of yellows.

## Pharaonic Egypt and a Rise in Yellow Pigments

For an Egypt steeped in the cycles of death and rebirth, yellow evoked, perhaps more than anywhere else, the solar star, that indispensable vehicle of regeneration, and gold, the incorruptible flesh of the gods. Also although they used yellow ocher blended with acacia gum in their architectural decorations to depict people's complexions, the Egyptians began looking for new yellow pigments by the middle of the third millennium B.C. That search, which began in Egypt, makes it possible for us to trace the history of two of them: orpiment and Naples yellow. But the Egyptians contributed—one could almost say they gave their all—to the development of a most unusual third pigment: mummy yellow.

*Located in the Valley of the Queens west of Thebes (modern-day Luxor), this fresco decorates the tomb of Khamuast, one of about a hundred children conceived by the pharaoh Ramses II (1301–1235 B.C.), also known as Ramesses the Great. This detail presents Ramses II standing before the sun-god Ra. In the ancient Egyptian canons of painting, pigments helped to reproduce reality by copying it as faithfully as possible. Orpiment imitated gold, while ochers were used to create backgrounds and render skin tones. According to an aesthetic convention dating back to the beginning of the first millennium B.C., artists preferred yellow-toned ochers to depict women, while redder ochers were used to portray men. This rule also applied to mummies, whose faces were painted with the same pigments in order to make them as lifelike as possible.*

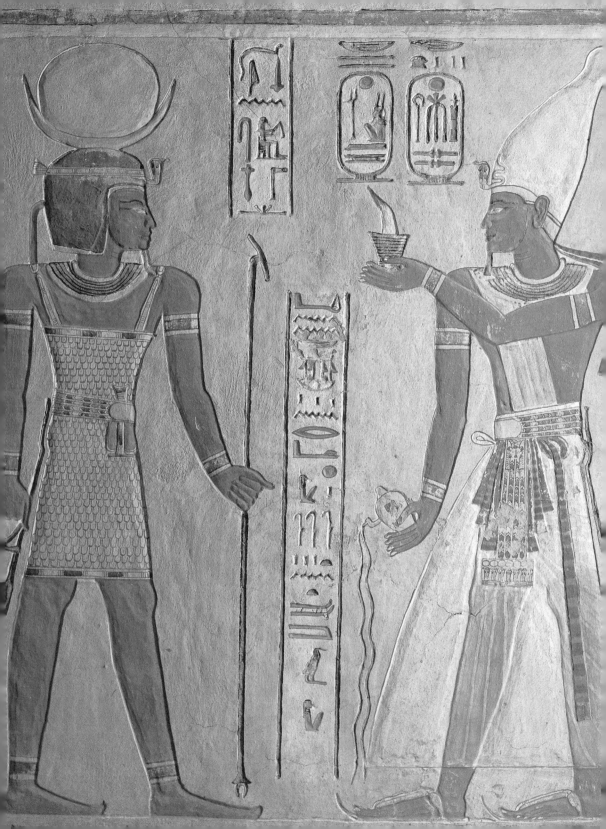

## ORPIMENT

Starting in the Old Kingdom around 2500 B.C., the Egyptians used orpiment, a natural yellow pigment derived from arsenic sulfide, a very toxic mineral found particularly in the Sinai desert and Asia Minor. This pigment was much prized for decorating funeral chambers and sarcophagi because its grains captured the light so well. It was especially used to depict wheat fields. With its golden tones, orpiment is often mentioned in funeral texts as a divine emanation.

The use of orpiment spread during antiquity, and Greek and Roman painters used it in abundance. It was even recommended as a means of retarding hair loss, but people also made a depilatory paste with it by adding lime! As a keen student of alchemy, the Roman jurist Gaius (110–180 A.D.) was so fascinated by the color of orpiment that he tried to heat the mineral in order to extract gold.

Whether it was used directly or as a warm, luminous base for other colors, orpiment also played a role in ancient Indian mural paintings, and the Hindi term for the color yellow derives directly from the word for orpiment.

Orpiment was highly valued in Western painting until the nineteenth century. However, in his celebrated *Il Libro dell'Arte* (*The Craftsman's Handbook*), Cennino Cennini alerted painters to the danger the pigment presented: "This color […] is of a most beautiful yellow which resembles gold more than any other color […]. But beware of soiling your mouth with it lest your person suffer harm." The use of orpiment was finally banned in the nineteenth century, by which time it already faced competition from a synthetic cadmium pigment. Chinese artists, however, remained faithful to it, for its nuances—which ranged from acidic citron yellow to the warmest orange—were irreplaceable in traditional painting.

## NAPLES YELLOW

Egyptian and Mesopotamian glassmakers share the invention around 2500 B.C. of the yellow pigment known in the West as "Naples yellow," which they fabricated by calcinating a mixture of lead and antimony oxide. Although it was common in ancient Greece, the Roman Empire

replaced it with another lead derivative: lead stannate, also known as "lead-tin yellow." Nonetheless, Naples yellow reappeared in the Middle Ages, and its use became widespread in Western art after the Renaissance, even though it was toxic and blended poorly with other pigments. Rubens, for example, esteemed it for its ability to render flesh tones.

### MUMMY YELLOW

Mummy yellow was considered a sacred color because it was obtained by grinding the dessicated flesh of the embalmed bodies wrapped in resin-, pitch-, and bitumen-soaked linen bandages recovered from Egyptian necropolises.

This distinctive pigment, however, was not discovered by painters; rather, this sinister mixture, which first appeared in ancient times, was used as a medicine. In the twelfth century A.D., European apothecaries imported and prescribed it. But from the Renaissance to the nineteenth century, mummy yellow was claimed by artists, who appreciated its shadowy yellow tints.

## INDIAN YELLOW

This vibrant yellow pigment has kept its secret for many years. While in use probably since the end of antiquity, it became prevalent at the beginning of the fifteenth century for miniatures painted on paper. The color's popularity spread to the Netherlands, and it was introduced into France via England in the seventeenth century. The exact nature of its origins has given rise to a variety of hypotheses from the most fantastic (the urine of certain kinds of serpents) to the more reasonable (a tree sap). In fact, it consists of a magnesium salt and a euxanthic acid

*The sari is a long piece of fabric worn, wrapped and draped, by women in India (seen here in Rajasthan). Aside from saffron and turmeric, and until the introduction of synthetic colorants, dyers used flowers from the bastard teak tree (Butea monosperma), the powder that covers the capsular fruit of the kamala tree, and even larkspur stalks to tint fabric yellow.*

collected from the urine or the dung of cows fed with mango leaves by a sect of Bengali milkmen. Once the urine has evaporated, it leaves behind a deposit from which are formed balls roughly 2¼ inches in diameter, with a greenish surface but a very pretty yellow inside. With its limpid quality but powerful coloring strength and excellent durability, Indian yellow replaced glazes developed from weld and turmeric, both of which resisted sunlight poorly. But in order to obtain the color, it was necessary to make the cows thirsty, and Indian law banned its production at the beginning of the twentieth century.

# A PROFUSION OF YELLOW DYES

Most plants contain pigments that dye things yellow. You could almost say that fabric boiled with several fistfuls of any leaves, bark, grass, and flowers will turn out "yellow." Each community protected its recipes. The Aztecs used dahlia and cosmo flowers. In Western Africa, they still use kola nuts and certain types of wild mushrooms. In Turkey, they used chamomile; around the Rio Grande, goldenrod.

However, dyes obtained from these sources often appear more like a dull beige than a beautiful, luminous yellow. Moreover, they were very vulnerable to sunlight and laundering. But several plants producing brilliant and durable yellows have been exploited by various civilizations: in addition to weld and turmeric, which we will discuss later, there was saffron.

Nontoxic and delicious, saffron has been used as a spice and dyestuff since earliest times. The pigment is contained in the stigmas of crocus flowers, in the upper part of the pistil. Harvesting saffron is quite laborious, since it involves removing the minuscule stigmas from the styles, and then drying them. In order to collect about a pound of stigmas, you need around ten thousand flowers. Once they have dried, the stigmas weigh only about three ounces, but they can color one hundred thousand times their volume in water. Saffron is the most expensive of all spices. Today it sells for about $1800 per pound. In every era, crooks have gone to great lengths to counterfeit it: *fibres de cheval,*

*This eighteenth-century Indian miniature (detail) comes from Basohji workshops in the Punjab hills of northwestern India. Mughal miniature painting reached its peak at the end of the seventeenth century with the Kangra school of Rajput painting. The style included a reworked palette featuring pure colors, particularly yellow and red, and stylized motifs. Private collection.*

onion skin, and even corn stigmas have sometimes been substituted for saffron filaments, while the powder can be faked with turmeric or, to give it an orange tint, safflower *(Carthama tinctorius),* or even ground brick.

Egyptians used saffron to dye textiles and bandages for mummies like, most famously, the ones wrapped around Tutankhamun (c. 1343–1324 B.C.). Beginning in 1500 B.C., it was also used to color official documents.

Always in great demand, this potent pigment has supported an international trade since ancient times. During the Middle Ages, wherever Muslims spread their civilization—from Spain, which became a major producer, to the Indus River—the cultivation of saffron increased, and the word "crocus" (from the Greek *krokos* meaning "filament") was little by little replaced by "safran," from the Arabic *za'faran* (yellow) via the Persian.

For medieval dyers, saffron was a costly but irreplaceable necessity. It provided the golden tones that weld could not impart, tints that were so appreciated by the nobility of southern Europe. Until the beginning of the twentieth century, saffron was used to dye wool, silk, cotton, and ostrich plumes. It was also the source of the precious yellow lac coveted by manuscript illuminators and painters. At the end of the Middle Ages, the Ottoman advance and the difficulty in supplying spices and products from the East led to a rise in saffron growers in the south of France, Normandy, and the Gâtinais region southeast of Paris, where, based on their exports to the Netherlands and Germany, the colorant served as a source of wealth until the start of the twentieth century. The discovery of the New World and exotic dyeing techniques, and then the invention of synthetic colorants, led to saffron's slow decline.

*A display of saffron stigmas at the spice market in El Hamma, Algeria.*

# THE YELLOW REALM: ASIA AND THE PACIFIC

In Asia and the Pacific islands, the color yellow occupies a place of honor. Associated with happiness, the gods, and power, it remains important to this day.

## THE HAPPY YELLOW OF INDIA

In India, the color yellow is connected to marriage (as indicated by the expression "to yellow the hands") and conjugal happiness, and the pigment extracted from turmeric plays an essential role in this context. Before the wedding ceremony, it is smeared on the couple's skin to bring them health, wealth, and many children. The color symbolizes vibrant sexuality and fertility, and single women and widows come and touch the newlyweds in order to benefit from those good auguries. It is also sprinkled on the invitations and the gifts, and turmeric colors and simultaneously purifies the foods served during the feast.

The positive values attached to the color yellow are so profoundly inscribed in the Indian civilization that every sensible person always carries a little yellow talisman, even if it is simply a little strip or corner of turmeric-dyed fabric. This pigment is also believed to combat illness, and in ancient India, sorcerers used it to treat jaundice.

## THE SUPREME COLOR OF CHINA

In China, yellow belongs to the emperor. Associated with rebirth, the color symbolizes the center of the world. This tradition is based on the belief that the ground in northern China is yellow; every year it is covered over with loess carried in by dust storms originating in the Gobi Desert. The color yellow became the emblem of the mythical first emperor, who united China and reigned "in the middle of the world." Beginning in the sixth century B.C., yellow, the color of honor, was

reserved for the emperor and princes of the blood. Synonymous with glory, progress, and evolution, it also signified happiness.

## THE YELLOW OF BUDDHISM

In the East, yellow also represents the color of Buddhism. The Buddha had clearly defined what garments monks could wear, and banned certain colors, most notably indigo. Buddhist dignitaries had to dress in fabrics dyed with saffron, which had a distinctly different connotation from that of turmeric. In India, saffron was associated with the Rajputs, the invaders who came from northern Asia at the beginning of the Christian era and who founded the warrior caste. When their citadels were besieged, the Rajputs went out to fight the ultimate battle in clothes dyed in a saffron brew, because its yellow evoked a virile vigor. In double-entendre songs obscuring erotic propositions, women commented on their husbands' sexual prowess by alluding to the color. Saffron was also associated with the *sadhu,* itinerant wise men reputed to be saints. They affixed their sect's characteristic mark to their foreheads with the help of a paste made of saffron, sandalwood, and often a little ash taken from the fires in front of which they meditated.

*Apart from yellow ocher, turmeric, and saffron, monks in Thailand also traditionally used sawdust from the wood of jackfruit trees to dye their robes* (kasaya) *in shades ranging from golden yellow to brown. The dye was colorfast, but the fabric first had to be washed in a mordant bath of cow dung and tannins.*

*Following spread: This fresco from the Yongju Temple in Korea portrays the death of the Buddha surrounded by his companions, who all wear the yellow robes characteristic of Buddhist monks.*

For the *sadhu* as much as for Buddhist monks, yellow ocher symbolizes the renunciation of the world. In the course of their peregrinations, the ascetics collect rags, sew them together in lieu of clothing, and color them yellow. But tints generated from these immersion dye baths must be regularly renewed.

The color yellow is tied to Buddhism in China as well, and the temples can be identified by the yellow papers affixed to their doors.

## TURMERIC, THE SACRED YELLOW OF POLYNESIA

For Polynesian cultures, yellow is the color of divine essence made real by turmeric. In several languages across this region, the word "yellow" derives directly from the name of the plant. Turmeric is the food of the gods and is therefore the sacred substance around which several ethnic groups, especially the Tipokias, organize their lives.

Until the beginning of the century, turmeric had been the principal source of wealth for these Solomon Islanders. Whether it was meant to color mats or serve as body paint, it was the subject of numerous taboos. The pigment was prepared near a source of fresh water, reserved especially for this purpose. The dyer, who submitted to strict dietary interdictions and abstained from sexual contact, stayed there throughout the entire procedure. The grated turmeric roots were boiled in water for one to two hours. Once the water had evaporated, the remaining pigment was heated in an oven under close supervision, so it would not burn. At the end of the cooking process, the yellow pigment was gathered together into a kind of cake, and then wrapped in bark. The clothing to be colored was then placed in a pot of water over a fire, with part of the cake and some coconut oil, until the mixture boiled. If the duties and ritual proscriptions had been respected, the dyeing was successful; if the color did not take, then the dyer had to admit the error of his ways and start all over again. When turmeric is blended with coconut oil and applied to the skin, it becomes more than simple ornamentation. It bears a ritual significance, for it is the perfume of the gods, meant to attract them and bring their benevolent attention to the wearer. The bodies of young initiates are coated with it, and it is also a medication. The privilege of using turmeric as snuff is reserved for tribal chiefs.

The yellow derived from turmeric also plays a role in a number of Melanesian rites. In the Fiji Islands, when the daughter of a Lau noble reaches the age of sixteen or seventeen, she is "forbidden from the sun" and must remain a recluse at home for some time. During this period, her body is coated with a blend of turmeric and oil so that her skin becomes more dazzling, but no one may see her, lest her luminous color tarnish.

*The French artist Francis Gimgembre uses spices as his pigments. Here, turmeric and cumin express their warm tonalities. But Gimgembre also colors spices; for example, he tints cumin green with a powder made of fennel seeds. The spice paste forms reliefs and hollows and gives his canvases a distinctive formal beauty. In addition, the perfume that arises from the surface engages the olfactory sense and brings another dimension to the artwork's appreciation. Untitled, 70 x 32¾", 1999.*

# WITH a color ranging from honey to sulfur

## The last flames of a prosperous era: antiquity

According to the Greek philosopher Xenophon (c. 430–355 B.C.), yellow is one of the three colors, along with red and purple, of the rainbow. The Greeks and Romans appreciated yellow for its warmth and luminosity, and they used yellow pigments and dyes with abandon. In Rome, dyers who specialized in coloring with saffron were called *crocotarii* (from the Greek for crocus). The most beautiful yellow material produced by their workshops was reserved for muses and priests. The color saffron had symbolized the perpetuity of marriage since the time of the Phoenicians, so the *crocotarii* were also entrusted with making the bridal veil. But only the richest patricians could afford saffron textiles. In the first century A.D., Nero (37–68 A.D.)scattered saffron over the streets of Rome in order to provide the plebeians a sense of the refinement reserved for nobility, thereby winning popular support.

Yellow ocher reigned in the field of architecture. With this inexpensive pigment, artisans created large monochromatic backgrounds for their motifs. During the Roman Empire, it formed the rectangular decorative panels known as *emblema*. In the House of the Vettii amid the ruins of Pompeii, for example, yellow ocher survived a cataclysmic volcanic eruption more than two thousand years ago.

However, the Romans' taste slowly changed, and red began to supplant yellow. Purple captivated all of imperial Rome, and terra cotta progressively replaced the strata of yellow ocher.

*Spices have been exploited for their gustatory as well as their medicinal properties, but saffron and turmeric (shown here in a Tunisian market) are the only ones that have achieved an equally glorious success in the textile and pictorial arts.*

## The decline of yellow during the European Middle Ages

To the medieval sensibility, yellow was considered a sub-white. From the start of the Christian Era, the color began to embody several

negative qualities. In the world of the theater, social climbers and traitors dressed in yellow. The meaning of yellow was marked with an ever greater ambivalence. Little by little, yellow logically became the emblematic color of Judas, and then of non-Christians (Jews and Muslims). If fabrics dyed with weld were still desired for their beauty, the color yellow became more and more associated with the signs of exclusion, until it finally became the symbol. By the reign of Saint Louis (King Louis IX of France, 1215–1270), Jews were obliged to don pointed hats, and then later on, to wear round patches on their clothing to distinguish them from the rest of the population; these insignia were colored yellow. Increasingly, yellow fabric in a costume was perceived as a sign of marginality, of eccentricity, and then of degradation. Starting in the thirteenth century, yellow, which was linked with green, became the color of madness, so much so that houses were "saffroned" as a sign of dishonor after rebellions and bankruptcies. In the arts, artists systematically resorted to yellow pigments to introduce light into their canvases and to represent gold, but in painted images, Judas was always dressed in yellow to signal his infamy. Even worse, he turned an orangish-yellow tint—the most disagreeable and sinful nuance of yellow—a sign of lies, hypocrisy, and felony. Assassins, heretics, renegades, fickle women, and forgers were therefore all represented by the shade.

If black was perceived as the most negative color during most of the Middle Ages, it was surpassed by yellow by the end of this era. It was the culmination of a long and complex evolution that still affects our sensibilities today.

## In Islam, a color capable of the best and the worst

We have seen have how during the Middle Ages in the West, yellow slowly became the discriminatory color, particularly in relation to Muslims. But what was their perspective? How did they perceive the color? Islam was born into a world dominated in part by the Byzantines, from whom they tried to distinguish themselves. Muslims described

*Today there are about ten million Fulani split among four principal clans. The Bororo Fulani are nomadic or seminomadic shepherds. Every winter in Mali, they celebrate the return of the herds from their transhumance on the steppes of the Sahel. This young man embellished his face with yellow ocher in celebration of the event. The corners of his mouth were tattooed during childhood with blue ink, according to custom. Sometimes gums are also tattooed.*

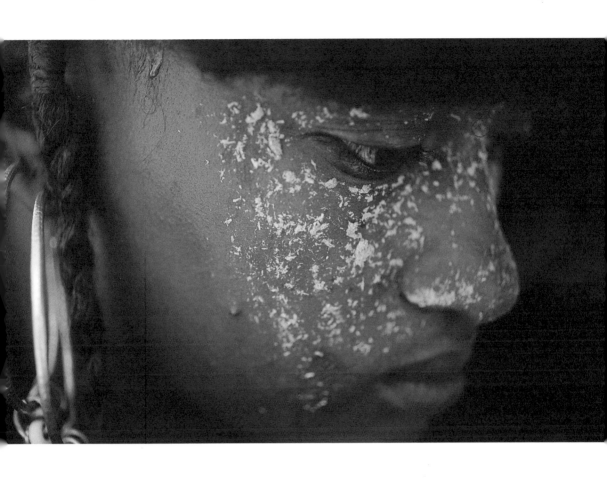

themselves as "Blacks," that is to say, "masters." They reserved the color red for all non-Arabs and used the term *Banu al-Asfar*, which can be translated as "the saffron people," to designate the Greeks and Byzantines specifically. For the latter, wearing yellow fabric was actually esteemed. In the denominational confrontations that characterized the medieval period, a mysterious agreement was established between East and West on the color both sides deemed appropriate for infidels. But if yellow was considered as the color of miscreants in Islam's early years, its perception in the Arabo-Islamic world was not limited to just this one characteristic.

For Arab philosophers, yellow could belong between red (which embodies warmth) and black (a predominance of coldness and the absence of light), or could belong, on a scale of increasing luminosity, closer to white. The color yellow is linked to the air element and to dryness. There are more than a dozen terms for yellow in Arabic. The most common, *asfar*, is borrowed from the Persian *safran*, and saffron is the source of one of the most beautiful yellows in Islamic textiles. In the Islamic lands, these fabrics signified power and wealth just as, in times past, purple textiles had for the Romans and Byzantines and yellow silk for the Chinese.

Given the extremely high cost of the main ingredient, dyeing with saffron was reserved for the most beautiful silks. Turmeric, sumac, pomegranate bark, safflower, and larkspur provided yellows of lesser quality, at substantially lower costs. People also used saffron combined with indigo to create green fabrics.

The Muslim taste for the color yellow spread even to the culinary arts. Thanks to the collection of recipes *Kitab al-Tabeekh* (*The Book of Cookery*) edited by Ibn Sayyar al-Warraq, a writer who lived in Iraq during the tenth century, we know that Baghdad experienced such a vogue for yellow that, in the early years of Islam, food was abundantly colored with saffron at the caliphate court. It is the most frequently mentioned culinary colorant in Islamic cookbooks, and is easily diluted in rose water, vinegar, and honey.

While the color yellow represents gold, the sun, butter, and honey in the Islamic world, these peoples are just as ambivalent about it as

*In the Charles Perrault fairy tale "Donkey Skin," the eponymous young princess asks her father for a series of increasingly extraordinary gowns in order to escape the prospect of an incestuous marriage. First she wants a dress in the color of the sky, then the moon, and then the sun, here illustrated by Louis Houpin. As a last resort, the heroine demands the sacrifice of a prodigious donkey. Éditions Servin, Toulouse.*

other cultures. Yellow is also the color of sulfur, the devouring flame, cowardice, and treason. In the Koran, Adam broke into a yellow sweat at the sight of the Angel of Death, and it is written that, at the time of the Last Judgment, the faces of those condemned to suffer the ordeals of the tomb will be colored saffron. In the Arabic language, the expression "to laugh yellow" means a smile filled with envy, and the word for bile derives from the word "yellow." Curiously enough, the link between the color yellow and bile can also be found in the French language, since *jaune* (yellow) originated from the Latin *galbinus*, which describes a pale green, the color of bile and venom.

# A SLOW reHaBILITaTIon

Beginning with the Renaissance, yellow's centuries of disrepute in the West progressively lessened. Under the French Empire (1804–1815), it even became a fetishistic color, and its warm, rich, lively, and stimulating tonalities were used abundantly in decoration and to express light.

Today we turn to yellow for its remarkable capacity to attract our attention (road signs, tennis balls, etc.). It symbolizes joy, summer, and energy (packaging for medicinal tonics, the interior design of day care centers, travel agency brochures). But yellow maintains the stigma of long centuries of discredit: the horror of the yellow star, the ill-fated cuckolded husband (known in France as the "*jaune cocu*"), a referee's yellow warning card on a soccer field, strikebreakers who cross the yellow line, and even the cowardice of Billy the Kid, who was called "yellow-bellied."

# THE USES OF YELLOW

# ocHers and yellow earTH PIGmenTs

THE OCHERS AND EARTH PIGMENTS DISCUSSED IN THIS VOLUME ARE ALL CLAYS COLORED BY IRON OXIDES. THE WORD "OCHER" (FROM THE GREEK "OKHRA," FOR THE COLOR OF AN EGG) HAS TRADITIONALLY BEEN RESERVED FOR YELLOW- AND RED-COLORED CLAYS. THE TERM "EARTH PIGMENT" DESIGNATES CLAYS COLORED BROWN, BLACK, AND GREEN. IN THIS BOOK, OCHERS AND EARTH PIGMENTS ARE SEPARATED BY COLOR, AND IN THIS SECTION WE WILL CONSIDER THE YELLOW VARIETY.

LATER ON, WE WILL EXAMINE OCHERS AND EARTH PIGMENTS THAT LEAN TO RED, GREEN, AND BROWN. IN THEIR NATURAL STATE, OCHER DEPOSITS ARE USUALLY BLENDED WITH SAND (THE PROPORTIONS CAN REACH 20% OCHER AND 80% SAND). IN ORDER TO ISOLATE THE PUREST PIGMENT POSSIBLE, MINERS FIRST DILUTE THE CLAY IN WATER, WHICH RUNS DOWN A GENTLY SLOPED CHANNEL. SINCE THE SAND IS HEAVIER THAN THE OCHER, IT SINKS ALONG THE ROUTE, WHILE THE

PIGMENT-CHARGED WATER CONTINUES ITS PATH DOWN TO THE DECANTING TUBS. THERE IT EVAPORATES SLOWLY, LEAVING THE PURIFIED PIGMENT AT THE BOTTOM OF THE BASINS. THE OCHER SLABS ARE THEN CUT UP AND ARRANGED AROUND THE BASIN SO THAT THE WIND AND SUN CAN DRY THEM OUT. FINALLY, THEY ARE TAKEN TO MILLS FOR GRINDING, AND THE RESULTING POWDER PRODUCES THE COLOR.

Prehistoric people in the West began using yellow ocher long after red ocher, in the Middle Paleolithic age (around 40,000 B.C.). At the same time, they discovered the technique of heating yellow ocher to obtain red ocher. But yellow ocher remained much less widely used than red ocher or black pigments. Blocks of yellow ocher gathered from deposits were crushed in a mortar or scraped, as in the caves at Lascaux. The pigment was stockpiled in its powder form, either in a pure state or mixed with kaolin. When diluted with water or animal fat, it forms a paste that can be applied to rock walls or human bodies. Although yellow ocher has faced competition from other pigments since ancient times, it has remained indispensable to artists, from the mural painters of pharaonic Egypt to the nineteenth-century French portraitist Jean-Auguste-Dominique Ingres (1780–1867), who called it "a gift from heaven." Its use extended from Africa, where the Igbo of Nigeria colored their statues with it, to North America, where the Inuit rubbed their ritual masks with yellow ocher, after first licking the wood to create a perfect seal.

# instructions

They have strong coloring power, are resistant to sunlight, can be blended with all liquids, are nontoxic, abundant, and inexpensive—ochers and earth pigments offer qualities that have made them valuable to artists in every era and every land. They can be mixed with gum arabic, casein, and egg yolk, and on rag paper, you can even use them just with water.

To turn ochers into oil paints, pour a cup of ocher into a container. Dilute the pigment by slowly adding a cup of boiled linseed oil (purchased commercially). Use a whisk to prevent the formation of lumps (the pasty mixture is difficult to stir). When the two ingredients are thoroughly blended, add half a cup of raw linseed oil and half a cup of turpentine. Stir well, and add more turpentine if the paste seems too thick.

Yellow ocher also plays a role in body painting. In Sudan, the Nuba blend it with oil and then use the mixture to mark their system of social organization on a tribal member's skin. Depending on the person's sex, age, marital status, and lineage, they use either yellow or red ocher. In addition, a slight color difference distinguishes the yellow ochers used on men and women. The distinction is based on the fact that the clay meant for women is taken from the top of the deposits, while the lighter minerals reserved for men are extracted from deeper down.

In the cosmogony of all Amerindian people whose survival depends on corn, golden yellow evokes the earth's transformed surface, just before the rainy season returns it to its lush green state. Among the Zuñi, Pueblo Indians living in the northwestern part of New Mexico, young men celebrate by painting their faces with yellow ocher, a symbol of the plant's divinity, to promote bountiful harvests. For many peoples, yellow ocher also symbolizes their land. On August 16, 1975, Australian Labor Party Prime Minister Gough Whitlam (1916–) officially handed over the title deed for part of a cattle ranch to its Aboriginal landlords, reinforcing the symbolism of the event by pouring yellow ocher into the clan leader's hands in acknowledgment of this reconquest of hereditary territories.

# WELD
## *Reseda luteola* L.

WELD, AN HERBACEOUS PLANT THAT CAN GROW FIVE FEET HIGH, GROWS WILD ALONG ROADSIDES AND ON OLD WALLS IN WESTERN AND SOUTHERN EUROPE, AND IN ANATOLIA. TODAY IT HAS ALMOST TOTALLY DISAPPEARED IN FRANCE, AND HARVESTING IT IS ILLEGAL. YOU SHOULD GROW YOUR OWN PLANTS IF YOU WANT TO USE IT FRESH. THE FRENCH WORD FOR WELD, "GAUDE," COMES FROM THE LATIN FOR "REJOICE." IT IS ALSO A MEDICINAL PLANT, AND ITS TAXONOMIC NAME, RESEDA, DERIVES FROM "RESEDARE" (LATIN, TO APPEASE, TO CALM). THE FRENCH ALSO CALL IT "HERBE-AUX-JUIFS" ("JEW'S GRASS"), FOR THE JEWS OFTEN CAME UPON IT IN THE COURSE OF THEIR EXILE ACROSS EUROPE.

Weld's dyeing capacities were used from the Neolithic age until the invention of chemical colorants. At the end of the nineteenth century, Europeans still cultivated it intensely for its yellows, but also tinted fabric green with it by dyeing the material first in a blue bath and then in a second bath with weld. Mixing colors in one vat was prohibited for most of the medieval era in the West. Weld was either used by itself or was supplemented with the broom plant by itinerant dyers; it was a less expensive approach, but provided a less durable yellow. From the end of the Middle Ages until the eighteenth century, weld was used extensively by the textile industry, and when it was combined with materials dyed with indigo, it created magnificent and long-lasting greens. When the French savant Charles-François de Cisternay Du Fay (1698–1739) established the first standard for dye resistance, he categorized weld as a "colorfast dye" plant. This classification meant that a fabric dyed with weld could withstand a hot bath of alum, white soap, and red tartar, and could tolerate exposure to sunlight over twelve days in the summer and eighteen days in the winter. Despite these qualities, weld was slowly replaced over the course of the eighteenth century with the yellow bark of the black oak, a tree imported from North America, and then by synthetic tinting products.

Dyeing with weld was practiced in North Africa, as well as in Ottoman Turkey, where it was imported from Dagestan in the Caucasus mountain range. But weld's importance extended beyond dyeing. From ancient times, painters have extracted a lac from it—yellow lake—by adding a blend of chalk and alum to a decoction of weld, which made the pigment precipitate to the bottom of the container. The final product could be saved either in powder or liquid form. When mixed with other pigments, it created greens; the most desirable shade, it seems, was budding wheat. Even though it was not very resistant to prolonged light exposure, yellow lake was popular until the invention of synthetic pigments. And, as it was inexpensive, it was popular in the eighteenth century for executing wallpaper designs.

## INSTRUCTIONS

The entire plant is the pigment. It is possible to buy dried weld from distributors of traditional pigments or from herbalists. The cultivation of weld has also been revived by several agricultural concerns specializing in dye-producing plants. Break up a kilo of the dried plant, then macerate it overnight in about 10 liters of water, preferably in a copper pot. Put it aside. In order to penetrate the textile fibers thoroughly with the dye, you generally have to prepare them first with a mordant of alum. The next day, dissolve 200 grams of alum in 10 liters of water in an enamel pot, add the fibers, and boil them. Let the fibers cool in the bath, then take them out and wring them. Empty the bath. Next, put the pot with the weld on the stovetop. When the water reaches about 30° C (86° F), add the fibers. Boil for two hours, stirring often. Remove the fibers, and rinse them with a water solution with 200 grams of dissolved chalk. (Be careful: children's chalk is not always made of real chalk.) Boil fibers in the dye bath for an additional hour. Let cool in the bath and rinse them in clear water. Weld yellow resists washing and sunlight and is one of the rare yellows that does not turn orangish.

# turmeric
## *Curcuma longa* L.

TURMERIC ORIGINATED IN INDIA AND WAS CULTIVATED EARLY ON THROUGHOUT SOUTHEAST ASIA AND IN A NUMBER OF TROPICAL COUNTRIES. A MEMBER OF THE GINGER FAMILY, THIS HERBACEOUS PLANT HAS VERY LARGE SMOOTH LEAVES AND SMALL YELLOW FLOWERS. TURMERIC IS GROWN AS A SPICE AND FOR ITS DYEING PROPERTIES. IN FRANCE, IT IS ALSO KNOWN AS "SOUCHET" OR "SAFFRON OF THE INDIES." ALONG WITH ITS USES IN TEXTILES AND PAINTING, IT IS AN ALIMENTARY COLORANT AND CAN BE FOUND IN MUSTARDS, MARGARINES, ETC.

While turmeric is linked in the Western mind to Indian curries, it is also the most popular dye-producing plant in all of Asia. As we have seen, it creates a very desirable yellow and plays a significant role in many rituals and ceremonies. Villagers in the high plateaus of Vietnam, for example, use it as a cosmetic. After bathing, they rub the color all over their bodies to give their skin the golden complexion of the heroines they sing about in their myths. By combining turmeric and indigo tints, dyers can create green fabrics, but the textiles turn and fade quickly, because turmeric, unlike saffron, is not very resistant to sunlight and washing. But for Indians and Indonesians, the dye's fragility is a positive attribute. Specific clothes, plangi, are worn to celebrate certain feast days. The plangi are tinted with the durable indigo dye, and then the solid backgrounds are decorated with designs made from turmeric. These patterns then disappear after several washings and can be replaced with other motifs, adapted to a new context.

In days gone by, Indians added whey to turmeric dye baths. By doing so, they blended together two of the most auspicious ingredients, for turmeric is linked to love and its fruits, and whey, which comes from the cow, is the source of total purification.

In Rajasthan, they enhanced the turmeric with a solution made from pomegranate tree bark, because its tannin content made the dyeing process more stable. A thick paste of turmeric and pomegranate skins was used to create designs on fabrics.

delicate workmanship, they form motifs with small beads and leaves on some areas to be left uncolored. When the dyeing is complete and the mats rinsed and dried, the women rub the undyed sections with a turmeric paste to color them yellow. In Guatemala, a green dye is made of a liquid extracted from turmeric roots combined with logwood.

Painters have used turmeric to fabricate luminous but elusive yellow lacs.

In Thailand, they used to add a mordant of sludge to turmeric dye baths used for cotton fabrics, or the juice of acidic fruit to baths meant for silk. Religious texts recommended a brownish yellow color for monks' robes, so after a turmeric dye bath the fabric was set in a jackfruit bath to dull the brilliant yellow and give it a brownish cast. In the islands of western Polynesia, turmeric blended with oil still serves on occasion to tint bark cloth (tapa) yellow. This ingredient, however, is used frugally throughout the entire region, for it is invested with a powerful symbolism. Yellow tapa are reserved for precise functions, therefore, such as protecting a young mother. On Whitsunday Island in Melanesia, they tint mats red with the bark of a local tree. With

## INSTRUCTIONS

Use fresh or dried roots for cooking and coloring. The roots must be washed, carefully dried, and then reduced to a powder. You could also just purchase prepared turmeric powder at the grocery store. This turmeric, however, is often itself tinted with other spices to intensify its color. Regardless, it still makes a beautiful dye. Turmeric is a powerful coloring agent; it can tint fabrics even if they have not been prepared in a mordant bath beforehand. Dissolve the turmeric powder in a pot of water. Use an equal weight of turmeric and textiles. Slowly bring it to a boil, and boil for an hour. Let the fabric cool in this dye bath. Wring it out, and then wash it and rinse in a water-vinegar fixative solution. Textiles dyed with turmeric are vulnerable to light and turn reddish with repeated washings. Turmeric is also sensitive to the pH of water, hence its classification as a semi-permeable dye. A dye bath acidified with vinegar will produce redder tones.

*In the red forest that blanketed the earth
like a sea of roses, when time sang with the
voice of the earth mother, when the tides of
time, in rising, swelled, full of life, when
milky breasts flowed endlessly, and it was
the beginning, and life reflected the blood-red
day, and I was new, and I came into love...*

Chantal Chawaf (1943–)

reD

In many ancient creation myths, the earth is described as red. Science today has revealed that one of the most widespread pigments on the surface of the globe is iron oxide, which turns red when exposed to air. Therefore, it is quite possible that the first supercontinent was indeed red at the very beginning of our planet's history. Paleontologists sometimes call this land "the continent of ancient red sandstone." From this primordial environment, the most complex forms of life appeared, culminating in warm-blooded animals. For many peoples, the color red embodied the coagulated blood of the earth. In Hebrew tradition, the first man was fashioned from red clay. God named him Adam because, in Hebrew, *dom* signifies "blood" and *adama* means "land of men." In Latin, *adamus* translates into "made of red

*About 600 million years ago, Earth's crust formed into a single continent, Pangaea, which had a red color from the high content of iron oxide and manganese in the sedimentary layers. The presence of iron oxide still reddens much of our planet's landscape, as we see here in Monument Valley, Arizona.*

earth." In Polynesia, the first living being was a woman, fashioned by a god out of red sand from an island's shores. In Tibet, the gods built a man with red skin. In China, the first man was molded from a cavity in a human shape. Little by little, red clay carried by the rain filled up the space, and this soil was brought to life by the heat of the sun's rays. Today we know that amino acids, those fundamental building blocks essential to life, do emit colors—like red—under spectroscopic analysis. More than any other color, red symbolizes strength. It is intimately linked to the blood of life and, therefore, to death. In relation to the feminine, red evokes fertility, from a woman's first menstrual cycle to the blood that accompanies childbirth. But the color also suggests sterility if, unavoidably, the bleeding reoccurs each month. In relation

to the masculine, red is the color of the blood
spilled during the hunt, in battle, or when
a crime must be avenged. In many rituals,
this richly symbolic color communicates the
potency of fecundity and virility, as well as
their excesses and dangers. It also upholds
the cohesion of the group, and to reinforce the
power of cult objects. But whether it involves
the realms of men or women, the color red
attracts and repels. Red is always mesmerizing.

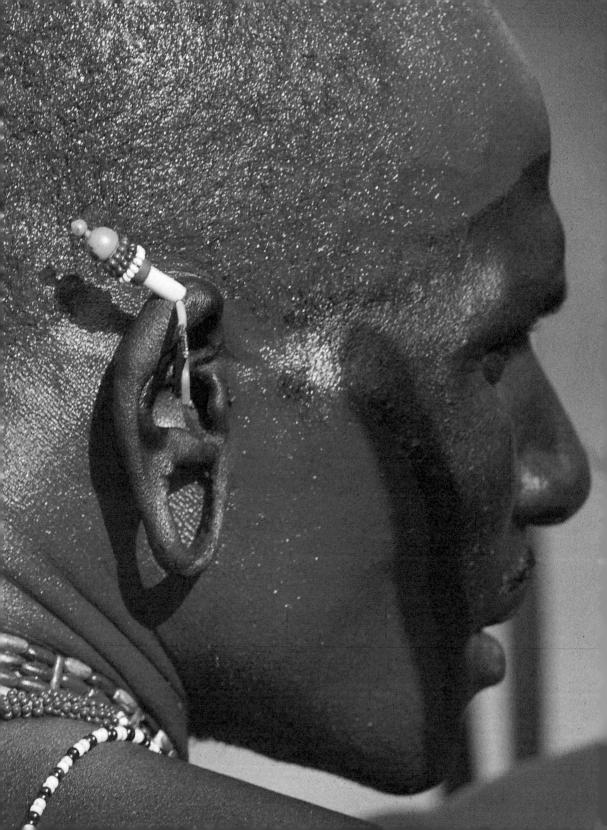

# THE REDNESS OF FERTILITY

In many cultures, the arrival of sexual maturity corresponds to an initiation rite in which the body of the young boy or girl is embellished with red designs. Pigments and dyes express the children's new status and protect them at this important and perilous moment in their lives. In this context, red accentuates the vital force of those who wear the color and emphasizes the resilience of biological activity.

## NUBILITY RITES

In Africa, red is sometimes considered as part of the human transformative process. The red stage generally corresponds with the age of puberty. The people of the lower Congo River isolate nubile girls for two or three months. Gathered together in small groups in huts situated far from their village, they shave their heads entirely and coat each other's bodies with a powder, derived from a red tree and thinned out with water. At the end of the period of confinement, the young girls bathe in the river before rejoining their community. Now they are eligible for marriage. Among the Cheyenne of the Missouri, the period of seclusion lasts for only four days, but they also cover the young girls' bodies with red pigment. For the Zuñi Indians who live on the banks of the Rio Grande, puberty can also be celebrated through ritual dances. Their faces covered with red ocher, the young girls embody the mythical corn virgins, the guarantors of abundance.

Circumcision usually marks the arrival of sexual maturity for many young African boys. Among the Ndembu people of Zambia, the color red explicitly unlocks the door to fertility. Their bellies and foreheads reddened with earth pigments, the young boys participate in an initiation rite symbolizing a red river. Represented by ocher-tinted water, this river connotes danger, the recently spilled blood, and the now-permissible union of the sexes.

At the conclusion of the nubility ceremonies, a young Ndembu girl is given a chick covered with red ocher, representing her access

*During the Maasai Eunoto ceremony, the first dance, called the "red dance," honors the pride and fierceness of the warrior nature. On this occasion, men coat their bodies and their hair with a glossy red ocher. Those who have already killed a lion or an enemy are celebrated in particular, and they are allowed to display their red finery for the duration of the ceremony. On the fourth day, when the rituals marking them as true warriors have been completed, each man's mother shaves off her son's long locks of hair and then covers his scalp with red ocher. It is her prerogative and her honor. From then on, her son takes his place among the elders of the community.*

to childbirth. Only after her first sexual union does the young bride wash away the ritual red pigment, and the reddened water is kept in the house to promote the arrival of children. As for the chick, it is allowed to grow free in the courtyard.

## From seductions to unions

*Ah! Louise, your face is turning red.*
—Luc Lang

Men in New Guinea say: "We paint our bodies with red ocher for, in the bush, there grows a tree whose vibrant red flowers attract the birds. In order to seduce women, we do the same." Red is seen best by the human eye because, of the all the rays in the light spectrum, this color refracts most rapidly on the retina. Ostentatious, alluring, and unsettling, red is simultaneously desired and feared.

Red is at the heart of many festivals that draw together boys and girls of marriageable age, and it is a significant element in many engagement and wedding ceremonies.

### THE POMEGRANATE OF CHINA

In China, red is considered a revitalizing color and is traditionally associated with the pomegranate fruit, whose many seeds symbolize a rich line of descendants.

During the Twelve Sisters Festival, which takes places in Yunnan in southwestern China, young girls offer their suitors a knotted scarf. If the young man finds two red sticks inside, the young girl wants to make him her lawful husband. A single red stick indicates that she only desires his friendship. Finally, the presence of a red chili pepper makes it absolutely clear that the young man should direct

*Incised with eerie facial details, this Neolithic head has been carved out of red amber, a fossilized resin found principally in sediments along the shores of the Baltic Sea. Stockholm, Historiska Museet.*

*Opposite page: This young Fulani boy prepares himself for the Geerewol ceremony, which marks the end of Niger's rainy season. Over several days, thousands of men, their faces embellished with red ocher to highlight the brightness of their eyes and to emphasize the whiteness of their teeth, participate in beauty contests, which are judged by women.*

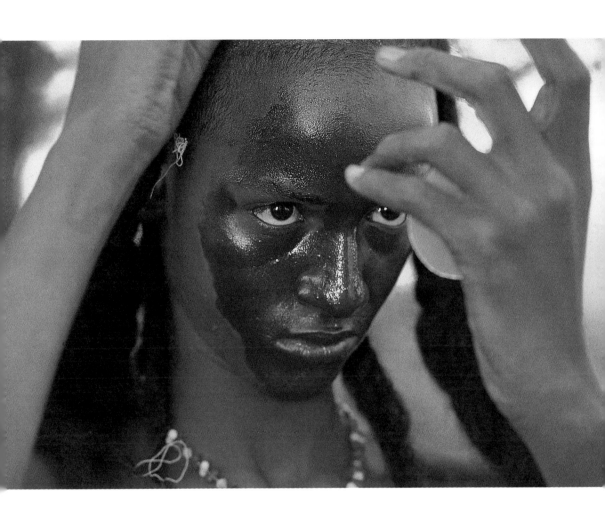

his attentions elsewhere. And the indigenous Miao who live in this province also celebrate the Flower Mountain Festival, an event that literally revolves around the color red. Over three days, young boys and girls dance and trace spiral patterns with an enormous red ribbon attached to the top of a large pole. Young girls of marriageable age wear bonnets made of red wool fabric. The married women set aside this coquettish headdress along with their virginity.

Red is omnipresent in Chinese marriages: it is the color of the clothing worn by the bridal couple, their families, and their guests; the color of the paper wrapped around their gifts; the color of the vehicles carrying the bride and groom; and the color of the ink used to write the vows and other documents connected to the event. Red is joy and happiness.

*This statue of a Baule woman (Ivory Coast) may have served a therapeutic purpose (such as recovery from sterility or protection during childbirth), but it is also possible that it played a role during funerary rites tied to women. Red ocher blended with palm oil or a colorant extracted from a chewed kola nut was used to color the wood red and reinforce its connection to the feminine world and the blood of fertility.*

*Opposite page: Young Maasai boys decorate themselves with red ocher mixed with water, milk, and animal fat.*

SATURNALIA AND THE HINDU "BINDI"

In India, the word for red shares a common root with the words for joy, painting, dyeing, theater, hilarity, and love. During the full moon over February and March, the feast of Holi brings all these words together at once. The celebration is a kind of saturnalia marking the beginning of spring. Its origin dates back to prehistory, when a fertility cult celebrated the renewal of life with rites aimed at stimulating sexual activity in the community—activity curtailed by winter's constraints. Today this spring holiday gives Hindus the opportunity to set aside the sexual and generational social barriers that habitually separate them and to give their instincts free rein. During the festival, people spray each other with water that has been tinted with substances,

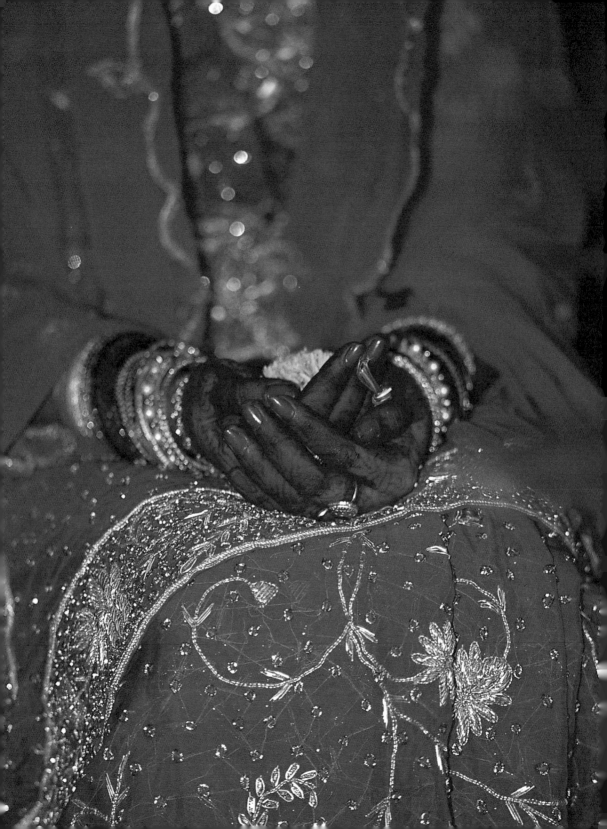

like red ocher, considered conducive to fertility. Sometimes they add a little turmeric as well. This red liquid symbolizes blood and conveys the spirit of life and the desire for love. It replaces the blood sacrifices once demanded by ancient Indian gods and goddesses before they would restore the spring. Today people submit more peaceful offerings to a red-flowered tree that represents Kama, the god of carnal love. And in the countryside, they sing licentious verses in his honor.

The color red is also essential in Indian weddings. The father presents his daughter with a "blood sari," the color of which henceforth identifies her as a wife. Even the part in the young woman's hairstyle is painted red using a paste of red ocher and sandalwood. This substance is also used to tint the soles of her feet and to create the *bindi* or *tikka,* the red dot that women wear on their foreheads to indicate their married status.

## MELANESIAN TAPA

On Pentecost Island in the Vanuatu archipelago, the color red plays a more important role after a wedding. Women braid the fine bark from blackberry bushes into mats called "tapa," then dye them red. They use ocher, which is shaped into little marbles when it is first gathered from deposits. After the ocher has been reduced to powder, they blend it with a brown dye made from the bark of a local tree to form a paste, which is then spread on the tapa to color the fibers. In this culture, tapa are important symbolic and ritual objects that incarnate the feminine principle. When a young girl marries, she goes to her husband's village with a large basket full of raw, uncolored mats. Her mother-in-law must dye them red as quickly as possible for, if she delays, the whole village will believe that she disapproves of the union.

*Throughout the Far East, the color red is perceived a dispenser of life and plays a role in all happy occasions. This red-lacquered wooden duck is being offered during a South Korean wedding ceremony.*

*Opposite page: A young Indian bride wears three different saris during the wedding ceremony. The "blood sari" pictured here is presented by her father. Through this act, he signals that his responsibilities as guardian are now over and transfers his daughter's care to his son-in-law. The sari's red color implicitly communicates the father's desire for a fertile union. The young woman's hands and feet are painted red by female members of the groom's family, a ritual meant to bring happiness to the young couple and to strengthen the new status of the young woman. Once she is married, she will wear red-bordered sari, exchanging it for a white one only when her husband dies.*

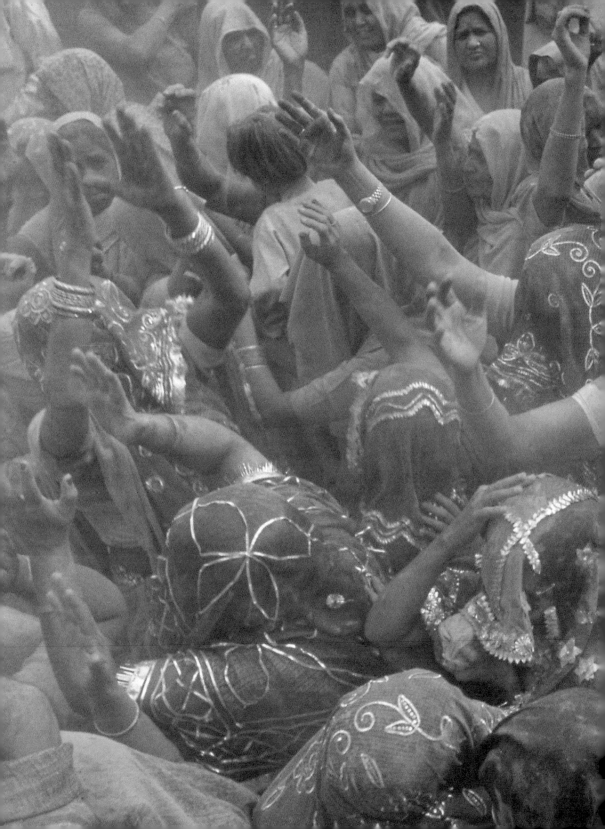

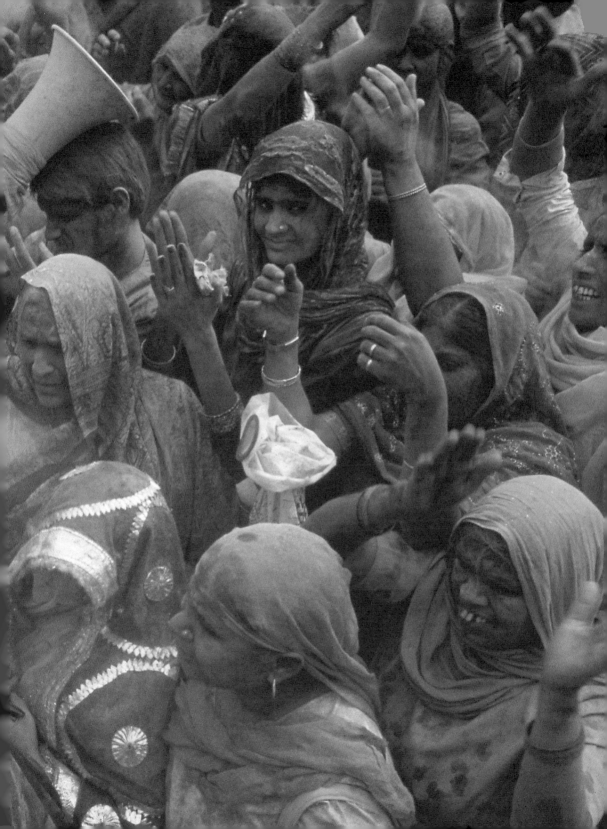

## menstrual BLOOD

When red refers to menstrual blood, the color may be part of a rich nexus of meanings involving the entire community.

### THE PRIMORDIAL MOTHER OF THE YAFAR

The Yafar people of New Guinea confer a place of paramount importance to blood, especially menstrual blood. Epitomized by red ocher, this pigment becomes the mythic blood of the primordial mother. In some sense, it is the manifestation of the most secret substance of creation, and it plays a role in cultivation rituals to promote the growth of plants. The complex system of rites and interdictions organizing the life of this society honors the sacredness of this substance and the color red. Their very rigorous taboos extend to food. It is strictly forbidden, for example, to consume eggs laid by a red hen or, especially, to eat any fruit whose intense red color simulates blood. Even the chewing of betel nuts is thoroughly codified.

## GODDess CHen JINGGU OF CHINese TaoISM

*The Indian Feast of Holi, shown here in Rajasthan, brings together men and women of every caste and every generation for debauchery dominated by the color red. Children once used blowpipes to douse passersby with ocher-tinted water. Today they drop water balloons that explode and drench the crowd. Farsighted Hindus wear old clothes during this festival, for no one can emerge unscathed from the Feast of Holi.*

In the religious Chinese Taoist tradition, red, the color of blood, also belongs to the feminine world. One particular red pigment occupies a prominent place: cinnabar, a magnificent blood-red sulfide that forms in mercury mines. For centuries, the Chinese believed that cinnabar could control the forces of life, and so this (highly toxic) substance was frequently an ingredient in elixirs of immortality. The Taoists characterize the region located under the solar plexus (an important part of the body in meditation practices) as the "field of cinnabar," and they call the interior part of the vagina the "grotto of cinnabar." The mineral's significance continues today based on red's reputation throughout all of Chinese history, and the color's meanings—good fortune, joy, and fertility—are reflected in the culture's myths. The much venerated Taoist goddess Chen Jinggu recounted in a tale that one day she came upon an enchanted terrain shaped like a woman's body and covered with a multitude of vermilion flowers.

Their color represented the womb—a woman's core and an embryo's haven.

## InDICATInG menses

Often considered as the moment when a woman is impure and danger-ous, the menstrual cycle is generally indicated by red, but the color also controls the mysterious and disturbing forces of the feminine nature. Among the tribes of the Pacific Northwest, the clothing worn by women during their periods is covered with rich red ocher designs while, in Australia, Dieri women paint the area around their lips red. During the Han Dynasty (206 B.C.–220 A.D.), the women of the harem used cinnabar to draw a red mark on their foreheads to signal the Chinese emperor that they were menstruating.

# PROTECTIVE reD

People often attributed prophylactic virtues to the color red because it symbolized the circulation of the blood intrinsic to life. Their beliefs led to many superstitions.

## ReD CLOTHInG

During ancient Roman celebrations of certain pagan rites—particularly the complex cult rituals of the Dionysian Mysteries—scarlet garments were worn by the initiates as well as the officiants to protect them against maleficent powers.

In its role as guardian, the color red often indicated those open areas of clothing that were considered particularly vulnerable to spir-its. Stitching, armholes, and necklines were therefore frequently highlighted with red embroidery. This kind of ornamentation was found on fabric wrapped around a fourth-century A.D. Incan mummy discovered in Paracas, Peru, and also on tenth- and eleventh-century outfits uncovered in excavations of the Viking site at Coppergate in

York, England. These costumes have bridged the ages. When, at the beginning of the sixteenth century, the German theologian and church reformer Martin Luther (1485–1546) decreed that a baptismal robe need not necessarily be white, people in Sweden reverted to ancient practices based on pagan customs and enfolded their babies in swaddling clothes decorated with red triangles, ribbons, and fringe. Not long ago, the Ainu of Japan still hemmed openings in their clothing with red, and the Fulani of Senegal sew a little piece of red fabric onto the nape of their headgear. In Bulgaria, a newborn's first outfit was made of red fabric, a color corresponding to the tint of the child's skin and the first stage in the cycle of life. Out of a similar desire for protection, young affianced Portuguese girls would embroider love notes to their future spouses in red on the nightdresses in their trousseaus.

Sometimes pigments rather than threads were used to incorporate protective signs on clothing, and red ocher was a favorite substance. Coastal peoples of the Athabaskan region of the Pacific Northwest drew red ocher symbols on the parts of their garments that corresponded to joints (knees, ankles, wrists, etc.). The wearer would therefore benefit from a spiritual safeguard against illness. The pigment's magical power frequently involved an entire series of rituals, including the collection and application of ocher. Among the Deg Hit'an, for example, ocher is gathered exclusively by men, because a feminine presence could provoke "ocher's return into the earth." The Kuchin people left offerings (such as reindeer tendons) at the site of an ocher deposit. Across this territory, ocher represented wealth and was traded as a luxury item. Today these painted articles of clothing are preserved as treasures by their descendants.

## RED THREAD

A simple red thread can guarantee an individual's security. Ailing Gypsies wrap their ring fingers with a red cord so that "the fever can no longer draw out a sweat." A red thread also helped a cuckolded husband fabricate a charm against a wife suspected of adultery. To make this amulet, he had to thread three magpie skulls on three boxwood

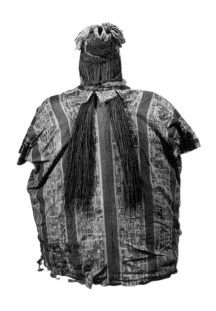

or rosemary twigs stripped of their leaves, then to tie them together with a red cord and place it under his spouse's bed. If she had a clear conscience, she could sleep without tossing or turning. If, however, she were guilty of an affair, she would reveal all the details of her misconduct during her night.

The Ostyak, who live in the Altai Mountains in the southern part of western Siberia, are afraid that the dead follow the tracks made by the bare feet of the living; therefore, walking without shoes for the first seven days of the mourning period is forbidden. Women can avoid this danger by taking a red thread, placing it on the deceased, and wrapping it around his left ankle. This red cord supposedly chases away the spirits.

At the beginning of the century in Morocco, a very powerful old charm was still used to protect men leaving for battle. First they killed and eviscerated a chameleon, then they embalmed it with coriander seeds and stitched it closed with red silk. The chameleon now became a magical sachet to be worn directly on the soldier's right shoulder. Red thread also protects crops. During pre-Communist Russian agrarian festivals before each harvest, the peasants would tie up a sheaf of wheat with a red ribbon and would pray to God for a successful crop. Once the harvest was over, they also attached a red ribbon to the last sheaf of winter wheat, and solemnly brought it back to the landowner's home to be set among the icons in a place of honor.

## RED BODY PAINTING

Red ocher can be used directly on the body. The Onge of the Andaman Islands in the Bay of Bengal cover themselves—every day from birth

*The Wari culture, which developed in Peru's Mantaro Basin in the early third century A.D., reached its apogee around 1000 A.D. The dead were placed in fardo, a kind of conical bundle made from several layers of fabrics embellished with figurative embroideries representing divinities or mythical, often anthropozoomorphic, beings. This wrapping helped some of this civilization's textiles to survive to our day. Aside from cochineal reds, pre-Columbian peoples used the leaves and roots from a plant known as raíz de teñir to dye their alpaca and llama wools deep red. Lima, Museo de Arte.*

to death—with a mixture made of tortoise fat, honey, and red ocher to guard against illness and scorpion bites. Thanks to this process, wounds only leave small scars, and the Onge appear to have extremely soft skin. For the Tucano of the Amazon, red ocher, which shields against evil spirits, fits into a larger context of hallucinatory ritual libations. Those participating in the ceremonies coat themselves with ocher in order to foster a sense of greater intimacy within the group, then they place woven ties (tinted red by a substance derived from the annatto tree) around their knees. The magical role of the ligatures is to accelerate intoxication from the drinks they consume to encourage longevity. The Tucano consider inebriation sacred and a significant feature in the harmony of life.

In China, a child can supposedly see spirits invisible to the adult eye and, therefore, requires a special safeguard. On the fourteenth day of the baby's eighth month of life, they paint a red mark on his forehead for protection, and if the child seems of a timid nature, his mother fashions little red fabric sacs containing cinnabar to help him acquire the courage needed to face his frightening visions.

The color red even protects domestic animals. In the Negev Desert, Bedouin women are responsible for the suckling ewes among their flocks. They mark their beasts by coloring their fleece red. Not only does the tint identify their sheep, but it helps keep evil spirits at a distance from the herd by making them think that the animals are wounded or dead.

*In the heart of Brazil, in the state of Pará, live several communities of Kayapo Indians. They are survivors of massacres perpetuated first by the conquistadors, then by those hunting for gold, rubber, and exotic woods. This woman has painted her face red with the pulp surrounding the seeds of the annatto tree. During ceremonies, the color evokes both the blood of fertility and war. The coating also protects her skin from the sun and insect bites.*

## RED FOOD AND INKS

Red's properties extend to a great number of ingredients, especially in Asia. At the beginning and middle of each lunar month, the Japanese customarily eat red rice (a gruel of rice and red beans) to stave off the threat of illness for weeks to come, thereby augmenting rice's vital energy with red's prophylactic character.

In China and India, a line of red characters might be inserted in the middle of the printed black-ink text to protect the reader from the wicked spirits that could emerge from the book.

## imitative magic

Red's role as a protector is also apparent in healing practices. From ancient times to the medieval era, Western medicine accorded red a position of importance based on a principle called "imitative magic": for symptoms characterized by the color red (such as loss of blood or acne), they used an equally red remedy. In addition, people also believed that the color attracted vitiated blood and corporeal humors toward the surface of the body and so thwarted infections.

In Rome they protected themselves against measles by wearing red garments, and also pressed red material against wounds to stop hemorrhaging. They even attributed hemostatic properties to the red pigments used by painters. Beginning with the Phoenicians, people often sprinkled hematite (a brownish-red iron mineral) and dragon's blood (a red-colored resin extracted from trees) on their cuts.

To avert smallpox epidemics, the Japanese made offerings of red-colored origami (the intricately folded paper) to Shinto divinities. They would also rub the origami on the bodies of the sick and then throw the paper into a fire or a river so that it could carry away the illness.

Would Mercurochrome still be considered as effective if it were not red?

# THE RED OF BATTLE

Warm and salient, red has probably been linked since earliest human times to the flush created by physical warmth—body heat—and has characterized primal expressions of elation. Red is a feature of many pre-hunt rituals, embodying the magical virtues attributed to blood and to the fire of the forge.

## THE HUNT

For many hunting tribes, red equals blood, that essential substance common to all mammals, and the color allows the world of humans to communicate with the world of animals. Participating in a hunt can signal a young boy's entry into adulthood. In Canada, the Cree adorn a brave young hunter with tattoos made from red pigment. These markings manifest his new status within the bosom of the community and stand as proof of his ability to overcome pain.

Before the Bororo (a tribe of hunters and fishers who live in the Brazilian state of Mato Grosso) leave in search of game, the men coat their bodies and hair with an intense red paste concocted with vermilion pulp made from the fruit of an annatto tree, the *urucú*, to increase their chances for success. The Amazonian Shipibo hunter also decorates his body—and his dog's—but uses red ocher. The Yafar of New Guinea blend red ocher with blood and extracts taken from odiferant roots. During consecration ceremonies, they spread the mixture on a young hunter's breastbone, and they also feed it to their hunting dogs to strengthen their vital force and their ability to draw prey. In funeral rites, a person's remains are painted with red ocher so that the deceased can return to his hunting grounds.

The Lapps (or Sami people) of southern Scandinavia venerate Leibolmai, the god of the hunt whose name means "man of alder." The alder, a tree considered sacred by the Lapps, is significant in numerous rites, especially those connected to the bear hunt. The tree's hallowed nature is based in part on the fact that, when its bark is chewed or boiled, it exudes a sap as red as blood, which is another sacred substance, full of magical potency. According to ancient Lapp beliefs, a man who covers his face with alder sap acquires the ability to repel evil spirits. But women also depend on the substance's virtues to block the harmful effects generated by the spirit of a bear killed during a hunt. The Lapp term for alder is the same one used for bear blood and menstrual blood. Women use alder sap to draw decorative designs on their sacred drums. Leibolmai is, in fact, the defender of

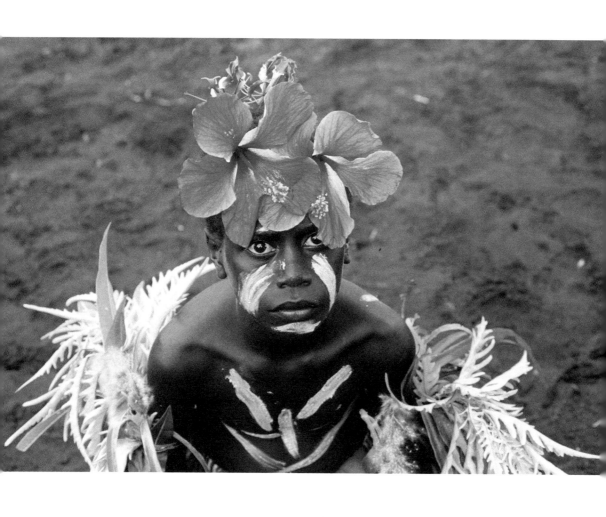

bears, and can help them rip a Lapp hunter to shreds. But if Leibolmai is worshipped appropriately by humans, then he extends his support to them. Lapps who were converted to Christianity against their will sometimes expunge the baptisms imposed on their children by "washing" them with alder sap and then giving them Lapp names in keeping with their traditions.

## war

The color red is also an adornment of war. The Etruscans had the custom, it seems, of smearing themselves with blood from their vanquished foes. In Rome, triumphant gladiators coated their bodies with cinnabar. The ancient Greek historian Herodotus (484–c. 425 B.C.) recounted how the Ethiopians left for battle with half of their bodies painted with white chalk and the other half with cinnabar to encourage their own desire for battle and frighten their adversaries. In ancient Israel, warriors colored their hair blood red using urine from cows that had eaten red dye plants like madder.

The Maori, whose vocabulary differentiates between more than one hundred shades of reds, paint themselves with red ocher before ritual combat. On these occasions, bird oil is used as a binder, but they blend the ocher with fish oil to coat an object or decorate a wall.

# RED PRIVILEGE

The color red frequently reflects the responsibilities held by an essential member of the community, whether he is charged with its sustenance or with safeguarding its integrity. War chiefs and religious leaders, therefore, often wear this color.

## A CHIEF'S HONOR

Red may be displayed directly on the skin using pigments. When a new leader is selected on Easter Island, his head is shaved and his scalp

*Among peoples who draw their sustenance from game, hunters often display body art or carry symbolic objects to help create links with the animal world, whether it is to receive the creature's pardon for killing it or to appease the powers watching over it. With its association to blood, the color red plays an active role in this realm. This young boy from the Solomon Islands near Papua-New Guinea wears foliage and red flowers for a ceremonial dance meant to communicate with the spirits of the forest.*

is then painted red. In the Pacific islands of Vanuatu, when a Motta reaches a high level in his community's social hierarchy, he spreads red ocher on his hair as an insignia of heightened power. And leaders who wish to draw attention to their rank coat their faces with a thick mask of red earth pigment.

## THE SPLENDOR OF SCARLET FABRICS

Wearing red fabrics has also often indicated strength, and all of nature's resources have been used to create red dyes. In addition to madder, it appears that our prehistoric ancestors availed themselves of white orach and swamp goosegrass, which provided red and orange tints.

*Religious images painted on wood panels, icons are the archetypal expression of the Orthodox Christian faith. This representation of the prophet Elijah was produced in tempera by the Novgorod School at the end of the fourteenth century. The technique consists of thinning pigments in a mixture of water and egg yolk. A red lead or red ocher primer was first painted on the wood panel before the actual compositional elements and the gold leaf were applied. The work's small dimensions (less than 10 x 8") suggest that it was used as a portable icon that the owner could carry with him. St. Petersburg, The State Russian Museum.*

In the East, the deep reds worn by the ancient Persian sovereigns on their thrones of power were derived from the orange-colored petals of dyer's safflower. This plant also furnished the red dye used to create the rising sun, the motif that decorates the Japanese national flag. "Tibetan red" was the Chinese name for the deep red derived from safflowers because craftsmen based in the mountains north of Kashmir held the secret of its manufacture. The dyed textiles were exported across the peaks of the ancient kingdom of Khotan as a part of the Tibetan tributary payment to China. These red fabrics were particularly prized by Confucian Chinese dignitaries.

For many years, red had been the only color used in Inuit dress and was reserved for important members of the community. Animal skins were boiled with bark from a derivative wood, like alder, to make the dye.

This approach to dyeing with alder was also familiar to the Ojibwa and the Menominee Indians in Canada, while native peoples in the region around Lake Chibougamau obtained fast red colors for their textiles by mixing red earth pigment—gathered from deposits on a hill called "the mountain of paint"—with the soft fish roe. They crushed the eggs until it formed a viscous paste and then incorporated the ocher. The Cheyenne of Colorado applied the same recipe to their buckskins.

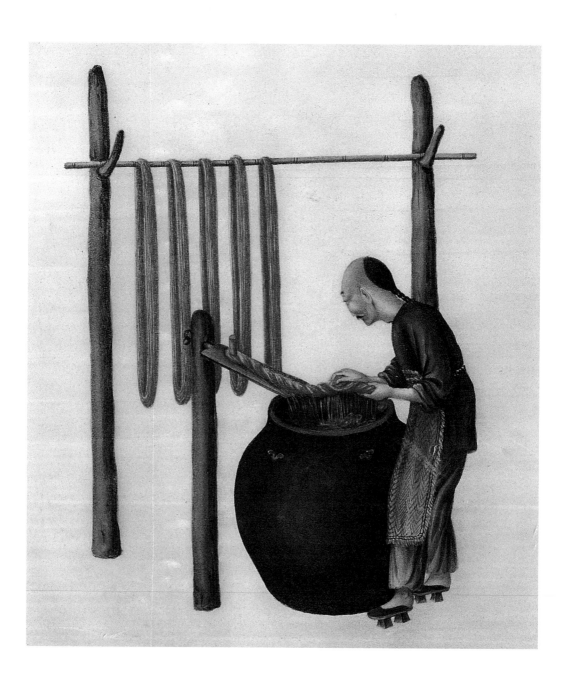

The Navajo could not obtain true reds from any of the dyestuffs available in the deserts of the American Southwest, and so they patiently took apart and unraveled the beautiful madder-dyed red wool uniforms worn by the Spaniards in order to reuse the fibers. Once these yarns were rewoven into tunics, Navajo chieftains could sport scarlet garments. Until the twelfth century, red was the most prestigious color in medieval Europe, favored by the rich and powerful. Dyers had various substances at their command to make red dyes and soon mastered the techniques necessary for each. Brazilwood, cochineal insects, madder plants, and, above all, kermes insects provided luminous reds resistant to sunlight and laundering. The kermes is an insect that feeds off oak trees found around the Mediterranean and in the Near East. Using her mandibles, the female attaches herself onto the leaves and lays her eggs. The kermes is often mistaken for a berry because the cocoon resembles a reddish pea. In order to extract the principal colorant, the female has to be removed from the leaf before laying eggs and then dried and crushed. The insect's coloring properties have been known certainly since the time of the Phoenicians and, clearly, must have been discovered before that era, because a paste made of meat and kermes-colored barley was found in a prehistoric cave at Adaouste (Bouches-du-Rhône) in southern France! A huge number of female insects were needed to produce just a little colorant, so the cost of the dye was exorbitant. Textiles colored with kermes were accessible only to princes and great dignitaries.

To this day, the color red remains a mark of honor in the West. That's why they roll out the red carpet to welcome celebrities, why the Légion d'honneur (France's highest civilian medal) consists of a red ribbon pleated into a rosette, and why they drape red bunting for inaugurations.

Even in death, red evokes power. The Kongo of Central Africa drape red shrouds on eminent people who have died, while in Nigeria, red textiles are placed on the roof of the hut sheltering the body of a notable person in their community.

*In China, sericulture, or silkworm rearing, dates to 2000 B.C. The eastern empire controlled the monopoly until the middle of the sixth century A.D. when it was introduced first to the Byzantine Empire and then, beginning in the twelfth century, to the countries of Western Europe. Numerous tinctorial plants were available in China to provide red dyes, including safflowers, the ears and stalks of a variety of sorghum known as kao liang, and even sapan wood (for fabrics mordanted with rice vinegar). Lyon, Musée des Tissus et des Arts Décoratifs.*

# Precious pigments: cinnabar and red lead

Except for ocher pigments, which were universally used by painters, other sources of red in the world of art commanded a high price and were reserved for the elite. Cinnabar, for example, provided the magnificent red hues apparent in the frescoes of the luxurious Villa of the Mysteries in Pompeii. Pliny the Younger (63–c. 113 A.D.) recounted how this expensive material was provided to the artist by his client, but how painters often cheated their patrons "by frequently washing their brushes. The cinnabar contained in the paint would therefore be deposited in the water and remain behind for thieves." In Byzantium, the use of cinnabar was an imperial prerogative, and the administration reserved a cinnabar-based red ink for the composition of imperial letters and edicts. Anyone using it without authority was put to death.

During the Middle Ages, the use of cinnabar was limited in Europe to ateliers specializing in manuscript miniatures, and monks were advised to add a crumb of ear wax to the pigment to prevent it from foaming. The mineral was also the favorite red for painters in the Far East.

Cinnabar has often been mistaken for red lead, a pigment fabricated from lead oxide beginning in the fifth century. According to legend, the Romans discovered it accidentally when, after a fire, they realized that the effects of the searing heat had turned lead white bright red. Much beloved by Chinese artists, the pigment can also be seen in Indian murals, in Fayum portraits, and in Western and Eastern paintings made until the nineteenth century, when it was banned as a toxic substance. Red lead possesses a beautiful orangish red tone, but only cinnabar exactly reproduces the color of blood. It could be coun-

*Taken from an illuminated book of hours made in a French atelier in the second half of the fifteenth century, this detail illustrates the month of March. The artist had several red pigments in his palette (including red ocher, cinnabar, and red lead) to which he added lakes derived from plant dyestuffs like madder, brazilwood, and kermes. Paris, Musée National des Thermes et de l'Hôtel de Cluny.*

*Opposite page: Around 100 B.C., the building known as the Villa of the Mysteries in Pompeii was decorated with frescoes notable for their use of cinnabar, one of the most precious pigments of the era. It was imported from mercury mines in Almadén, Spain, then purified and turned into a fine powder in Roman workshops. This intense red shade may have been chosen with a sense of ostentation, but it may also have been linked to a form of religious sexuality honoring the abundance of life.*

terfeited by using goat blood and crushed, shiny, orange-red berries from the rowan tree. Red lakes were made from tinctorial substances like madder, cochineal insects, brazilwood (which formed columbine), and kermes. Their reputation extended from Hindu mural artists to Irish monks, who used them to embellish their illuminated Gospels. For artists from antiquity until the nineteenth century, these lakes provided a vivid range of reds and conveyed many subtle nuances, but they lacked a necessary brilliance.

# THE RED OF THE GODS

The color red and its associations with the blood of fertility, with the hunt, and with war frequently combined to strengthen the power of religious objects.

## EVOKING BLOOD

Red signified blood, especially in Africa. The red paint used in Tsogo statuary was created out of sawdust from the padauk tree, which grows forty-five feet high. Other red woods (like rosewood and camwood) also provide red sawdust, which could be blended with water or palm oil. In addition, local varieties of sorrel, sorghum, and the hibiscus flower could be used to redden the wood, fabrics, and skins that form masks.

## BLOOD AS A COLORANT

If red pigments and colorants can summon up the image of blood, then sometimes actual blood served directly as the coloring substance, becoming doubly powerful both by its nature and its hue.

The Dogon offer up the blood of sacrificial beasts for their most important ceremonial mask. By coloring this ritual object, the blood joins forces with its religious authority. The seminomadic Baining, who live on the Gazelle peninsula at the northwest part of the island

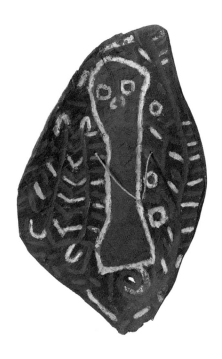

of New Britain in Malaysia, also mix blood with saliva to coat their sculpted masks. The Sami draw blood, either their own or that of their reindeer, to paint their wooden idols and ceremonial drums. They also use alder bark sap, which becomes a substitute for blood once it has been consecrated by magic rites. Alder is also used by the Inuit, who redden their wooden masks with a concoction made from alder bark and urine or boiled hemlock. The acidity of the stale urine helps to fix the colors. They expose painted masks to the infusion of urine vapors when the men gather together before certain ceremonies. By provoking a minor nosebleed, a painter would add his own blood to the colorant and improve its adherence to the primer. This personal contribution allowed the mask to exercise its maximum potency.

## RED AND DEATH

The color red reveals all of its ambivalence in the context of death. When it is menacing, its very power foreshadows and seals its destruction. But because the color red is intimately linked to the forces of life, it also carries within it the hope for rebirth and, since the beginning of humankind, has accompanied the dead on their voyage to the great beyond.

### FROM ANGER TO ANNIHILATION

When Yahweh decreed the destruction of the realm of Saba in southern Arabia, he sent red rats to eat away the immense irrigation dam the

*The central highlands of Irian Jaya, in Indonesian New Guinea, are the refuge for the last tribes on Earth that practice cannibalism. One of their creation myths recounts that the great ancestor lived alone in the jungle and staved off his solitude by sculpting trees. These totems came to life one day and gave birth to men. The warriors and hunters of Irian Jaya developed an original method of painting on bark, particularly to decorate their shields. The one pictured here shows red and white lines traced with kaolin and an ocher pigment. The delicate champlevé work carved out with a bone from a cassowary (a forest ostrich) highlights some of the designs. Paris, Musée du Quai Branly.*

Sabians had built on the river Adhanat, thereby drowning the kingdom. At Hogwarts, the boarding school where the apprentice wizard Harry Potter, the hero of J.K. Rowling's enormously successful book series is studying his future profession, students sometimes receive "Howlers." Recognizable by their red envelopes, these insulting letters scream out their messages when they are opened. In every culture and every era, red evokes aggression, an extreme anger that could lead to a brutal death.

In classical Arabic, the term for the color red stems from a root referring to ardor and intensity, but also violence. Red can be a sign of misfortune: a red death is a bloody death, a cruel person is said to have a red eye, and a condemned person is said to have red wool. A chronicler of Persia's Safavid court wrote that when the sovereign appeared dressed in red, everyone was terrified because it signified that someone would surely be put to death that day.

The Siberian epic *Geser*, which illustrates different modes of social organization, recounts the battles and alliances between three brothers, and depicts a defiant character, an evil rival named "Red with Envy." Slain in battle, he was decapitated, and all evils were born from his body parts, which were thrown onto the ground.

Divine choler was frequently expressed in red. Tibetan artists followed a precise liturgical code to represent the deities in their pantheon, and invariably used red pigments to symbolize passion and brutality. Their wrathful gods, therefore, always have a head of red or orange hair.

In the Philippines, red represents the powerful gods who can dispatch death. The Ifugao people say: "If you dream that someone gives you a betel nut, and you accept it, and you chew it and you spit out red saliva, then you will be killed by an enemy, for red is the color of the Solar and Lunar divinities who cause such deaths."

*This mural painting or thangka adorns the Pemayangtse monastery in the Indian state of Sikkim. Its dominant red tonalities depict Vajrapani, the lord of secrets. The name of this fierce divinity translates into "wielder of thunderbolts," which are represented here in the form of dumbbells fitted out with arrowheads, according to the religion's iconographic codes.*

## DEATH INVIGORATED

The link between the color red and the blood of life in funerary rites has existed since the dawn of time. Scientists have discovered human bones

coated with red pigments, usually ocher, in many prehistoric sites, such as the Cro-Magnon burial ground unearthed in the Dordogne region of France. This practice probably fulfilled a desire to connect the deceased with the color of the vital fluid and thereby encourage the soul's return to its physical form. Furthermore, ocher's cauterizing and antiseptic properties were probably already known in this era.

This longing to help their dead survive in the afterlife was so strong that, in the Paleolithic era around 40,000 B.C., our ancient ancestors heated yellow ocher in order to redden it, achieving the first chemical transformation in human history.

Archaeologists found cinnabar pigment scattered in eighth-century Chinese tombs uncovered in Henan province. But whatever the substance used here or elsewhere, the presence of the color red in funerary rites has survived the millennia. Even today in many regions of China, they place a little incense-filled ball of red paper between a dead person's lips to help him on his eternal voyage.

In Buddhist mortuary rituals, the link between death and the blood of life is embodied in a cup of red wine. During a woman's funeral, her children must mimic a descent into hell to liberate the soul of the deceased, drowned in a puddle of blood. The red wine represents the blood, which the children must share and drink to the last drop. Then the souls of both the mother and her children will find a sense of peace.

From the Maghreb coast to the Middle East, they still add henna to the body of the dead.

For some, the end of life is the moment to return to the redness of fertility. In the culture of the Kalabari people of southeastern Nigeria, for example, they lay out the deceased in a successive series of rooms on the eve of his burial. The first is draped with red-colored fabric, similar to the one worn by a woman during childbirth. Symbolically completing the circle, it marks the end of a person's existence in the context of his entry into life.

# THE USES OF RED

# ocHers and reddish
## eartH PIGments

THIS ENTRY DEALS WITH THE
SAME TYPE OF PIGMENTS
DISCUSSED IN THE "YELLOW"
CHAPTER. LIKE THOSE
PIGMENTS, RED OCHERS AND
RED EARTHS CAN BE FOUND
AROUND THE WORLD.

WE HAVE SEPARATED THEM
INTO THREE TYPES OF
COLORS THAT, WHILE NOT A
SCIENTIFIC ARRANGEMENT,
HIGHLIGHT THE VARIETIES
OF THESE EARTH PIGMENTS.

Red ocher was the first pigment used by humankind; it served in funerary rites. Fragments of red ocher and a basalt pestle were discovered near Nazareth in an ancient sepulcher dating from 90,000 B.C. In the Neolithic era, red ocher was common in tombs, where layers were spread on bones or lumps of pigment were strewn about.

The most opaque of all the pigments, red ocher has played a role in pottery-making and in the world of textiles throughout the ages. First used in prehistoric rock paintings, ocher has been most highly sought by visual artists, from illustrators working in medieval European monastic scriptoria to Persian miniaturists, from the Maya to the Italian Primitives. Some of them bound the pigments with linseed oil, others with brine, urine, soot, tar, buttermilk or cow's blood, lizard or snake fat. To create their bark paintings, Aboriginal artists in Australia's Arnhem Land crushed the stalk of a wild orchid with their teeth in order to release its transparent sap and then blended it with the pigment as needed, using the stem as a brush. The Yolngus,

who live in the western part of the Australian continent, manage to obtain a specific ocher from distant Arnhem Land, because they value its purple tonalities and its ability to give luster to painted surfaces. When they smear this ocher on the bodies of initiates, they first blend it with yellow fat extracted from the liver and kidneys of sharks or rays, or even from a kangaroo tail. All these animals are chosen specifically for the power and sense of wellness they embody. In ancient Egypt, a muralist would snap a cord moistened with a blend of ocher and water against a surface to define the grid that would help him correctly determine the proportions for the figures and motifs in his painting. Beginning in the Roman era, red ocher competed with cinnabar, and then with red lead, but throughout the centuries, it remained irreplaceable, particularly for its ability to cover large surfaces, as is evident from Etruscan tomb paintings or from the decoration of wooden outriggers in Borneo.

At the beginning of the twentieth century, women living in the Transvaal still walked over eighty miles to reach Rust de Winter, a region famous for its red ochers, so that they could paint large

## INSTRUCTIONS

You can calcine, or roast, yellow ocher to turn it red by dehydration. In ocher factories, they calcine loaves of yellow ocher at 850° C (1500° F). It is a delicate operation and must be error-free. Loaves are then crushed in mills. With the flames produced by a household stove, you will only be able to obtain a rosy hue, but it will be a pretty one. Put the yellow ocher in an old pot without any water. Heat it slowly while stirring from time to time until you achieve the desired color. This pink ocher can be used like any natural ocher.

You can cover about 200 square feet of wall space by layering similar tones made with the following mixture: blend two cups of linseed oil, four cups of turpentine, and a half cup of drying agent with 50 grams of ocher. The mixture must be perfectly homogenous. Using a natural sponge, spread the liquid on a wall that has first been primed with a matte emulsion. Always begin with the lightest tint. Repeat the process with a darker pigment or even with the same one to accentuate the tone.

multicolored designs on the walls of their homes. After first moistening the earth, they fashioned the pigment into compact balls for easier handling. Once they dried, these balls would form little reserves of pigment, which, according to the women, would last them "half a lifetime."

# common madder
## *Rubia tinctorium* L.

MADDER IS A HARDY PERENNIAL PLANT THAT GROWS ABOUT THREE FEET HIGH. ITS SQUARE-STEMMED ROOTS EXTEND TO OVER TWO FEET IN DEPTH AND CAN STAIN HANDS RED. NATIVE TO PERSIA, IT HAS BEEN CULTIVATED IN THE MIDDLE EAST AND IN THE MEDITERRANEAN BASIN SINCE ANTIQUITY, AND IT WAS LATER INTRODUCED TO THE SOUTH OF FRANCE AND TO THE ALSACE-LORRAINE REGION IN THE NORTH. MADDER IS THE ONLY PLANT THAT PROVIDES A TRUE RED. THE PIGMENTS IN ITS ROOTS ARE SO POWERFUL THAT MADDER CAN TINT THE MILK AND EVEN THE BONES OF THE ANIMALS THAT FEED ON IT. IN THE FALL, PLANTS OVER TWO YEARS OLD ARE HARVESTED. IN THE OLD MADDER FACTORIES OF VAUCLUSE IN FRANCE, THIS EXHAUSTING WORK INVOLVED EVERYBODY. TWO MEN WIELDED THE MADDER PITCHFORK TO EXTRACT THE ROOT. WOMEN AND CHILDREN THEN GLEANED THE FIELDS FOR ANY BROKEN BITS. THE ROOTS WERE FIRST DRIED IN THE SUN, AND THEN BEATEN TO REMOVE ANY EARTH THAT MIGHT STILL BE CLINGING TO THE PLANTS. THEY WERE THEN GROUND TO POWDER IN THE POWERFUL MADDER MILLS.

Madder is one of the most ancient dye plants and has probably been in use since Neolithic times. It was cited in early Sumerian texts, as well as in the Bible. The mummy bandages wrapped around Tutankhamun were dyed red with madder. North of the Black Sea, madder-colored textiles have been recovered from Scythian tombs dating from the fourth century B.C. More than 2,400 years later, the color still maintains its freshness. Many publications have described the development of madder cultivation in Europe and in the Near East during the Roman Empire, along with its decline in the West, the shortages that occurred when the secrets of Adrianople red—which allowed the Turks to dye cotton using mephitic ingredients (baths of rancid fats, oil, urine, excrement, and sheep and cow blood)—were finally uncovered, the economic protectionism pursued by the seventeenth-century French finance minister Jean-Baptiste Colbert, the new plantations in the Vaucluse, economic prosperity, then the definitive downturn brought about by the discovery of synthetic

# instructions

Buy pulverized madder, because grinding the roots is a laborious process. Mix 225 grams of powdered madder and 125 grams of bran (to intensify the color) in cold water to make a liquid paste. Set aside. To prepare the fibers, dissolve 200 grams of alum and 60 grams of cream of tartar in a pot with 10 liters of water. Put in the fibers and boil them for an hour. Let both the water bath and the paste sit overnight. The next day, remove the fibers from the water bath and add the madder paste to the pot. Blend well then slowly heat the mixture. When it reaches 40° C (104° F) gently reintroduce the fibers and slowly increase the temperature of the bath to 70° C (158° F). Maintain this temperature for an hour while stirring constantly. Do not let the temperature rise above 80° C (176° F), or the dye will turn brown. At the end of the dyeing process, let the pot boil for 2 minutes (and no more!) to fix the color. Remove the fibers and let them cool. Wash them with a little castile soap and rinse very well. Madder was one of the three plants that Colbert deemed as "colorfast"; that is, it creates tones resistant to laundering and sunlight.

To dye leather, a medieval reference book includes the following recipe: "Take a piece of clean natural Cordovan leather, and wash the outer part of the skin with alum. Set a bronze cauldron over a flame, and heat madder and wine until you are just able to still dip in your finger, then add the leather and stir constantly until it has soaked up the color."

pigments… What is somewhat less familiar is the non-European history of madder. In the lands of Islam and in India, for example, they mordanted fibers using olive oil or alum combined with goat droppings. Asian varieties of the madder plant had been used since earliest history in Japan. Armor worn by medieval warriors was made from pieces of metal connected by a multitude of silk braids intricately woven together to form patterns. Like their battle standards, they dyed the threads red to impress the enemy. The Japanese tell the story of a certain lord from Karga who was so frightened that he sent his spies into enemy territory to abduct the artisans responsible for creating such a striking color.

Common madder has been popular with painters, who mixed dried and ground roots with alum to create a lake with the color of crushed red currants. Madder was a widespread element in Western art, from Pompeian frescoes to Pierre-Auguste Renoir (1841–1919). But not too long ago, Arunta artists in Australia developed a madder-based paint to decorate their sculptures and create rock paintings. For centuries, Maithil women living in northern India have adorned the adobe walls of their homes with frescoes peopled with figures from the Brahman pantheon. For their red shades, they use madder juice bound with milk from their goats.

# cochineal insects

THERE ARE THREE PRINCIPAL TYPES OF TINCTORIAL COCHINEAL INSECTS: THE ARMENIAN COCHINEAL (PORPHYROPHORA HAMELI), A HAIRY LITTLE INSECT, BARELY MORE THAN THREE-EIGHTHS OF AN INCH IN DIAMETER, WHICH LIVES ON REEDS AND CERTAIN GRASSES IN ARMENIA AND TURKEY; THE POLISH COCHINEAL (PORPHYROPHORA POLONICA), EVEN SMALLER, WHICH FEEDS OFF THE ROOTS OF THE HARDY PERENNIAL GERMAN KNOTGRASS AND CAN BE FOUND IN THE SOUTHERN REGIONS AROUND THE BALTIC SEA AND IN THE UKRAINE; AND THE MEXICAN COCHINEAL (DACTYLOPIUS COCCUS), AN INSECT ABOUT THREE-EIGHTHS OF AN INCH IN DIAMETER, WHICH COLONIZES PRICKLY PEARS AND VARIOUS CACTI IN SOUTH AMERICA, CENTRAL AMERICA, AND THE CANARY ISLANDS. THE AMERICAN KIND IS THE EASIEST TO OBTAIN. BUT WHATEVER THE VARIETY, ONLY THE FEMALES CAN BE USED, BECAUSE THE MALES DO NOT CONTAIN CARMINIC ACID, THE COLORING PIGMENT. THEY HARVEST THE PREGNANT FEMALES JUST BEFORE THEY LAY THEIR EGGS AND DRY THE INSECTS IN THE SUN. A FOURTH TYPE OF COCHINEAL IS USED FOR ITS TINCTORIAL PROPERTIES: THE LAC INSECT (KERRIA LACCA) OF ASIA, WHICH LIVES IN COLONIES IN CERTAIN SPECIES OF TREES. FOR MANY YEARS, PEOPLE WONDERED ABOUT THE COCHINEAL'S EXACT NATURE. SOME AUTHORS BELIEVED IT WAS A BERRY OR A LADYBUG OR EVEN A WORM. AT THE BEGINNING OF THE EIGHTEENTH CENTURY, SCIENTISTS FINALLY CLASSIFIED COCHINEALS AS MEMBERS OF THE INSECT FAMILY. BUT THE CONFUSION BETWEEN COCHINEALS AND KERMES INSECTS DOES NOT SEEM CLOSE TO FADING AWAY.

Since 700 B.C. in Peru, dyeing cotton and alpaca with cochineals has been practiced on fibers mordanted with alum or lemon juice. The peoples of Latin and Central America also used the insect as a pigment and for cosmetics, and they tended large nopales (prickly pear cactus) fields well before the arrival of the Spaniards.

The farming of these insects (which the Aztecs called "the blood of prickly pears") is quite complex, and requires a maintenance that is delicately balanced between the survival of the nutritive plant and the parasites. In the nopales fields of southern Mexico, the annual yield can reach 264 pounds of insects per acre. Given that the coloring strength of the Mexican cochineal was almost ten times that of kermes, the Spanish conquerors quickly realized that it represented enormous wealth, like gold, silver, and pearls.

They escalated production and, starting in 1520, exported hundreds of tons of dried cochineals to Europe, then, via Venice, to the Near East and the Far East. In the course of the eighteenth century, people succeeded

in introducing the Mexican cochineal to Algeria, Java, Cádiz in Spain, and, above all, to the Canary Islands, which became the premier exporter of the insect in the nineteenth century. Easier to harvest and priced lower than its counterparts (thanks to slave labor on the plantations), Mexican cochineals little by little supplanted the Polish and Armenian species that had been used since antiquity in the Old World for dyeing, painting, writing, and illuminations. Harvested and exported since the high Middle Ages in northern Europe, Polish cochineals had dyed Flemish, Florentine, and Venetian cloths, colored leather, and even tinted horses' manes in Turkey, but the industry collapsed after the seventeenth century and almost totally disappeared. Armenian cochineals, used for dyeing in the Near East since the first millennium B.C., met the same fate. The success of Mexican cochineals touched off a similar failure in kermes farming in Europe. The reign of cochineal insects foundered at the end of the nineteenth century with the increasing popularity of chemical dyes. However, cochineal's lack of toxicity means that it is still used as a coloring agent today, particularly in cooked meat products.

## instructions

*This recipe is very similar to one used by pre-Columbian peoples.*

Finely grind 30 grams of cochineals in a mortar until you achieve a fine powder. Thin it out with a little water to form a paste. Set aside. To prepare the fibers, dissolve 200 grams of alum and 60 grams of cream of tartar in a pot with 10 liters of water. Add the fibers and boil for an hour. Let the cochineal paste and the water bath rest overnight. The next day, extract the fibers and empty the preparation bath. Fill the enamel pot with 10 liters of fresh water. Add the cochineal paste and dissolve. Let the dye bath boil for 15 minutes. Remove the pot from the heat and, using paper towels, remove any cochineal carapaces that may have settled on the side of the pot so that you have as clear a dye bath as possible. (The shells will spot the fibers.) When the water temperature cools to 40° C (104° F), gently reintroduce the fibers. Bring the temperature back up to a boil for an hour. Turn off the heat and let the fibers cool in the bath.

Rinse them carefully. Given the cochineals' coloring strength, you can repeat the process and dye new fibers in the same bath, but be careful not to use more than 250 grams of material this time otherwise the tints will be too pale. Cochineal dyes are very resistant. You can also color light woods by plunging them directly into the dye bath and boiling them for an hour.

# BRAZILWOOD
## *Caesalpinia* L.

WHEN WE USE THE TERM "BRAZILWOOD," WE ARE REFERRING TO VARIOUS SPECIES OF THE GENUS CAESALPINIA THAT POSSESS COLORING PROPERTIES. STRICTLY SPEAKING, BRAZILWOOD IS A TREE WITH YELLOW FLOWERS AND A DARK RED GRAIN THAT REACHES ABOUT A HUNDRED FEET IN HEIGHT AND GROWS ALONG THE LENGTH OF THE BRAZILIAN COAST. THERE IS ALSO PERNAMBUCO WOOD, A TROPICAL CREEPER, AND SAPANWOOD, A SMALL SPINY TREE THAT GROWS IN INDIA, MALAYSIA, AND THE PHILIPPINES. ALL PRODUCE COLORS RANGING FROM ORANGE TO VIOLET, INCLUDING PINK AND RED TONES. THE FIRST USE OF THE TERM "BRAZIL" OR "BREZIL" WAS IN 1190. THE WORD DERIVES FROM THE ROOT "BRAS" OR "BRES", WHICH MEANS "EMBERS," AN ALLUSION TO THE FLAME-RED COLOR OF THE DYE EXTRACTED FROM THE TREE.

During the Middle Ages in the West, red was the most desired color. To cope with the demand, Europeans began to import "brazilwood" from Java, Ceylon, Sumatra, and the Indies at the end of the twelfth century. The caravans and vessels transported the wood chips to Baghdad, and from there to the Mediterranean coast where Venetian ships then took on the cargo. Imported from distant lands, brazilwood made an expensive dye reserved for luxe materials. Moreover, workers had to reduce the shavings to powder, a rather laborious process. It was only at the end of this era that the necessary preparatory steps to create the dye were truly mastered.

Craftsmen succeeded in achieving luminous tones, particularly orange hues, and medieval Europe had banned the creation of this color by superimposing yellow and red dyes. Brazilwood also created a fashion for pink shades seen in the masculine and feminine princely attire of the fourteenth and fifteenth centuries. When the Portuguese explorer Pedro Álvarez Cabral reached the New World in 1500, he came ashore on a land he baptized "Ilha de Vera Cruz." The conquerors discovered new types of dyestuffs there, which they incorporated with those they knew, and the name "Vera Cruz" was changed to "Brazil."

The Portuguese rapidly exploited this wealth...and the indigenous peoples, who were ordered to fell the trees by setting fire to their bases and stripping the bark from their trunks. The chopped and shredded wood was shipped to Lisbon. Unfortunately, this providential gift aroused greed, triggering conflicts between the Portuguese and the French until the middle of the sixteenth century when sugar cane became an even more valuable commodity. The name "Brazil" remained a testament to the vitally important role played by tinctorial tree species in the world economy during the Age of Discovery. In the eighteenth century, brazilwood dyes continued to be used abundantly in the manufacture of printed fabric. Red shades could not, in fact, be achieved without mordants. And yet, because the mordant used to generate light red tones (a blend of alum and cream of tartar) was colorless, they tinted it with brazilwood to verify that the product had impregnated the fabric. Textiles treated in this manner were then dipped in madder or cochineal dye baths, and the colorant only adhered to the mordanted sections.

## INSTRUCTIONS

For brazilwood, the tinctorial principle (brazilin) resides in the tree trunk and main branches. The wood must be shredded. Pour a liter of boiling water over 300 grams of sawdust. Set aside. To prepare the fibers, dissolve 200 grams of alum in a pot with 10 liters of water. Add the fibers and boil for an hour. Let the wood paste and the preparation bath rest overnight. The next day, remove the fibers from the preparation bath, wring them out, and empty the pot. Filter the wood paste, and save the sawdust, because it can be reused once it has dried. (When you use it next, divide the amount of fabric by half.) Pour the tinted liquid in the enamel pot and add enough water for a total of 10 liters of liquid. Add the fibers. Slowly raise the temperature and maintain a boil for 30 minutes. If you take out the fibers at this point, they will have a beautiful cherry red color. After boiling them for an hour, the color will turn to violet. Whatever your desired color, let the fibers cool in the water bath, and then rinse. If the wood is good, you can continue dyeing, but don't forget to divide the weight of the fibers or the fabric with each successive dye. The color is resistant to launderings, but is sensitive to light. Depending on the level of the water's acidity or alkalinity, the shades can range from orange (acidic) to purple (alkaline).

Although extracting a red lake from brazilwood is a rather complicated procedure, it is easier to create red ink: soak 50 grams of brazilwood sawdust in 25 centiliters of cold water for three days. Filter and then reduce in half by boiling. Add 8 grams of gum arabic and 8 grams of alum. Blend well and use over the next few days.

# Henna
## *Lawsonia inermis* L.

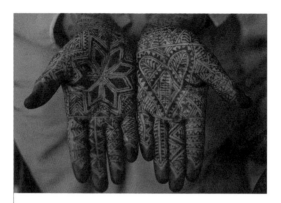

NATIVE TO INDIA, HENNA IS A SHRUB THAT CAN GROW ABOUT SIXTEEN FEET HIGH. IT IS CULTIVATED THROUGHOUT THE MIDDLE EAST AND IN NORTH AFRICA. THE COLORING INGREDIENT IS LOCATED IN THE LEAVES, WHICH ARE HARVESTED IN THE SUMMER AND SET OUT TO DRY. MICHEL ADANSON, THE NATURALIST WHO CLASSIFIED THE PLANT IN THE EIGHTEENTH CENTURY, DESCRIBED IT AS FOLLOWS: "THEY USE IT TO MAKE A PASTE THAT IS THEN APPLIED OVER A PERIOD OF FOUR TO SIX HOURS TO A PERSON'S NAILS AND, WITHOUT ANY DISCOMFORT, IT IMPARTS A BEAUTIFUL VERMILION COLOR WHICH LASTS FOR CLOSE TO SIX MONTHS. I TESTED THIS OUT ON MY TOES, AND THE COLOR ONLY DISAPPEARED AFTER FIVE MONTHS BECAUSE OF THE NAIL'S NATURAL GROWTH."

In ancient times, women were already blending henna with wine to dye their hair and nails. In sub-Saharan Africa, they cold-dyed textiles with it. Although henna is not mentioned in the Koran, tradition holds that the Prophet recommended its usage, and Allah brought it to paradise. According to legend, the first woman to use it was Fatima, the Prophet's daughter, during her marriage. On finding her very pale, her father said: "Go out and take the first plant you find. Crush it and rub it on your hands and feet." And that was how she discovered henna, which from then on became a sign of joy and benediction. Henna used as body decoration occupies a prominent place in ceremonies throughout the Arabo-Islamic

*In the Maghreb, a decorated hand with patterns drawn with henna.*

world, where it is treated with respect. They use it in circumcisions because it stops the flow of blood and heals the wound, and also symbolically protects the infant.

During weddings, it attracts divine protection to those who have colored their feet and the palms of their hands with the plant.

Henna also features in the daily life of the people of the Maghreb, for they believe it has the power to chase away evil spirits. It is customary to cover a newborn with a mélange of henna and olive oil until the child's skin takes on a brownish-red tone. In Moroccan tradition, when people move to a new home, they set down a bowl of milk and another of henna as offerings to the household genies to facilitate a peaceful cohabitation. And when a man dresses for battle, his wife prepares a henna paste, and if she is breastfeeding, she replaces the water with her milk. She coats her husband's right palm so that the dye can protect him and unfailingly remind him of his wife's love and his duties as a father. A popular belief exists throughout the Arab world that a child may be sleeping inside his mother. Women who have not been able to conceive cite this to

## INSTRUCTIONS

Henna stains the skin, so put on gloves even before the henna comes in contact with the water.

Commercially available henna often contains adjuvants, so it is best to obtain dried leaves from an herbalist and to reduce them to the finest possible powder. Make a paste by blending 150 grams of henna powder with a little water. Heat 10 liters of water. Add 3 cups of lemon juice and the henna paste. Separately, dampen the fibers with tap water. When the temperature reaches 40° C (104° F), put in the materials and let boil for an hour. Let the fibers cool, then rinse them carefully.

You can paint an area of flat color on rag paper with dried henna paste. Carefully dry the deposit and then scrape. To color parchment or leather, you can use a thinned-out blend of water and henna powder spread with a large brush or a roller. You may need several coats to obtain the desired tint. You can also draw patterns using a brush.

avoid repudiation. Among the recipes aimed at waking this child, one consists of drinking a filtered concoction of henna that has rested overnight in the moonlight. Henna also serves in funeral rites. According to a disappearing tradition, henna marks are made on the shroud corresponding to the location of the dead person's eyes, mouth, and nose. With its antifungal properties, henna helps preserve the corpse from a rapid decomposition, and protects the deceased on the voyage to the great beyond.

*I see the red flag outside my window; the shadow, in fact, appears violet and dusky to me; it has an orangish glow, but why isn't there any green? First of all because red needs to have hints of green, but also because of the presence of orange and violet, two tones that introduce yellow and blue, which make green.*

Eugène Delacroix (1798–1863)

# VIOLET

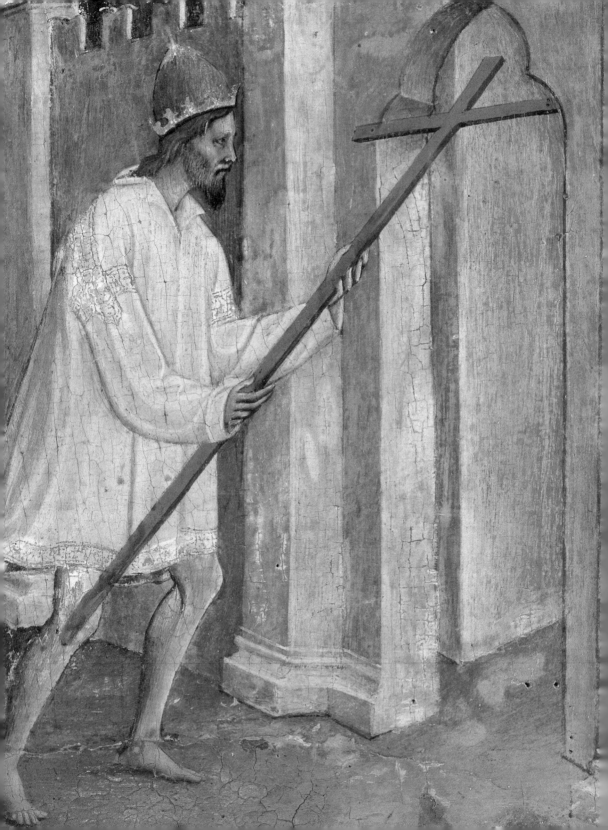

Some twelve thousand mollusks for barely
more than a few drops of colorant. The history
of the color violet is often confused with that
of purple, which has captivated imaginations
for more than three millennia. Among the
most complex dyes to extract and, therefore,
the most expensive, purple has seduced the
powerful, from Roman emperors to Church
dignitaries, to such a degree that other
sources of violet have almost been forgotten.

*By the fifteenth
century, purple's
secrets had long
been forgotten, and
artists resorted to
a blend of red and
blue pigments—like
azurite or lapis
lazuli mixed with
red ocher, red lead,
or cinnabar—to
create violets for
their paintings.
Lacs extracted from
various dyestuffs
such as cochineal
insects, kermes, and
madder provided
an infinite range of
violet shades, and
Renaissance artists
took full advantage
of the variety of
colors. Michele di
Matteo (recorded in
Bologna between
1409 and 1467),* The
Emperor Heraclius
Carries the Cross
to Jerusalem. *Paris,
Musée du Louvre.*

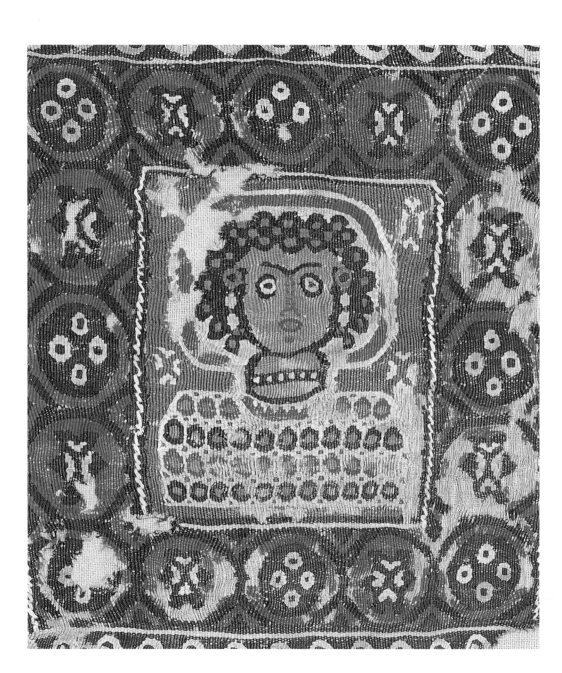

# Purple

Purple is a colorant secreted by marine gastropod mollusks, principally species of *Murex* and *Purpura*, and the same words refer to the range of tints—from deep red to darkest violet—obtained from this substance.

## The Origins

According to legend, the dog belonging to Melkart, the Phoenician god of dyers, was responsible for discovering purple. And, indeed, in the ancient city of Ugarit in Phoenicia, a land spanning parts of modern-day Lebanon and Syria, archaeologists have uncovered traces of murex used for tinting dating back to 1500 B.C. In the latter part of the second millennium B.C., the cities of Tyre and Sidon developed a monopoly in extracting purple and dyeing fabrics, most notably silk. In fact, veritable hills of crushed seashells have been found next to the dyeworks in these communities.

The farming of murex by the Phoenicians required enormous effort. First they had to find the mollusks in the waters of the Mediterranean, then break open the shells. The mollusks were left to soak for some time in basins, and then workers had to remove the liquid from a minuscule gland. Next a fascinating phenomenon occurred: exposed to sunlight, the juice turned from a whitish color at first into a yellowish green, then to green, violet, and finally a deeper and deeper red. Precisely controlling the duration of the fluid's exposure to the light was critical to obtaining the desired color. Then they colored the raw materials: carded wool and unwoven silk and linen fibers. The dyeing was irreversible, and the tints were magnificent.

## A Prestigious Color

These highly esteemed textiles were sold throughout the Mediterranean region, but this dyeing process required multiple delicate steps, which themselves required considerable time and manpower.

*The sands of the Egyptian desert preserved a large number of the textiles wrapped around Coptic mummies. This linen and wool tapestry example dates from the ninth century A.D. The violet tones of certain design elements may have been created by purple dyes, whose waning use was still common in Byzantium and its provinces. Traditional purple dyeing techniques faded away completely soon after. However, it is more likely that the purple colors in this fabric were obtained by a double tinting of madder or safflower reds superimposed on a woad-based blue. Paris, Musée du Louvre.*

From the beginning, purple was reserved for the clothing of nobles, kings, priests, and magistrates; for all the civilizations around the Mediterranean Sea, it represented social prestige. Only the rigorous Spartans failed to fall under purple's spell. In their culture, the word for "to tint" also meant "to dupe." The tinting of cloth was only permitted for battle attire, which was colored red so that the bloodstains would not show. Spartan dyers used plant dyes for these fabrics.

Purple tincturing was also practiced in Chaldea and Assyria. Mesopotamians had already mastered the technique on leather by the second half of the second millennium B.C. We know, in fact, that King Tushratta of Mitanni sent his brother-in-law Amenhotep III sheepskin shoes dyed purple. They were lined with multicolored silk and studded with precious stones, gold, and silver.

## CELEBRATED IN LITERATURE

Throughout the Mediterranean world, purple's renown continued to grow, and Greek texts echoed the praise. In Homer's *Odyssey* and *Iliad*, it was the color of the leather strips supporting Odysseus's nuptial bed and the belt worn by Ajax; the tail of a noble Trojan warrior's horse was immersed in purple to make it more striking; the queen of the Phaeacians spun purple wool; and the river nymphs wove "sea purple" fabric. The poetess Sappho (seventh–sixth century B.C.) praised the Lydians for their ability to tint their sandal straps purple. In the work of Aeschylus (c. 525–456 B.C.), Clytemnestra celebrated her husband Agamemnon's return by spreading on the floor purple rugs made by his niece Hermione. In Susa, Alexander the Great came upon large quantities of purple textiles that had been dyed in the city. Close to two hundred years old, their colors were still vibrant. Excavations in the ancient purple-producing cities of Greece have revealed dye vats that still bear the violet traces of the industry.

In the Bible, purple was reserved for the cult of Yahweh and for priests' vestments. The prophecy of the Apocalypse, which heralded the fall of Babylonia, declared: "And the merchants of the earth shall weep and mourn over her; for no man buyeth their merchandise any more: ...

fine linen, and purple, and silk, and scarlet…" (Revelation 19:11–12). A verse from Numbers bids the children of Israel add a purple strip to the fringes bordering their garments. Imitation colors rendered clothing impure, and it was forbidden to replace murex with indigo, which in its darkest shades could give the illusion of purple. Around 950 B.C., King Solomon brought artisans from Tyre to decorate the Temple of Jerusalem with precious fabrics tinted purple. Years later, the Virgin Mary was received there by the High Priest, who gave her purple wool to weave a veil for the Temple with her companions.

## PURPLE AT ITS ZENITH

The Roman and Byzantine empires raised purple to its apogee. Under the Roman Republic, the toga, a mark of citizenship, was edged with a purple band. The robes worn by triumphant soldiers were completely purple and bordered with gold, and the generals at the head of armies were clad in a *paludamentum*, a purple cloak.

Roman emperors then made the color exclusively their own. Declared *color oficialis*, purple became the symbol of political power and the prerogative of the Caesars and emperors until the end of the Byzantine Empire. Caligula (12–41 A.D.) had the king of Mauritania assassinated for dressing in a purple robe more beautiful than his own, and Nero condemned to death anyone who dared to wear imperial purple. During the second century A.D., the extraction of fluid and the dyeing of fabrics became state monopolies, and the entire production was subjected to strict conventions. Public officials were appointed to every province to verify the implementation of procedures and to

*The people of Pre-Columbian America exploited the tinctorial properties of a different species of murex mollusks. Unlike those in the Mediterranean Sea, it was much easier to extract colorant from this variety. By simply rubbing the shell on a rock, the mollusk exuded the milky foam containing the pigment. Fabrics immersed in this liquid quickly turned purple. Paris, Musée du Quai Branly.*

organize the distribution of material. In this era, purple even reached distant Chinas. In Chinese culture, colors had always indicated precise rankings in the court and, based on an ancient and complex series of relationships, they were closely linked to a complete religious and philosophical system. Violet seems to have been added to the spectrum considered socially acceptable at the end of the Han dynasty, in the early third century A.D. In addition, the color violet was perceived as the unity transcending the duality of yin and yang and therefore symbolized in painting the ultimate harmony of the universe.

## BYZANTINE PURPLE

While the West moved away from purple as it entered the medieval era, the Byzantine Empire maintained its use for several more centuries. Under Emperor Justinian (482–565 A.D.), textiles intended for the court and as diplomatic gifts—and even the parchment used for official documents and illuminated gospels—were dyed purple. But it was the color's swan song. Extraction and dyeing techniques slowly sank into oblivion here as well as in the Islamic lands, where purple had also been used from the very beginning of the Muslim era (although without arousing the same fascination). The color violet was rarely mentioned in texts, except in language borrowed from the Persian, and according to certain authors, it may have even been referred to as a "dead color," that is to say, a lusterless color used as a base.

*This young Japanese woman wears a violet costume, typical of the Heian period (794–1185 A.D.), on the occasion of a holiday at the imperial palace in Kyoto. In fact, the color violet was introduced into Japanese dyeing and painting techniques during the Heian era. They extracted it from the* murasaki *root, a variety of yellow alkanet. This plant was first used to color kimonos deep violet; then painters discovered how to develop a lac from it and thereby enlarged their palettes.*

## THE DECLINE

The ancient formulas for purple were permanently lost by the ninth century, and it was not until the very beginning of the twentieth century that people discovered the chemical structure of purple and the methods of dyeing. While the word "purple" survived in Western texts, from then on it referred to a caliber of fabric, at times quite modest, a sign that imperial purple had been completely forgotten. Similarly, in the language of heraldry, "purple" indicated a rarely used

Textiles dyed purple were an imperial prerogative in Byzantium. Emperors also reserved the privilege of commissioning rare manuscripts—and, above all, Gospels—to be created on purple-tinted parchment. These works may have originated in ateliers in the eastern provinces of the Byzantine world: Syria, Palestine, and Mesopotamia. Several volumes dating from the sixth century A.D. have survived to our day. Some were embellished with scenes taken from the Old and New Testaments. This example, from the Gospel according to St. Luke, dates from the eighth century. Composed in large capital letters, the gold text stands out against the purple-blue background of the parchment. Vienna, Kunsthistorisches Museum.

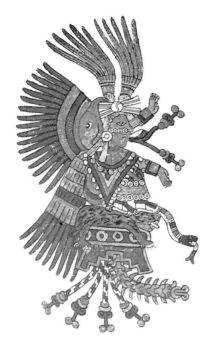

color of gray or black undertones, and only specified a violet shade again in the fifteenth century. At that time, Pope Paul II (1417–1471) decreed that cardinals would wear purple—in emulation of Roman and Byzantine emperors—but it was cochineal insects and kermes that provided the violet from that point on, although inevitably they had an orangish cast. Today in the Roman Catholic Church, the majesty of purple is still reserved for cardinals.

## THE OTHER PURPLES

The peoples of the Mediterranean were not the only ones to have exploited the tinting properties of marine fauna. In western Polynesia, islanders availed themselves of sea urchins to color bark cloth lavender blue and purple. In Guatemala, they extracted juice from the *Purpura patula* mollusk, which can be found on the coasts of Costa Rica and Nicaragua. The Maya particularly appreciated this colorant. The violet tint made the fabrics highly valuable, and they were used for feast days and days of prayer, as well as for the vestments worn by members of different religious brotherhoods. Later on, purple played a role for the Aztecs who settled on the Mexican plains. The colors used to paint ideograms in their codices also contained semantic values. The pictogram for a human being indicated more precisely if the person was female if it was drawn with the color yellow, and oddly enough, here as elsewhere, the color purple signified royalty.

*The Aztecs extracted purple from a shellfish called the widemouth rocksnail (Purpura patula) to dye their textiles and paint their manuscripts (pictured here, the tenth-century Codex Borbonicus). The rocksnail particularly provided the color for the depiction of the chiefs' finery, while the bodies of several priests were entirely represented in purple-violet hues. Paris, Bibliothèque de l'Assemblée Nationale.*

# VIOLET TEXTILES MADE WITHOUT MUREX

## MEDIEVAL EUROPE: VIOLETS BASED ON MADDER, KERMES, AND ORSEILLE

Although purple fell into oblivion, Medieval Europe did not deprive itself of violet textiles for long. The simplest method was to blend or add red tones (made from the madder plant or kermes insects) to blue tones (pigments made of woad), an approach used since ancient Egypt. But, to the medieval mind, violet was not a combination of red and blue but of red and black. Above all, the medieval Christian West approached colors with a significant philosophical handicap based on religious beliefs. Mixing colors was perceived as diabolical and was therefore prohibited. Moreover, the dyer's craft was strictly compartmentalized by corporatist rules, and the workshops that had mastered red dyes and those that worked with blue were kept separate.

By treating dye baths with mordant, madder and kermes had long been used to produce violet tones, which is the reason why medieval violets lean more toward red than blue. For domestic dyes, they also used blackberries and other red fruit, sap from dyer's croton (a Mediterranean shrub), and various lichens. Among the latter, orseille (*Roccella tinctoria*), a reddish-brown lichen gathered from the rocky coasts of the Mediterranean, was the most popular. Orseille was a common dye for the ancient Akkadians, Hebrews, and the Greeks, and Ottoman artisans colored many textiles with it. However, it was only effective when combined with ammonia, and was usually prepared with urine, if possible from a male source since urine from a female was perceived as harmful, according to some formulas.

*The German painter Konrad Witz (c. 1400–1447) evoked the magnificence of ancient purple fabrics in his painting* The Emperor Augustus Caesar and the Sybil. *Dijon, France, Musée des Beaux-Arts.*

These substances produced a lovely purple-blue-red tint, but it was not resistant to age and repeated washing. Their fraudulent use in the place of costly kermes was severely punished during the Middle Ages. Dyeing with orseille, however, experienced a brief boom in the mid-nineteenth century when a dyer in Lyon, France, discovered a

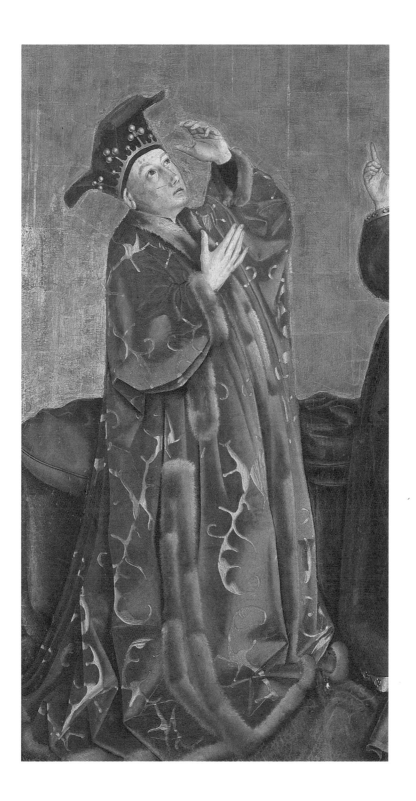

process for preparing a durable orseille color, thereby making it more commercial and, above all, finally producing colorfast violets. Sold under the name "French purple," it failed to achieve a wide success. Indeed they searched keenly in this era for violet dyestuffs that could color the large quantity of fabric needed for half-mourning dress, as the importation of logwood was not sufficient and dyers were not able to correctly set violets made from alkanet plants. But shortly after the discovery of French purple, the first synthetic colorant was invented: mauveine (or aniline purple), made from coal tar. Orseille would continue to be used, however, as an alimentary and pharmaceutical dye until 1977, when it was banned for its toxic side effects.

# VIOLETS IN ART

Kalasha women and young girls in Afghanistan make themselves up for the Feast of Flowers by drawing thick violet circles around their eyes. Today they apply cosmetics, but in the past, they would have used a powder made of ground partridge leg. This method, however, was quite uncommon. Most violets used in painting were based on minerals or lacs extracted from dye-producing plants.

## MINERAL-BASED VIOLETS: MAINLY MANGANESE AND HEMATITE

### MANGANESE

From prehistoric times, artists have taken violet pigments from nature, and manganese, a light-gray metal, was among the first to have been used. Artists could obtain shades of purple-blue pigments by grinding

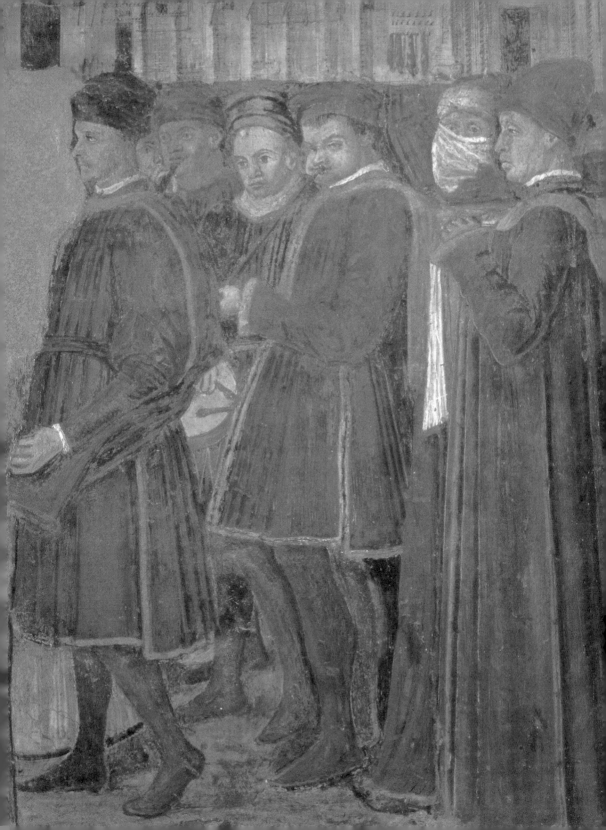

it. You can find it in many rock paintings, most notably the ones in Pech-Merle, France, which date back 20,000 years.

Prehistory was a great period for manganese. In this era, our ancestors seem to have preferred its deep violet hues to black ones made from wood charcoal. They grated or crushed the mineral and blended it with water or fat for their cave paintings. They then applied it with their fingers, with a stencil, or with the help of a brush made of animal bristles. The use of natural manganese "pencils" in the Paleolithic era has been amply demonstrated, as archaeologists have recovered fragments from numerous sites inhabited by Neanderthals, particularly in the south of France and in Israel. The discovery of pointed, scraped, or incised remains suggests that manganese was also used for body painting or decorating animal hides. Later on, it was only used selectively in art, for example, by eighteenth-century painters working with Rumanian glass and basing their broad palette of violets on the mineral. Many people outside Europe also relied on this natural violet. In Australia, the Arunda tribe used it for body decoration. They applied manganese to the shoulders and chest, after first coating the skin with fat to help the mineral adhere and to give the finished design a pearly gray tone. Although the Arunda possess an ample vocabulary that allows them to distinguish between multiple skin tones, they designate this tint with the same word that refers to black and to various shades of brown.

The Hopi people of Arizona used manganese to decorate their ritual objects. They chewed the pigment to make a paste and, to increase the amount of saliva, they simultaneously chewed a particular variety of melon seeds. Only those seeds bearing a little black fleck were chosen, for this mark was supposed to create an affinity between the seed and the pigment.

HEMATITE

The other common violet mineral pigment used since prehistory is hematite—also known as "sanguine"—a red iron oxide that yields a purple hue when roughly crushed.

*Painted about 1000 B.C., these silhouettes were made by Neolithic people on rock walls in the Lake Nakuru region of Kenya. They used hematite (a black rock containing iron oxide), which reveals violet undertones when reduced to a coarse powder. Hematite had already been used in the oldest known rock paintings, Paleolithic sites in southern France and northern Spain dating around 40,000 B.C.*

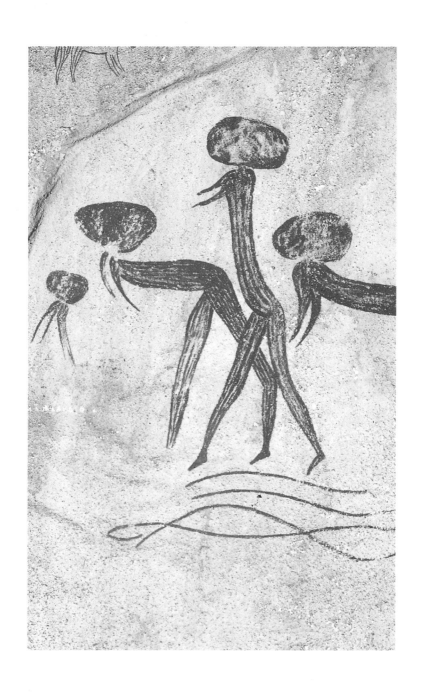

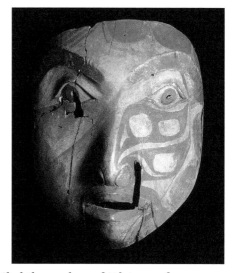

Paleolithic and Neolithic peoples found raw hematite in outcroppings and did not need to mine it. During antiquity, hematite was very much in vogue, particularly for wall paintings. Its name dates from this era, derived from the Greek word for blood. In a powder or stick form, hematite was used in the Middle Ages to outline preparatory drawings for frescoes. Leonardo da Vinci (1452–1519) and the artists of the Renaissance availed themselves of it later on for nude studies and for portraits. By the eighteenth century, its use was widespread throughout Western art.

*This mask was worn during rituals of the Yakutat people, one of the tribes of the Tlingit nation who reside in the southeastern coastal region of Alaska. By the nineteenth century, the Tlingit had developed extremely elaborate masks incarnating totemic ancestors like the beaver, duck, raven, salmon, owl, etc. Guardians of tribal memory and order, the masks were used by shamans in ceremonies celebrating the origin of the people. The violet color on this example could have been created by a base coat of manganese oxide applied on the wood, or perhaps a dye of mulberry or blackberry juice. Princeton, New Jersey, Museum of Natural History.*

## PLANT-BASED VIOLETS: INDIGO, MADDER, AND ORSEILLE

Painters in the ancient world made good use of indigo's purple-blue tints by crushing the blocks and using the powder like a pigment. They also prepared violets by combining azurite and Egyptian blue with red ocher or with madder lake, thereby creating a whole range of colors.

Medieval European illuminators also took advantage of indigo's violet tonalities, and used lacs as well, particularly ones extracted from orseille and bound with albumen or gum arabic. In addition, medieval painting guilds sometimes referred to violets derived from a mysterious plant source, which they named *folium.* For most of the Middle Ages, violet hues were essentially used in compositions to shade other colors. From the beginning of the fifteenth century, red plant glazes (madder, brazilwood) were combined with blues based on lapis lazuli, azurite, and indigo to increase the number of violet tints. The path was then opened up for the rich color palette of the Renaissance.

# THE USES OF VIOLET

# LOGWOOD
## *Haematoxylon campechianum* L.

NATIVE TO THE NORTHERN PART OF SOUTH AMERICA AND TO CENTRAL AMERICA, PARTICULARLY THE YUCATÁN PENINSULA, THE LOGWOOD TREE BEARS YELLOW FLOWERS AND CAN GROW UP TO FORTY-FIVE FEET HIGH. IT WAS LATER INTRODUCED TO THE ANTILLES, BRAZIL, AND THE WEST INDIES. THE PRINCIPAL DYE (HEMATOXYLIN) RESIDES IN THE HEARTWOOD FOUND IN THE TREE TRUNK AND MAIN BRANCHES.

THE LATIN TAXONOMIC NAME FOR THIS SUBSTANCE COMES FROM THE GREEK ("HAEMA" FOR "BLOOD" AND "XYLON" MEANING "WOOD"), FOR THE FRESHLY CUT WOOD TAKES ON A RED COLORATION. LOGWOOD MAY BE HARVESTED WHEN THE TREE REACHES TWELVE YEARS OLD. ITS WEALTH OF TANNINS HAS LONG MADE IT AN IMPORTANT COMPONENT IN THE CREATION OF BLACK DYES.

The logwood tree was used by the Aztecs in the pre-Columbian era. The French owe their name for the tree, campeche, to the Spaniards who, at the Bay of Campeche in the Gulf of Mexico, filled ships bound for Europe with logwood timber. The heartwood, the essential part of the logwood tree, was full of possibilities and, indeed, depending on the metallic salts used for the mordant, it revealed a variety of dye colors ranging from blue (made with a copper mordant, hence the name "blue wood") to gray to black (made with iron, called "black wood") and extending through violet (made with alum), purple (with zinc), and red (with tin).

According to some ancient texts, logwood was the source of that still-mysterious shade known as "prune de monsieur." From the seventeenth century on, the Spanish, English, Dutch, and French competed with each other to establish large colonial plantations. The export of the timber to European dyeworks was on such a massive scale that it imperiled the woad pigment industry in Europe, but it quickly became apparent that colors obtained from logwood were not very resistant to sunlight and washings.

## INSTRUCTIONS

Logwood is available commercially in the convenient form of coarse sawdust.

Pour one liter of scalding—not boiling—water over 300 grams of the sawdust. Set aside. Prepare the mordant bath by dissolving 200 grams of alum in 10 liters of water in an enamel pot. Add the fibers and boil.

Let the wood paste and the fiber bath both rest overnight.

The next day, remove the fibers from the mordant bath, wring them, and empty the pot. Filter the wood paste. Keep the sawdust, as it can be reused once it has dried (with half the amount of fibers). Pour the filtered tint into an enamel pot and add enough water to make a total of 10 liters of liquid. Next add the fibers. Bring the pot slowly to a boil and maintain for 45 minutes.

Let the fibers cool in the bath, then rinse them with vinegar.

However, one tint was found to be stable—black—and it formed the basis of the wood's enormous success. Beginning in the sixteenth century, Western Europe experienced a growing craze for black clothing, which affected both religious and secular attire. In the nineteenth century, everyone wore black, from the dandy to the judge, from the young widow to the parson. First the small craft workshops and eventually the large-scale dyeing industries were, therefore, keen to discover some efficient product that would allow them to color fabrics by the ton.

Complex formulas were invented, combining logwood with sumac, fustet, birch, indigo, etc. Based on the high potency of the tannins in the logwood, the mixtures generated deep and resistant true blacks that worked on wool, silk, and even cotton. One of the recipes called for twenty-two ingredients, including a series of useless, even toxic (particularly the orpiment) organic and inorganic elements.

Logwood's reign was slowly weakened by the rise of chemical dyes, but they only succeeded in dethroning it at the end of World War II. Logwood is still used today to color nylon.

# ALKANET
*Alkanna tinctoria*

NO MORE THAN TWENTY-EIGH INCHES HIGH, THE ALKANET PLANT BEARS BLUE FLOWERS AND HAS A HAIRY STALK AND LEAVES. ITS NAME PROBABLY DERIVES FROM THE ARABIC "AL-HENNEH" ("HENNA"), NO DOUBT BECAUSE OF THE CONFUSION BETWEEN THE TWO PLANTS, WHICH ARE BOTH USED IN DYEING AND IN COSMETICS. ALKANET IS ALSO KNOWN AS DYER'S BUGLOSS FOR ITS OX-TONGUE-SHAPED LEAVES ("BOUS" FOR "CATTLE" AND "GLOSSA" FOR "TONGUE"). IT GROWS WILD IN ARID MEDITERRANEAN AREAS, AND WAS CULTIVATED UNTIL THE END OF THE NINETEENTH CENTURY IN THE SOUTH OF GERMANY AND IN HUNGARY. A RELATED SPECIES, ONOSMA (ONOSMA ECHIOIDES L.) CAN BE FOUND EVEN IN SIBERIA WHILE THE MURASAKI VARIETY (LITHOSPERMUM ERYTHRORHIZON) IS COMMON IN JAPAN.

Alkanet has been used since classical times in the Mediterranean world, particularly in Greece and Persia. The plant gained importance during the Roman Empire because it was sought out as a substitute for purple. However, people everywhere tried to improve the tint's fragility, as it was not resistant to sunlight and laundering.

Discovered in 1828, an Egyptian third-century A.D. papyrus from the tomb of a follower of the occult sciences lists a series of formulas for extracting more stable violets from alkanet. The document advises dissolving the root in a blend of nut oil and water, and points to camel urine as a better adjuvant to fix the color. If the dyer desired paler tones, on the other hand, the papyrus suggested cooking the root with wild cucumber, colocynth, and hellebore. The Gauls used fresh or dried roots for their dyeing. Pliny the Elder (23–79 A.D.) described them as follows: "They are as thick as a finger, separated into leaves like the papyrus, color the hands blood red, and provide rich colors for wool." In Japan they use a local variety of alkanet, adding ashes or vinegar to the dye bath in order to obtain a wide range of violet tones.

Apart from its use as a dye, alkanet also played a role in the development of cosmetics during antiquity, for its pigments blended easily with the lubricants and oils used as the foundation of unguents. Wealthy Romans owe their scarlet lips and rosy cheeks to the plant.

# INSTRUCTIONS

The colorants are contained in the plant's roots. You can collect them before or after florescence, in the springtime or in autumn. They contain a very powerful pigment (alkanin), which yields a variety of tints ranging from red to blue. Unfortunately, it is not soluble in water, but it is possible to dye with alkanet by using alcohol at 35° C (95° F). You can produce beautiful but transitory violets on fibers mordanted with alum.

Dissolve 200 grams of alum in an enamel pot with 10 liters of water, add the fibers, and boil. Let the fibers cool in the mordant bath overnight. The next day, remove the fibers, wring them out, and empty the pot. Fill it with 8 liters of alcohol. Add 500 grams of alkanet roots, crushed carefully. Immerse the fibers and heat; monitor closely so the alcohol maintains a temperature of 40° C (104° F). Ventilate the room, because the process generates a foul odor. After an hour, remove the fibers, rinse them in clear water and let them dry in the shade.

Today in Arabic lands, alkanet still remains an ingredient in lipstick. The salve is presented in a little stoneware bowl, and women dab at it with their fingertips, then apply it to their lips. They call it "Fez red." Europe forgot alkanet during the Middle Ages, but it resurged in the eighteenth century as a dye for calico. However, the issue of the dye's delicacy was never resolved, and the textile industry eventually abandoned it even before synthetic colorant substitutes were developed. Alkanet continued to be used for some time as an alimentary, cosmetic, and pharmaceutical tint, but it was rejected here as well when people realized that it had disturbing side effects.

# brambles
*Rubus sp.*

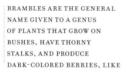

BRAMBLES ARE THE GENERAL NAME GIVEN TO A GENUS OF PLANTS THAT GROW ON BUSHES, HAVE THORNY STALKS, AND PRODUCE DARK-COLORED BERRIES, LIKE BLACKBERRIES. BRAMBLES GROW SPONTANEOUSLY IN THE WILD AND IN GLADES ACROSS THE TEMPERATE REGION. THE RUBUS TYPE CONSISTS OF OVER TWO THOUSAND VARIETIES. BRAMBLES CAN EVEN BE FOUND IN THE ARCTIC TUNDRA, WHERE THE LAPPS USE RUBUS CHAMAEMORUS, A SPECIES RESISTANT TO THE REGION'S DEEP WINTERS.

During prehistoric times, brambles constituted a significant contribution to nourishment. The nostalgic myth of the golden age evokes a world where wild animals are peaceful and brambles yield honey. Dyeing with blackberries and mulberries was probably practiced from Neolithic times, but no traces have survived today. On the other hand, Egyptian papyruses dating from the beginning of the first millennium A.D. mention combining berries with crushed green grapes to obtain purplish tones.

In the West, Pliny the Elder recounted that the Gauls used blueberries, bilberries, and huckleberries to tint slaves' clothing violet. The chronicler added: "It was a purple which they harvested without moving and on the earth firm like cereal grains." Actually, compared to murex, harvesting berries seemed quite easy. But unlike dyes derived from murex, tints made with blackberries and other red fruit resisted neither sunlight nor washing. No longer motivated by the desire to imitate purple, the people of the Middle Ages only used brambles for domestic dyeing. During the Renaissance, however, they were included in the first treatise of dyeing aimed at professionals, which appeared in Venice in 1548.

RUBUS FRUTICOSUS L.
Die Brombeere

Thanks to the English, who visited the Ottoman Empire at the end of the seventeenth century, we know that blackberries and other red fruit were used to dye wool for rugs and many fabrics. On the other side of the world, the Inuit of the polar regions of North America harvested berries, the juice of which not only colored textiles but also stained the wood of their ritual masks. Among the Tlingit people of North America, it is used mainly to color the wool thread used in their embroidery. Blackberries and mulberries formed the basis of the still-vibrant tint of many of the ancient designs, while those made with modern dyes have turned a yellowish brown.

# INSTRUCTIONS

Use blackberries and mulberries harvested at the end of summer, when they are solidly black, or you can buy the frozen variety, which yield the same result as fresh berries. Wear gloves, as the berries can stain. Carefully crush a kilo of the berries in a large bowl until you have a fine puree. Thin it out with water and add two cups of lemon juice. Set aside. Dissolve 200 grams of alum in an enamel pot holding 10 liters of water, add the fibers, and boil. Let the pot of fibers and the bowl of berries both rest overnight. The next day, remove the fibers, wring them, and empty the mordant bath. Filter the berry solution to eliminate any small bits that could spot the textiles. Put the filtered berry juice in an enamel pot and add enough water to make a total of about 10 liters. Add the fibers to the dye bath. Put the pot on the stove. Slowly increase the temperature while constantly stirring. When the liquid boils, maintain the boil for an hour and a half while stirring regularly. Turn off the heat and let the textiles rest in the pot until it cools. Finally, take out the textiles, wring them, wash them with a bit of castile soap (olive oil soap), rinse them carefully, and set them to dry in the shade.

The fibers will acquire purple-blue-pink tones, which sometimes have a tendency to turn gray over time and with washings.

*The man bent over his guitar,*
*A shearsman of sorts. The day was green.*

*They said, "You have a blue guitar,*
*You do not play things as they are."*

*The man replied, "Things as they are*
*Are changed upon the blue guitar."*

Wallace Stevens (1879–1955),
"The Man with the Blue Guitar"

# BLUE

Over three billion years ago, the first creatures arose in the aquatic depths of the primitive world. Among them were microscopic algae filled with all the colors that would one day light up the earth. Slowly they refined the free oxygen in the atmosphere and opened the way for the plants that would follow. They created the conditions conducive to the appearance of new forms of life and, for the first time, these single-cell organisms developed pigmentary color. It was blue, and these algae are called "blue-green algae."

Greek mythology tells how the color of the sea was created by the undulations of the long azure tresses belonging to the young ocean nymphs—the Nereids.

*The West has long propagated a romantic image of the Tuareg, who were known as "the blue men of the desert" because the indigo-dyed fabrics they wore ran onto their skin and stained them blue. Indigo is at the heart of their rituals and ceremonies, stretching from birth to death. Sometimes a woman will rub her mouth with a corner of her veil to make her lips blue. This fascination with the "blue men" has often obscured a painful history marked by war, famine, misery, and oppression, where they have been the victims—a cruel irony for a group who call themselves the Imashaghen, an Arabic term denoting "the free people."*

# A BLUe PLaNeT?

And yet, for the ancient Greeks, the sea was green or "wine-dark," and they had no term to refer to the blue sky. The color blue does not figure either in Homeric poetry or the philosopher Theophrastus' (c. 372–287 B.C.) treatise devoted to colorants, powders, makeup, roots, and tinctorial essences. Nor is there an expression in the Old Testament to designate what we could call blue. The same applies to a number of languages that refer to blue as a pale black or a dark green. The Maori refer to the sky according to the kinds of clouds it has, and they have an ample vocabulary at their disposal to describe them. When the sky is clear, they use a phrase like: "It is a good day." And to describe the ocean depths, they call the sea "dirty gray" or "blue-black." In the Mayan ruins at Cobra on Mexico's Yucatán Peninsula, waterfalls depicted in the murals are represented in turquoise blue, but the water appears black. The blue backgrounds characterize exterior views. The Aztecs believe that the color is an attribute of the water goddess. In their codices, blue also indicates the direction south. In medieval European imagery, the seas were green, and it was only after the fifteenth century that the West began to depict the ocean—and water in general—with the color blue.

# WHere BLUe is rare!

Nature provides a profusion of yellow, red, brown, and black colors and pigments, but she is much less generous with substances that create blue shades. Until the invention of synthetic colors, people only had access to a few pigments and some rare dye plants that could express the color. Blue played no role in prehistoric rock paintings and was traditionally much less common than white, yellow, red, and black in ceremonial rituals. But because it was rare, it was sometimes even more prized.

*Eugène Delacroix painted this* Study of a Cloudy Sky *in 1825. The following year, the German chemist Unverborden accidentally extracted a pure form of indigo by heating it. A few years later, this basic material (indican) helped to create the first artificial colorant, mauveine, thereby paving the way for the production of synthetic colors. Paris, Musée du Louvre, Department of Graphic Arts.*

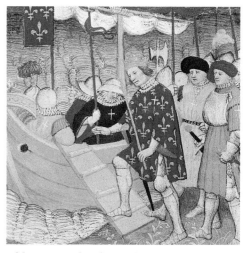

*Created in fifteenth-century France, this miniature adorns Le livre du trésor des histoires (The Book of the Treasure of Histories) and illustrates the embarkation of French king St. Louis (Louis IX) for the Crusades. For centuries, people believed the sea was green, and artists depicted it that way. Paris, Musée du Louvre, Department of Graphic Arts.*

*Opposite page: The vibrant blue toga worn by the angel in this medieval Byzantine Trinity was probably painted with lapis lazuli. Imported from Afghanistan, the finely crushed rock provided an intense blue hue. Although artists of the Near East were the first to use it in painting, lapis was also found in some particularly magnificent Byzantine mosaics dating from the tenth to the twelfth century A.D., in which fragments of it nestle next to minuscule gold, silver, and semiprecious stone tesserae applied to a wax background. Moscow, Tretyakov Gallery.*

This was the case, for example, for the Ainu people who live on Hokkaido, an island in the north of Japan. Men and women adorned themselves with ropes of wooden and bone beads; they sometimes added glass ones, which they acquired in exchange for provisions. Blue beads were particularly desirable, because this color was not available from resources in their own environment. The same problem existed in Australia. When several rock paintings containing shades of blue were discovered in the northern part of the Kimberley, the surprise was great indeed. Blue stones were found near the location of the works, but tests revealed that they consisted of glaucony, a green mineral. The artist had reduced the stone to powder, then blended it with water to give the rock surface a pale blue tint.

The quest for blue sometimes required great effort and ingenuity. For the Cheyenne of Colorado, blue symbolized the earth, the source of all life. The (unfortunately unidentified) blue pigment they used to paint their suede tunics was, therefore, invested with a sacred importance, and they traveled far to collect it from a secret spot in the plains of the Northwest. Cree women adorned clothing with porcupine quills tinted blue with duck excrement.

The search for the color blue also extended to body painting and tattooing, and people found substances and developed techniques that would allow them to sport the shade. The Polynesians of the Samoan islands created deep blue tattooing colors from soot derived from burning the oily kernels in the fruit of the oil palm tree. One after the other, the seeds were slipped onto a cord and placed in a stone cavity. They were then set aflame, like a torch. The fire generated a very black, oily smoke that settled on the stone, where it was collected with a banana leaf and stored in a seashell. The tattooer coated his tools with

this soot before piercing the skin and depositing the pigment in the epidermis. The Maori covered themselves with a bluish clay gathered from lagoons; it also served as a soap.

# BLUE PIGMENTS

Although yellow-, red-, and brown-colored ochers and earth pigments were plentiful and could be used almost without preparatory effort, the two principal blue pigments provided by nature—azurite and lapis lazuli—were concentrated in only a few locations and required extensive crushing and cleaning. The other blue pigments (especially Egyptian blue and smalt) that played a role in the history of art before modern chemical breakthroughs were created by humans.

## LAPIS LAZULI, OR BLUE IN ALL ITS GLORY

*Opposite: The Ndebele people of South Africa developed a unique tradition of mural decoration. The geometric forms are borrowed from the repertoire of bead designs woven by women over the centuries. It is also the women's role to embellish the facades of their homes. Using very stylized symbols, they record upon the walls the events that mark their own lives, the lives of their families, and their villages. Until World War II, the colors were based on plants and minerals, except for blue, which was often derived from blue laundry detergent meant for "whitening" linens.*

In the ninth century B.C., the ancient Assyrians used a blue in their frescoes derived from cobalt, a substance afterward limited to glass-making. Lapis lazuli, a semiprecious stone, the main mine deposits of which are located in Afghanistan, reigned for many years as the king of blue pigments. However, the use of lapis lazuli as a pigment during antiquity remained the exception, and Afghan painters appear to have been the first to crush the stone around the fifth century A.D. India imported it by caravan and, beginning at this time, the pigment form of lapis was used regionally as far as Tibet. Arab painters worked with it as well. The Venetians imported lapis lazuli to Europe in the Middle Ages. For artists, lapis became the most beautiful—and the most expensive—color in their palette. They called it *ultramarinus* ("coming from beyond the sea"), hence "ultramarine," in contrast to azurite, known in days of old as *azzurro citramarino* ("a blue from this side of the sea"). The stone was finely ground and sometimes mixed with ox bile. Cennino Cennini suggested conferring this fastidious

and precise labor to women, for they were more constant than men, but he recommended avoiding old women. (Were they more distracted?) In illuminations and medieval manuscripts, the areas painted with lapis lazuli often reveal a slightly granular appearance. Depending on their position, the different-sized particles reflect the light in different directions, giving the pigment an incomparable luminosity. Beginning in the twelfth century, a technique was developed to eliminate the rock's impurities, and from then on, ultramarine came in a more malleable paste containing plaster, resins, oil, and wax. This precious pigment was reserved for painting the Virgin Mary's gown, and the amount to be used was specified clearly in contracts between the artist and the sponsor of the art work.

## Manufactured Blues

### EGYPTIAN BLUE, THE FIRST SYNTHETIC PIGMENT

Although Egypt did not have its own lapis lazuli deposits, they imported it for decorative work beginning in the pre-dynastic era (prior to 3100 B.C.). Lapis inlays adorned the eyelids of the funerary mask in the sarcophagus of Tutankhamun. Egyptians did not depend much on lapis lazuli as a pigment, but their search for natural and artificial alternatives to the precious stone led to the creation of what was known as "Egyptian blue" around 2500 B.C. It is the oldest synthetic pigment, and was made by pulverizing glass fired with copper shavings. This material enlarged their palette of blue and green shades, allowing them to represent the colors of the Nile, their venerated river, with accuracy. By grinding it very finely, they also created blue ink. Egyptian blue was exported to Rome during the imperial era and was used by painters

*Following spread: Eugène Delacroix created this work, Night, or the Flood, using artist's pastels, which were fabricated by mixing a base of thick aqueous paste of white pigment (like lead white, for example) with a glue (in olden days, it was an oatmeal mush) and the actual pigment color. The resulting paste was then molded into a stick and dried. Delacroix could have used blue pastels made of azurite or even of Prussian blue, a synthetic pigment accidentally discovered by two chemists at the very start of the eighteenth century. Paris, Musée du Louvre, Department of Graphic Arts.*

for murals in the most beautiful palaces. Traces can also be found in portraits from Fayum. During this period, it was called "coeruleum blue," "vestorian blue," and "Roman blue" (the old name for "Pompeian blue"). The use of Egyptian blue fell into oblivion by the tenth century A.D., and only recently have scientists discovered the exact nature of this mythic pigment.

SMALT AND OTHER SUBSTITUTES

When Egyptian blue disappeared, painters only had azurite and lapis lazuli available to them until the sixteenth century. At that time, the development of smalt, a blue pigment based on cobalt, replaced the costly lapis in preliminary sketches. Smalt imparted a transparent blue color, with a more purplish tone than lapis lazuli. Many of the skies depicted in seventeenth-century European painting were created by smalt. But it was crushed glass and therefore difficult to handle. Moreover, it was not stable in oil paint. As a result, when chemists discovered the synthetic pigment Prussian blue at the very beginning of the eighteenth century, it was enthusiastically welcomed by painters and quickly replaced smalt and lapis lazuli. But in 1828, Jean-Baptiste Guimet (1795–1871) discovered how to reproduce the magnificent lapis lazuli artificially. This product became enormously successful, especially in the chemical industry, and it was distributed all over the world in the form of blue balls of laundry detergent, meant to give linens a bluish tint so that they would appear whiter. Through some unexpected detours, this laundry bluing returned to the artists' realm in the course of the nineteenth century. In Africa, people used it to color wood sculptures, especially those made by the Igbo from the eastern province of Nigeria; in the southern part of the continent, women in the Transvaal mixed it with ocher to decorate their homes in vibrant colors; and the native peoples of Canada utilized it abundantly to embellish their caribou skins.

# THE MYSTERY OF THE BLUE VATS

The perception of the color throughout the ages and around the world was often directly linked to the complex process of dyeing things blue. Whether the dye was derived from dyer's woad or from the great family of *Indigofera* (which included several hundred distinct species), indican (the actual coloring substance) was concentrated in the leaves but remained colorless until it was oxidized. This process led to more or less complicated, but always odiferous, soaking techniques until the fabric finally turned blue after being exposed to the air. There was a "gestational" aspect to blue dyeing, which played a role in determining the symbolic meaning of the color in many cultures. Poorly crafted blue dyes produced dirty, dreary colors that provoked suspicion and even a disdain that could extend from the dyed fabrics to the color itself.

## THE FIRST BLUE DYES

Neolithic people dyed textiles a lilac hue using blueberries and dwarf elderberries (a variety of elderberry). Mastery over the delicate technique of tinting with dyer's woad was also demonstrated in several areas and, in the Bronze Age, this practice was common from Norway to India.

## EGYPTIAN DYER'S WOAD AND INDIGO

In Egypt, they turned first to pigments derived from dyer's woad and then, starting in the Roman era, used indigo to color sacred cloth, but the *Papyrus Anastasi* shows how the vats used to soak the dye could be objects of aversion. This document was composed in the thirteenth century B.C. to help persuade students toward bureaucratic tasks and away from the textile arts and the repugnant use of mordants like urine: "The lot of the dyer at home is worse than any woman's. He works on his knees in the heart of things. Never does he breathe the pure air. When he does not produce enough in a day, he is beaten like

a lotus in the pond. He must give bread to the guardians just to see the light of day. The dyer's finger smells like rotten fish. His two eyes are wrecked by fatigue."

## THE ROMAN EMPIRE, INDIFFERENT TO DYER'S WOAD

In the western part of the Roman Empire, indigo was not used, although it was known, and coloring techniques based on dyer's woads and lichen were neglected or forgotten. Fabrics tinted with dyer's woad were so dingy that they devolved into work clothes for craftsmen and peasants. Rich Romans looked down on them, and their contempt extended to the color blue in general, which they considered dirty and mediocre in its light form and alarming as a dark shade, which evoked death and damnation. Wearing blue was therefore debasing. On women, it was a sign of easy virtue; on men, an effeminate or ridiculous trait.

## THE SINGULAR STATUS OF INDIGO IN INDIA

Thanks probably to knowledge of working with dyer's woad, India was able to develop a technique during antiquity for tinting with indigo, which then spread successfully throughout the Near East. But the use of indigo in India experienced a unique fate. Indian civilization, in fact, perceived anything dyed as degraded, because it was alienated from its initial state. A potent dye like indigo, even in light shades, was therefore considered a blemish by the upper-caste Brahmins. Even the craft of dyeing—and especially indigo dyeing—was considered impure, and was often practiced in isolated areas by Hindus who had converted to Islam. Indigo was also the emblematic color of the lowest caste—the Sudra, the "Untouchables"—who were also linked to the blue lapis lazuli stone. If a member of the three upper castes came into contact with indigo, even accidentally, he lost his rank. A person who, for example, walked through a field of indigo, or was cut by a branch from an indigo shrub, or ate food wrapped in an indigo-dyed cloth

*Betty Goldberg, a visual artist based in Paris, works with vegetal dyes and reappropriates traditional Japanese tinting methods for her own artworks. Composed of Japanese plant fibers, the textile pictured here was woven in a folded-resist technique, using wooden tablets and dyed by natural fermentation in an indigo vat.*

had to perform a ritual expiation in order to be reintegrated into his caste. For instance, he had to consume the five elements produced by the cow, that source of absolute purification: milk, clarified butter or ghee, curds, urine, and excrement. A woman, even one born into the Brahmin caste, is associated with the lowest caste, and unable to access Vedic knowledge. She is, therefore, theoretically not threatened by disgrace in the event of contact with indigo. But the power attributed to indigo sometimes proved an important aid: when an infant catches cold in Rajasthan, they apply a compress soaked in indigo-dyed water to his belly. Indeed, they believe that a cold comes from the northern sky, which is the direction of the Brahmins. For them, indigo represents the color of the vile and the impure, and so this practice dispels evil. Following the same logic, they attach a cotton cord dyed with indigo and threaded with blue-painted terra cotta beads to the wrists and ankles of a newborn child as protection against the evil eye.

## western africa and the passion for indigo

*Still on its loom, this Indonesian ikat is a work in progress. This specialized weaving technique is created by a reserve method, in which certain parts of the warp or the weft threads are tied up to prevent the dye (in this case, indigo) from penetrating them. Today chemical colors have tended to replace ancient dyestuffs everywhere but, on certain Indonesian islands, women valiantly perpetuate their rich tradition of dyeing with indigo plants. Their knowledge is part of a remarkably deep and complex social machinery linking the science of plants with medicinal practices.*

A beautiful Ghanaian legend recounts the birth of blue. In days of old, the sky was close to the earth and nourished humans. Everyone could grab a little piece of cloud to eat. This celestial nourishment filled the heart and gave each person who had consumed the sky the ability to float and dream, and to rediscover the peace and happiness of the time when the supreme god lived among the humans. But collecting the clouds was an arduous task, because one had to be pure of heart and mind and had to guard against becoming intoxicated with the heavens. This is what happened to Asi, who selfishly wanted the blue. One day, while in the company of her daughter, she was looking at the sky and her eyes were starved for blue. She considered the linens wrapped around her child, and their whiteness seemed devoid of life. "If I eat a little bit of the sky, maybe the blue color will saturate my skin to its innermost depths. And with a little bit of luck, my hair will turn deep blue." She devoured a big piece of sky and fainted. When she woke up from her stupor, her child was dead and, on the baby's diaper, a blue mark spread out from the spot the child had wet.

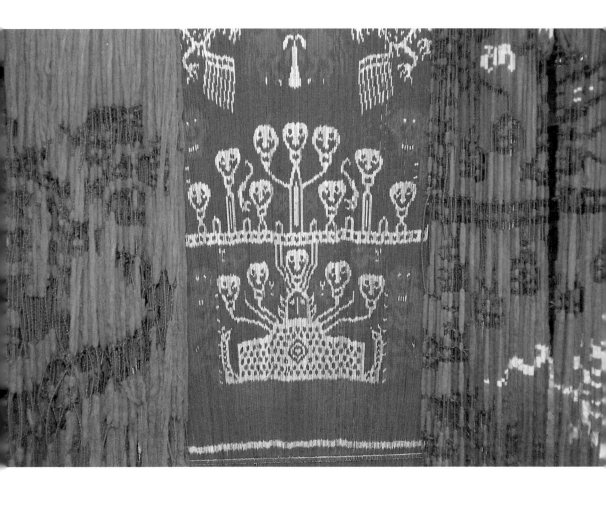

Asi covered her face and her hair with ashes. Then the water spirits spoke to her: "This stain was made from indigo and comes from the leaves you gathered to set your child on to sleep. In order for the blue to arise, you will need your daughter's urine and the ashes that you have spilled on your body. Now, sacred indigo will color the earth, but only mothers will be able to bring it into being." Asi returned to the village, learned the art of dyeing, and her daughter's spirit was incarnated a little later in a new child. Indigo descended from the sky, which separated itself from the earth, and never again could humans try to consume it. Since then, the color blue has been associated with love and maternal tenderness.

Western Africa experienced a veritable love affair with indigo blue, which was used to dye most cotton fabrics. The Tuaregs of the Sahara—"the blue men of the desert"—adore fabrics saturated with indigo and the characteristic odor of the indigo plant. Their nickname derives from the fact that the color from the indigo-dyed textiles they wore would soak into the pores of their skin until it gave them a blue tint. The clothing, therefore, was not merely an adornment but became part of their body, transformed it, and perfumed it. A Bambara myth says that the fabrics worn by men of old received the sweat of their wearers like an offering.

## INDIGO DYEING AS A CULT

East of Bali on the Indonesian island of Sumba, indigo dyeing operates like a true cult, marked with secrets, taboos, and complex rituals linked to sacred powers, prayer, the ancestral manes, and fertility. The purview of women, dyeing precisely measures out and punctuates their lives. Their participation, from sexual maturity to menopause, ends with a total mastery of the craft process and marks the completion of a vital feminine cycle. The maceration of the plants is seen as a child's suckling at his mother's bosom, and each aspect of dyeing symbolizes the joys and the sorrows women face. The journey the fabrics make between villages mimics the path that women follow when they leave their paternal homes to marry. The songs that accompany their

movements during the dyeing process tell of their unhappiness when a man leaves them or when death steals away those whom they love. The dyed cloth represents the women's mute protestation against what they perceive as injustice in their lives; it is a whisper of love.

# Blue Dread

For most Western countries, blue benefits from such a positive connotation today that it is hard for us to imagine that the color ever had a negative reputation. But in fact, it was sometimes despised and often feared.

## The Blue Fear of the Roman Empire

Not only did ancient Europe disparage dyer's woad, but it associated the color blue with the enemy—Celtic and Germanic barbarians. These peoples actually used the plant's tinctorial properties to color their skin for certain religious ceremonies. Older Germans even turned to it to darken their gray hair. Even worse, according to Caesar (100–44 B.C.) and Tacitus (c. 56–117 A.D.), the barbarians were wont to color their faces and bodies with woad before going to battle. The blue-gray tint gave the northern warriors a ghostly appearance, which terrified the Roman legions. As a final straw, these ethnic groups were blue-eyed, considered ignominious in Rome; in the theater, such features were the objects of caricature.

## The Ambivalent Blue of the Near East

For the Arabs, blue was seen as an essential color of nature, and they associated it with the element of air, with the cold, and with the eyes of northerners, the impious ones. The Koran characterizes the guilty excluded from paradise at the Last Judgment as "blue," and during certain dynasties, blue was the obligatory color worn by Jews and Christians living in Islamic territory.

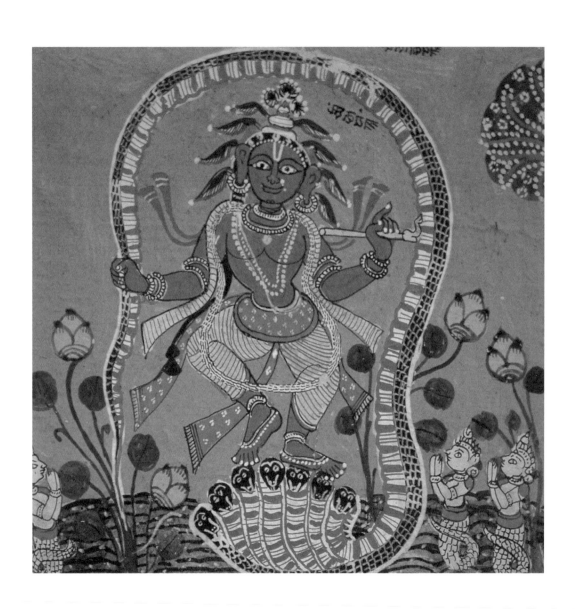

Popular sayings reflect the Muslim ambivalence vis-à-vis the color blue. In Syria, they say that a person of a devious or vindictive nature has blue bones, while a blue enemy designates a bitter adversary. For the Egyptians, a bad day is described as blue.

Furthermore, blue is often perceived as a magical color in Islamic lands and, therefore, likely to bring either misfortune or happiness. But, if they distrust blue, at the same time Muslims protect children by fastening a blue stone or some blue-colored grains of alum to their clothing or cribs. They also repel the devil with turquoise blue. In Moroccan tradition, women used a blue stone to avoid undesirable pregnancies, but the stone had to contain a characteristic black blotch and had to be living rock, which could be verified at the merchant's by pouring a little lemon juice over it. If the stone became foamy, it would be effective. Near Eastern superstitions associated with the color blue were shared by the Jews. During circumcision ceremonies in certain regions, they drew vertical and horizontal lines above and below the child's eyes with a bluish paint. This adornment emphasized their beauty and protected against the evil eye, but also symbolically called the man that the child would become to a life of modesty measured by the narrowness of his gaze.

## THE MENACING AND FEARFUL BLUE OF ASIA

The color blue was often marked by negative connotations in Asia as well. In the Mongol culture, the Buddha of the East, Akshobhya, was represented in blue to symbolize his capacity to destroy the enemies of light. For many years in Turkey and across all of Central Asia, blue was the color of mourning.

China associated the color blue with torment. Blue evoked specters, could foretell death and, in ancient times, signified an elevated social position but one attained by upheaval. Blue eyes, which brought to mind the ethnic minorities of Central Asia, were considered ugly, and a blue-eyed man was a ghost or a man of bad character. Nevertheless, as a sign of filial piety, children would offer their aged parents long blue silk coats called the "clothing of longevity."

*Krishna is the eighth incarnation of Vishnu, who conceived him by plucking a dark hair from his head to destroy the demons that troubled the earth. Ancient sources describe that his skin was as "somber and blue as a rain cloud, his eyes like the lotus, and his earrings made of precious lapis." Images of Krishna are common in the foyers of Hindu homes, and he is often represented there sporting a mischievous countenance, and in the act of playing the bansuri, the flute he uses to seduce the universe.*

## THE rejected blue of India

In India, blue is the color of abjection. It attracts misfortune and, in its darkest shades, is linked to erotic passion. The god Krishna, the ecstatic Dionysian divinity, is always painted blue and, during magical ceremonies aimed at annihilating an enemy, the officiant is covered with blue. The color is also linked to bereavement, and no tradition-bound or superstitious Hindu, whatever her caste, would dare wear a blue sari if her husband were still alive. Moreover, if a woman does put on a blue bracelet, it will be one made of plastic, for this material holds no symbolic value.

## THE funereal blue of the Amerindian peoples

*Piero della Francesca (c. 1416– 1492) painted his Madonna del Parto for the chapel of the cemetery at Santa Maria a Nomentana in Monterchi near Borgo. It was only in the course of the twelfth century that artists gradually began to portray the Virgin Mary wearing a blue mantle, and they reserved their most beautiful pigment, lapis lazuli, a semiprecious stone of incomparable brilliance, for its depiction. Monastic administrators were particularly precise in their contracts with artists, and surviving documents frequently mention the exact amount of lapis lazuli the painter had to use in the commissioned art work.*

In the Hopi culture, the color blue is linked to the west, the home of the dead. To dream of a spirit holding a blue-colored prayer feather is considered a very ill omen.

Among the Kogi people of Colombia, small seashells are placed on the deceased during cremation ceremonies, with the number of shells equal to the number of the dead person's children. Daughters are represented by bivalves and sons by gastropods, but all the shells are blue, the color of death. The point of this ritual is to prevent the deceased from calling on one of his descendants to serve him in the hereafter.

# THE Triumphant Destiny of blue in the West

We have seen how cultures perceive colors in relation to a multitude of factors. In the West, the color blue's fortune evolved from the most marked distrust to a generalized acceptance.

The disdain for blue manifested by the Roman Empire endured for many years. Throughout the Middle Ages, blue remained a belittled

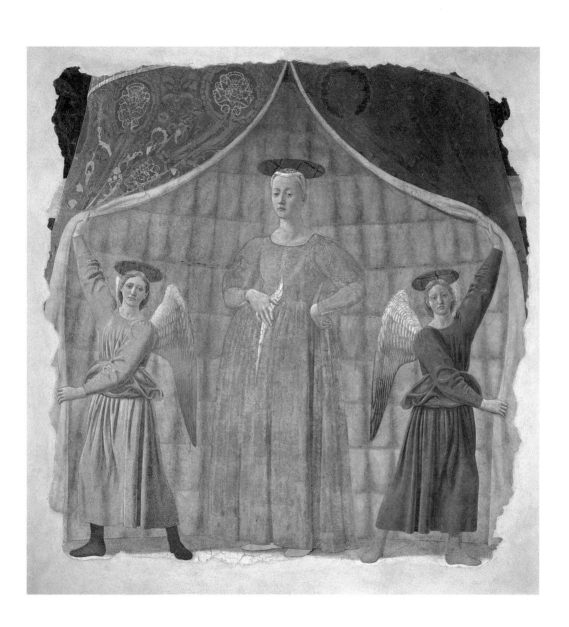

and unattractive color. Suddenly, at the beginning of the twelfth century, an evolution of taste began, driven by the growing adoration of the Virgin Mary. In this era, blue was the color of mourning, and in all the arts, from stained glass to manuscript illumination, the Virgin's somber attire was exchanged for a blue cloak. Blue pigments—azurite, indigo, and above all lapis lazuli—could be ground finer and finer and purer and purer, allowing artists to obtain lighter and more luminous tones. Validated by the Church's vision of the Virgin Mary, blue fabrics were first demanded by kings, then by aristocrats, until the desire for blue slowly spread across all society. The blossoming of blue accompanied an increased use of dyer's woad, and the tinctorial techniques progressed steadily until dyers were finally able to produce strong, solid colors. By the end of the Middle Ages, the hierarchy of colors that had reigned in Western thought was entirely reorganized, and blue now dominated. From then on, it evoked royalty and nobility, fidelity and peace. The infatuation with blue that began in the twelfth century continued through to the Renaissance and beyond. And when indigo invaded Europe in the eighteenth century, they called this rage for blue "indigomania." In the fine arts and the decorative arts, there were close to twenty distinct colors, among them midnight blue, baby blue, steel blue, sky blue, and navy blue. Since this time, blue has basically become the favorite color in Europe, the United States, and Latin America. Now perceived as a neutral and pacific color, blue brings together the world through the universality of jeans and the emblems of many international organizations: the United Nations' forces (known as the "the blue helmets"), the flag of the European Union, etc.

# THE USES OF BLUE

# azurite

AZURITE OWES ITS NAME TO THE PERSIAN WORD "LAZHUWARD," WHICH DESIGNATES BOTH THIS CUPROUS ROCK AND THE COLOR BLUE. THE PRINCIPAL MINERAL DEPOSITS WERE FOUND IN CYPRUS, ARMENIA, FRANCE, ITALY, AND ESPECIALLY, GERMANY. DEPENDING ON THE PLACE AND THE ERA, COLORS BASED ON AZURITE WERE KNOWN AS MANGANESE BLUE, BREMEN BLUE, MINERAL BLUE, OR BLUE VERDITER. IT WAS ALSO CALLED "BLUE OCHER" AND "BLUE ASHES" (SOMETIMES "SANDERS BLUE"). THE EGYPTIANS WERE THE FIRST TO USE THIS PIGMENT IN PAINTING, DURING THE FOURTH DYNASTY, AROUND 2500 B.C. THEY OFTEN DISCOVERED MALACHITE IN THE SAME DEPOSITS, FOR THE TWO MINERALS SHARE VERY SIMILAR CHEMICAL COMPOSITIONS.

The Romans imported it from Armenia and called it *lapis armenis* ("stone of Armenia"). While its use in painting remained marginal, the discovery of an optician's coffer in excavations of a second-century Gallo-Roman tomb in Lyon, France, indicates that azurite and other pigments played significant roles in the manufacture of makeup and medicine. In the Middle Ages, azurite was a key element in many manuscript illuminations, and beginning in the fifteenth century, painters combined it with indigo or lapis lazuli to achieve a full range of blues. Until the seventeenth century, azurite was used to depict skies and, thanks to its slightly greenish tint, contributed to a variety of landscapes. Furthermore, when the substance was blended with yellow pigments, it mirrored the incredible chromatic richness of vegetation.

In Asia, azurite was considered an influential and exalted mineral. Alchemists and Chinese painters used it abundantly between the third and ninth centuries A.D. Such was its importance that the art of painting was also labeled "the art of cinnabar and azurite" or "the art of red and blue." The color red was associated with blood and blue was linked to plant life, so the description reflected the pigments' prestige. When describing the vibrant décor of Buddhist temples, people today still use an expression that can be roughly translated as "red-blue," even though the buildings' chromatic range includes many other colors. Master painters purified the pulverized azurite by liberally cleaning the resulting powder in flowing water, thereby

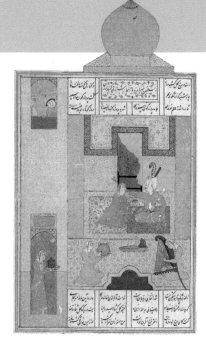

According to tradition, azurite was brought to Japan at the beginning of the seventh century by an artist monk named Doncho. Originally from present-day North Korea, Doncho also introduced the Japanese to new methods of fabricating ink, paper, and various colors. The vibrant blue tones in Tibetan Buddhist paintings were created by painters working with coarsely crushed azurite. Unfortunately, many of the areas treated in this manner have generally not survived the test of time because, in numerous artworks, the pigment has separated from the support structure.

Azurite was a typical element in thirteenth- and fourteenth-century Persian manuscript illuminations. Under the Safavids and the Mughals, Indian painters brought it in from Hungary until those deposits were exhausted. Azurite was then replaced by lapis lazuli imported from Badakhshan, in today's Tajikistan.

obtaining a fine concentrate they called *ks'ing,* meaning "the color of the kingfish." Just before the painter began to work, he would blend the azurite with a thick glue to render it opaque and heighten its brilliance.

*At the end of the twelfth century, the Persian poet Nizami (c. 1140–1209) wrote* The Seven Beauties, *which describes the tales told to the Sassanian ruler Bahram V (421–438 A.D.) by his seven wives. Each evening one wife would entertain him with a story. The princesses came from seven different lands and climates, and the sovereign built them each their own structures within the palace, each distinguished by its own color. Dating around 1550, this work by a Sefevid painter illustrates the king's visit to the Turkish pavilion. St. Petersburg, Institute of Oriental Studies.*

## INSTRUCTIONS

Buy roughly crushed azurite that you can further pulverize in a mortar, yielding a powder with a texture slightly finer than that of ground coffee. If the powder is too fine, the pigment loses its intensity. On the other hand, be careful that the particles are not too coarse before you blend them with a top-quality binder, because the grains will not adhere as well to the support structure as a fine powder. Moreover, they will be much more vulnerable to wear and tear. Azurite provides a slightly lighter blue than lapis lazuli. Unfortunately, it darkens with age. Given its steep price (around $385 for 3.5 oz.), artists usually reserve the pigment for small surfaces. It blends well with gum arabic, egg yolk (which gives it a slightly greenish tonality), and casein (mixed in a proportion of 20% to water).

# DYER'S WOAD
## *Isatis tinctoria* L.

THE WOAD PLANT RESEMBLES A LETTUCE, AND FORMS ITS SEEDS ON TALL YELLOW FLOWERS. ORIGINALLY FROM THE REGION AROUND THE BLACK SEA, WOAD PROBABLY SPREAD TO EUROPE DURING THE NEOLITHIC PERIOD, AND ITS CULTIVATION DEVELOPED IN FRANCE, ITALY, AND GERMANY IN THE MIDDLE AGES. TODAY IT GROWS WILD IN MANY PARTS OF EUROPE. APPROXIMATELY ONE TON OF WOAD LEAVES PRODUCES ABOUT FOUR POUNDS OF BLUE PIGMENT. THE BLOOM, WHICH FORMS DURING THE FERMENTATION PROCESS, IS USED TO COLOR WHITEWASH IN SOFT SHADES OF BLUE (WHICH GAVE RISE TO THE EXPRESSION "PASTEL TINT"). IN THE LAURAGAIS REGION AROUND TOULOUSE, THEY COAT THE YOKES OF CATTLE WITH IT, BECAUSE WOAD BLUE REPELS FLIES.

Dyer's woad—also known by the name "glastum"—may be considered the western cousin of indigo. Its leaves, like those of plants from the genus *Indigofera*, make it possible to dye material in resistant blue shades, which only appear after the fabrics are exposed to air. However, the coloring properties of indigo are twenty times more powerful than those of woad, which made it a formidable commercial adversary when these two sources of blue competed in history.

Dyeing with woad has been apparent since Neolithic times, particularly in the south of France. Egypt used a local variety of the plant in 1500 B.C., and we know that, around 600 B.C., the Hebrews obtained green textiles by redyeing saffron-colored yellow cloth in vats of woad. In the countries of the Far East, however, woad was quickly supplanted by indigo while, in the West, it became the emblematic plant for the people of France, Britain, and Germany throughout the Middle Ages. The word "British" even derives from the word *brith*, which means "woad" in Celtic and signifies "brindled" in Gaelic. When the fashion for blue textiles flourished in the thirteenth century, the cultivation of dyer's woad grew considerably in the German territories of Saxony and Thuringia, in England, in Spain, and above all, in the north and the south of France. In the fifteenth century, the Languedoc region exported almost forty thousand tons of woad a year to London, Antwerp, Hamburg, Rouen, Bilbao, Saint Sebastian, northern Italy, Byzantium, and Islam.

## INSTRUCTIONS

The simplest method is to buy fresh or frozen leaves. Boil 500 grams of leaves in 4 liters of water and let the temperature drop to 50° C (122° F). Stabilize the temperature for a day. When bubbles appear on the surface of the pot, add 6 grams of slaked lime and stir, maintaining a temperature of 50° C (122° F) for three hours. Next add the dampened fibers, let them soak for several minutes, then remove them, rinse them (they are green), and leave them exposed to the air until they turn blue. You may have to repeat the process until you achieve the color you desire.

Dyeing with cocagnes is too complex to be explained here. Furthermore, it involves letting the balls macerate in water or, if one is brave enough, in urine for two months. This fermentation process is pestilential.

Woad powder is a bluish-gray pigment with a disagreeable odor. Blended with water, gum arabic, or casein, it can be used on rag paper. Be careful to use very little binder (only 1 or 2%) so as not to break up the pigment and dull its color. The addition of a little bit of Meudon white will create lovely nuanced shades.

The fermentation of fresh leaves increases woad's coloring properties tenfold, and the resulting blues are much more beautiful. In order to obtain deep, rich blacks, dyers also turn to woad for the first color bath (which they call the "foot") and follow it up with a second dye based on oak gall. Above all, they use woad, in conjunction with weld, to create true greens. Starting in the sixteenth century, woad began to compete with indigo from the New World, which led to the bankruptcy of entire regions. Despite a brief burst of support in the seventeenth and early nineteenth centuries, the fate of woad was sealed in the world of textiles. It continued to be used, however, as a pigment by Western painters until the invention of Prussian blue.

Such was its success that it gave birth to the expression "the land of Cockaigne" (or "the land of plenty"). *Cocagnes* were balls shaped out of the paste derived from woad leaves, which had been crushed to a pulp by windmills and left to ferment for several weeks. Once they had dried, they kept for a long time and traveled well.

# INDIGO
## *Indigofera tinctoria* L.

THE GENUS INDIGOFERA ENCOMPASSES SEVERAL HUNDRED SPECIES. INDIGOFERA TINCTORIA L., (ALSO KNOWN AS "TRUE INDIGO") IS THE ONE MOST USED IN DYEING. IT IS A SHRUB ABOUT THREE FEET HIGH, COVERED WITH BRISTLES, AND BEARING LITTLE VIOLET FLOWERS THAT DEVELOP INTO PODS. THE TINCTORIA SPECIES GROWS IN TROPICAL ASIA, BUT YOU CAN FIND OTHER VARIETIES IN HOT CLIMATE ZONES FROM CENTRAL AMERICA TO YEMEN, PROVIDED THAT THERE IS ENOUGH WATER AVAILABLE FOR THE PLANT. THE INDIGOFERA LEAVES CONTAIN INDICAN (THE GLYCOSIDE MOLECULE THAT TURNS INTO INDIGOTIN), WHICH IS THE PRINCIPLE COLORING SUBSTANCE IN INDIGO.

Dyeing with indigo has been practiced since ancient times in every region where plants containing indigotin grow. To extract this substance, the traditional method is fermentation: the leaves are piled in a bucket with water so that they decompose. This stage is called the "indigo vat." Each culture has its own recipe, passed down from generation to generation. In Morocco, they add two fistfuls of dried figs, dates, or sugar, wood ash, and quicklime, and the dyers consider the fermentation complete when a characteristic odor emanates from the vats. The Ersari, a tribe of the Turkmen people of Central Asia, use sour wheat flour and sheep or cow bone marrow. Until the 1950s in Europe, urine was the adjuvant to tint wool blue. The treatment of indigo with sulfuric acid has been practiced in Anatolia since the seventh century, exploiting their natural resources of sulfur.

Once the dyeing is finished, it is possible to give the fabric a lustrous appearance by pounding it with a wood block. This is done in Vietnam and also by the Hausa of Nigeria, who beat the fabric for two days. The material is so saturated with indigo crystals that it emits a metallic sound. Indigo dyeing is often practiced by women. In the Yoruba culture of Nigeria and Benin, dyeing is associated with the cult of the divinity named Ita Mapo, who protects the world of women and their activities, such as pottery, the pressing of oil, and the fabrication of soap. Every forty days, the women interrupt their dyeing to make offerings of bean, corn,

and coffee berry dishes, presented during ceremonies in which they sing and dance in honor of the god. Throughout all of Asia, indigo dyeing is accompanied by warnings: menstruating and pregnant woman are not allowed to interfere with the procedure. In Laos, they also fear the presence of monks. The science of plant dyes and of medicinal plants has long been linked, and certain dyes confer protective features upon the garments they color. In Japan, for example, indigo is thought to give fabrics an odor that helps to guard against snakebites.

Blue pigments extracted from indigo had long been popular with painters and calligraphers, and they also served to color wood, especially African statuary.

## INSTRUCTIONS

The extraction of indigotin by fermentation is long and complicated; the simpler and faster recipe below uses sulfuric acid. However, one must be extremely careful. Break up a block of indigo, which is commercially available in lumps or cakes. Take out 9 grams, and place it inside a folded newspaper, isolating the substance from the printed ink with a sheet of white paper. Reduce the indigo to a coarse powder using a hammer, then crush it in a mortar to make a fine powder. Take out 3 grams of indigo and put in a glass jar with a thick base and a narrow neck. Put on fitted protective gloves for the rest of the procedure. With a test tube, measure out 12.5 milliliters of acid. Pour the acid very gently into the bottle containing the indigo. Stir with a glass pipette until the acid is absorbed. Repeat three times to obtain a paste. Carefully close the jar and put it aside for at least two days. Then, drop by drop, pour the indigo paste into a large pot containing 10 liters of cold water. (Caution: Never add water to the acid; always add the acid—very carefully—to the water.) Stir with a glass pipette until completely dissolved. Add the textile and begin to heat the pot very gently. Let boil for 30 minutes, stirring constantly, then turn off the heat and let cool in the dye bath. Take it out and wash with castile soap (olive oil soap), rinse thoroughly, and let dry. You will obtain an intense blue with violet undertones, resistant to sunlight and washing. You can vary the tint by changing the quantity of indigo or the amount of soaking time. Also, by plunging a fabric already dyed yellow (with turmeric or weld) into an indigo bath, you will obtain an otherwise-impossible "true green." To make violets, immerse textiles previously colored red with madder or cochineal insects into the indigo dye bath.

*Green: said of many things which have green in them. People speak of an evergreen oak because it is green all the time. And certain cabbages are called green cabbages because their leaves do not whiten like those of white cabbages.*

Antoine Furetière (1619–1688)
From his *Dictionnaire universel* (*Universal Dictionary*), the publication of which caused his expulsion from the Académie Française

green

One day vegetation appeared and for millennia helped blue-green algae improve the quality of oxygen in the planet's primitive atmosphere. This vegetation contained a green pigment—chlorophyll—that, stimulated by solar radiation, allowed plants to absorb carbon gas and emit oxygen. This chemical process is known as photosynthesis.

The delicate gaseous equilibrium that allows us to breathe on earth today all depends, therefore, on a green pigment. Ironically, although the plant world soon colonized the planet's submerged surfaces, no plant could provide a dye to make a green as beautiful as any nature offered in profusion.

*This fresco, Flora, or Spring, adorns a Roman villa in Stabia, a city in southern Italy. Roman artists excelled in working with green earth pigments, which had yellow, blue, or gray undertones depending on their source. In addition, they were often blended with other pigments, like yellow ocher and Egyptian blue, and even lightened with lead white in order to create a variety of tones. Although much less expensive than malachite, earth pigments were just as beautifully resistant to age. Naples, National Archaeological Museum.*

# more Blue than Yellow

If blue and violet pigments and tinctorial substances are hard to find, green ones are even less common. On one side, the number of pigments can be counted on your fingers: malachite, verdigris and several others derived from copper, and green earth pigments. On the tincture side: nothing. No plant contains pigments capable of dyeing fabric a vivid green resistant to sunlight and repeated washing. Therefore, humans learned very early on to create green by adding yellow to blue or blue to yellow. What seems simple to us today, in fact, required serious investigation and, no doubt, much trial and error. Actually, in most cultures' perception of color, green is closely tied to blue or is mistaken for it, while yellow is seen as a quite separate tint.

## prehistory and antiquity

We have seen how blue, being a rare color, did not play a role in prehistoric pictorial art, but artists during that period would have been able to use the green earth pigments available in their environment. It seems as though they abandoned those sources, however, probably because the colors derived from the pigments were not very visible on the caves' rock surfaces, where the only source of light would have come from torches or oil lamps. In northern Europe, where birch wood had been used productively since Neolithic times, people tried to make green dyes from the leaves of this tree. But, even with a mordant of vinegar or urine, the birch-based tints were more brown than green.

We know very little about Babylonian textiles over in the Fertile Crescent, given that the climate in Chaldea and Assyria—unlike arid Egypt—was too humid to preserve fabrics. But the richness and the brilliance of the colors must have been extraordinary, judging by the costumes portrayed on their ceramics. A number of them depict green outfits with red borders, but we have no information available on either the plants or the techniques they used.

On the other hand, it appears that Egyptian dyers managed to create green fabrics by superimposing a yellow saffron dye on a woad

*Painted on stucco, this garden mural embellishes the tomb of Sennedjem (West Thebes, Nineteenth Dynasty). In ancient Egypt, palm trees, sycamores, papyrus, lotus, and water lilies were irrigated by a checkerboard network of canals. The pleasure of simply being in this lush environment was, in itself, a tribute to the gods. The artist availed himself of a wide variety of green pigments—copper derivatives, ground malachite, and green earth pigments—in order to capture the garden's freshness. He also blended ocher and orpiment with Egyptian blue.*

*Following spread: The Princess and Her Falcon, an eighteenth-century gouache miniature attributed to the master artist known as Nainsuka of Guler, was painted in an atelier in the High Punjab. The diversity of green shades results from the use of green earth pigments, and the dexterous combination of blue and yellow pigments, including the luminous Indian yellow.*

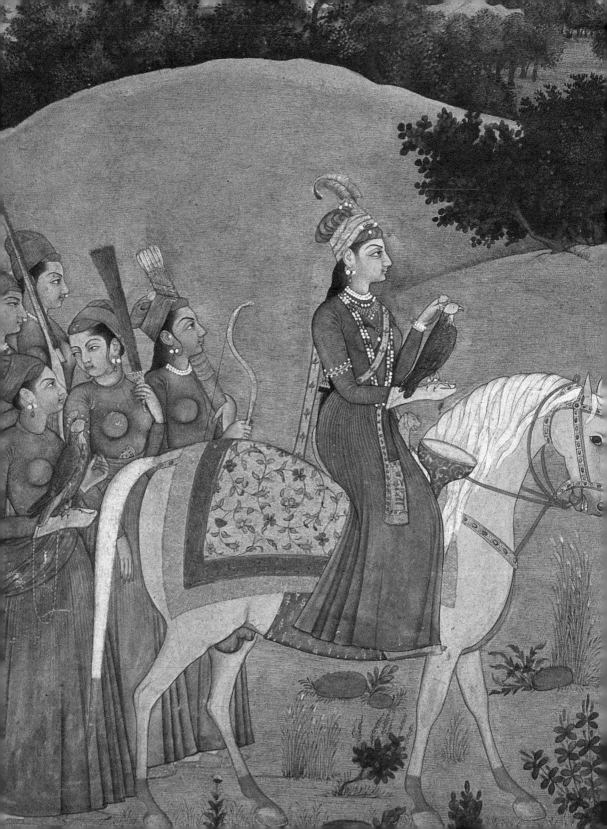

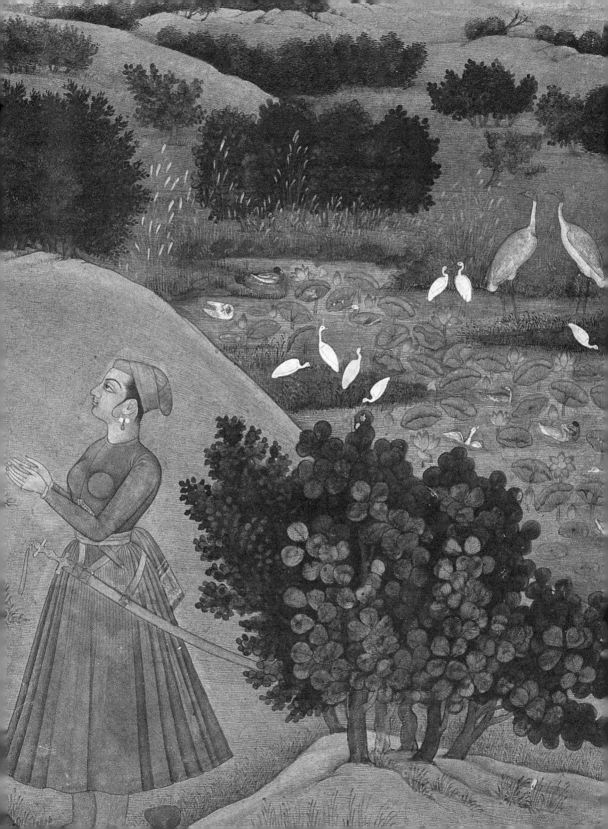

pigment dye. For Egyptian artists painting on papyrus or on friezes, the principal source of green was malachite. Chrysocolla (a copper derivative found in the oxidized zones of mineral deposits), was also available, as were mixtures of blue and yellow pigments, particularly Egyptian blue and yellow ocher. The ancient Cretans and Greeks frequently blended blue and yellow to enlarge their palette of greens, but the Roman world focused on existing rare pigments, and they achieved an exceptional mastery with green earth pigments. Those substances were the source of most of the painted landscape scenery found in Pompeii, in the French cities of Lyon and Vaison-la-Romaine, and in many other archaeological sites.

*The great twelfth-century scriptoria of Burgundy competed for talented illustrators to decorate manuscripts. This character represents the right downstroke of the letter H. The detail is taken from an illuminated copy of* Moralia in Job *(Morals in the Book of Job) created at the monastery of Cîteaux. In twelfth-century Europe, it would have been impossible to dye fabrics as green as the ones worn by this figure. Illuminators, however, took advantage of green pigments like copper resinate, created from a blend of bitumen, turpentine, and copper acetate. Dijon, Bibliothèque Municipale.*

## oriental Greens

For their textiles, the East made greens based on indigo. In medieval Japan, dyers then superimposed a yellow color derived from a local variety of jasmine, while in India people turned to turmeric, saffron, and other yellow-pigmented tinctorial plants to produce deep green fabrics. Double dyeing was also familiar to the Arabo-Islamic world, and today many Oriental carpets contain blues that were originally green, made from a combination of indigo and a yellow obtained from weld, saffron, or turmeric. This second dyeing was less resistant to age than indigo, so the blue tonalities slowly became more prominent.

Indigo can also be found in Indian mural painting, where the greens are a result of binary combinations of indigo plus yellow ocher,

Beginning with the Renaissance, the prohibition against mixing dye colors in the same dye vats was slowly lifted. Artisans started to superimpose blue and yellow tints. This example of cut velvet on a silk background dates from the first half of the fifteenth century. Paris, Musée National des Thermes and the Hôtel de Cluny.

or lapis lazuli plus orpiment, but artists also used malachite. In China, they mixed azurite with orpiment to form green.

## Amerindian Peoples

During the Teotihuacán civilization, which ruled in Mexico between 300 and 650 A.D., painters created frescoes with greens made of crushed malachite—sometimes mixed with chalk to form pale green tones—and even with combinations of blues (azurite and lapis lazuli) and yellow ochers. The Tlingit of North America developed a unique approach to creating successful green dyes: they boiled fabrics in a brew of hemlock bark and copper oxide collected from grating old coins.

## The Case of Medieval Europe

The medieval Christian West was averse to blending colors, which was a serious drawback when it came to dyeing things green. Moreover, the ateliers that worked with red dyes were responsible for yellow, while only those dyers who specialized in blue had the permission to create green colors. Finally, the apothecaries, who catered to the dye workshops and supplied the necessary chemical ingredients, could be very far apart. Given the situation, yellow and blue had little chance of meeting. On the other hand, the pigments did come together in painters' ateliers. But the Biblical interdiction had so permeated people's attitudes that manuscript illuminators preferred to turn to existing green pigments. The shortage of choices was less onerous for the dyers, who tried to fashion green tones by using bracken, plantains, buckthorn berries, nettle and leek juices, foxglove, broom plant branches, ash tree leaves, and alder bark, among others. The results were mediocre, even with leaves from the plum tree, which was the only material with acceptable green-making attributes. The dyers obtained washed-out tones that were barely resistant to light and laundering, and in any case, they could never attain a green to equal the beauty of malachite. (Efforts made elsewhere to create dyes based on this mineral and on green earth pigments were not very successful.) In addition, the

only way for the color to take, even a little, was to add a mordant to the dye baths, but it made the green fade quickly and the fabric fall apart, eaten by the metallic salts. City dwellers rejected these rather unappealing textiles, and dyeing material green was rarely pursued, except in the countryside, where it colored peasants' clothing. Only at the beginning of the sixteenth century, as attitudes evolved, did Northern European dyers reconsider creating green textiles, based on a first blue dye made of woad, followed by a yellow dye made of weld. Formulas began to circulate, but the blending of blues and yellows to make greens did not really become widespread until the middle of the eighteenth century. At that time, greens fashioned from an indigo bath and then a weld bath became common. Given that green-colored textiles needed two successive procedures, they were sold at a higher price than just yellow or blue fabrics, and this often led to disputes when the yellow faded and the fabric ended up blue. But in the 1720s, the demand for fashionable Saxon green was so great that many dyers attempted to make the color.

# IS THE GRASS ALWAYS GREEN?

The color green is generally associated with vegetation. But vegetation is not green for everyone, and this color sometimes plays a role in a much more complex system of associations.

## THE MULTIPLE FACETS OF CHLOROPHYLL

For the people who live in tropical regions, vegetation has a bluish cast. Those living in arid environments instead perceive a yellow kind of green, and reserve the term "green" for turquoise and for the dusk sky. The Aboriginal artists of Utopia, in the central desert of Australia, use colors reflecting the rough terrain they travel. Reds, yellows, oranges, and browns predominate, and they possess a rich vocabulary for these shades. On the other hand, the colors we call "green," "blue," or "violet" are little represented in their geographical context, and they associate

these with elements in the world outside. Therefore, leaves, which we would characterize as green, are designated by the term also used for the bronze spots appearing on the backs on catfish, the pale colors of the rainbow, and the skin of Europeans.

## BLue-Green anD Green-BLue

Many cultures integrated green with blue and gave these colors the same name. As a consequence, green and blue were mixed up in ancient Indian texts. In order to specify the exact shade, people evoked parrot feathers, plants, birds and fruit…a long list of names describing the full range of these colors. The Bidjogo women of West Africa, responsible for painting the walls of their shrines, only separated green from blue when they came in contact with balls of blue washing detergent. They continue to trace geometric designs on the surfaces of cult sites by crushing grasses and palm leaves to obtain ephemeral green tones.

For the Motta people of Vanuatu (also known as the Banks Islands), the perception of colors is connected to the impression of shine. Therefore, the carapace of certain insects would qualify as a "green-blue" while a matte version of the same color (a bird's down, for example) would be assigned a different term. Several Indonesian dialects share a similar approach; for example, the term that comes closest to our "green" refers to young leaves, but it also means the color of a clear blue sky, while gray is described as a "dark green."

Sometimes the somber or luminous nature of a color is perceived as its characteristic element, as is the case for the Hanuno-o tribe of Mindoro Island in the Philippines. Therefore, if "green" actually

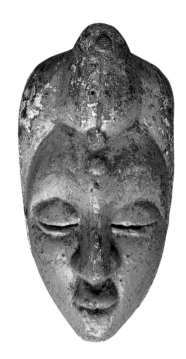

*The color green is rarely seen in African sculpture. Red, yellow, white, and black tints are preferred, while green pigments are seldom used. This mask from Sierra Leone probably owes its green tone to a blend of blue and yellow, perhaps even blue washing powder and yellow ocher.*

specifies the colors obtained by blending blue and yellow, dark green would be referred to by the term "black," as would violet, indigo, dark gray, and sober tones in general.

The vocabulary of color for the ancient Greeks was nurtured by references drawn from their environment, and so they spoke of frog green, olive green, apple green, and even "the sea green of the tumultuous tides," characteristic of flowing green fabric. In the ancient Roman circus games, certain gladiator teams were identified by their leek-colored mantles. In a famous passage from his *Art of Love*, Ovid (43 B.C.–17 A.D.) recommends that women who wish to please their husbands dress themselves in a green of Paphos myrtle or the darker green of oak leaves.

# From Power to a Cruel Destiny

Associated with vegetation, the color green evokes growth, which is by definition ephemeral. In Africa, where green is generally perceived in positive terms, the Fon of Benin call this color "raw leaf." For the Ndunga of the Congo, green, a symbol of nourishment, is linked with virility. In Ghana, it evokes newness, fertility, and vitality. The color green sometimes embodies all hopes, but can also represent all dangers.

## The Renaissance Green of Egypt

Colors were so present and meaningful in ancient Egypt that they defined objects and served as metaphors. The sea was, therefore, called the "Very Green." In hieroglyphics, the word for green was assigned to a symbol of a sprouting papyrus, because in Egyptian thought, a close connection existed between plant renewal, strength, and the color green. A green-colored face in a mural painting was a sign of good health and foretold the rebirth to which every Egyptian aspired. This

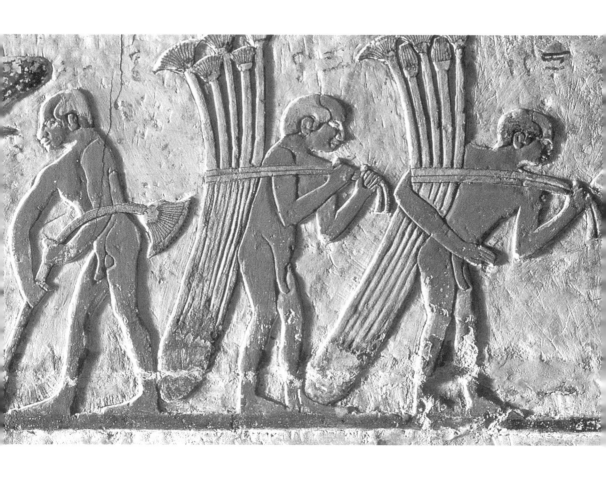

color was invested with a prophylactic power, as it had been since the Neolithic era. Makeup palettes fashioned of green slate have been found in numerous burial sites. They were placed in the dead person's hands and still bore traces of the malachite used to paint the contours of their eyes. Malachite protected the living from the hazards of existence and fought off the demonic powers haunting the world beyond. This custom endured for many years, for mummies in the age of Tutankhamun still had eyes outlined in green by the priests in charge of funeral ceremonies. Archaeologists have discovered a profusion of green-colored amulets in the tomb excavations, particularly small scarabs sculpted of malachite. The presence of these objects communicated protection and vitality for the deceased, and bore witness in his favor before Osiris, god of the dead.

## THE OASIS OF ISLAM

For the inhabitants of the Arabian Desert peninsula, green was synonymous with nature and was associated with moisture and the earth. It is the origin of life. God made plants green and the sky blue to make things easier visually for His creatures, because these two colors were both so beneficial to sight. In classical Arabic, the words "green," "vegetation," "grass," and "paradise" are all derived from the same root. A Koranic surah recounts how the blessed will wear green in the Garden of Eden. And, indeed, this image of paradise guided the leaders of the Umayyad dynasty. At the dawn of Islam, they built splendid palaces in the deserts of Syria and Jordan, designed around magnificent gardens that re-created the green profusion of nature. In Morocco, the expression "My stirrups are green" still signifies "I bring the rain to regions that need it." In the Middle East, people celebrate the New Year with wishes of green, and beet leaves are hung in new homes as good omens. The color green is a desirable element in cuisine as well, and many recipes explain how to prepare green delicacies featuring abundant raw and cooked celery, powdered and whole pistachios, rue, and coriander.

*This bas-relief was discovered in the tomb of Nefer and Ka-Hay in the necropolis at Saqqara, about eighteen miles south of Cairo. Dating from the Fifth Dynasty around 2400 B.C., it depicts the harvesting of papyrus. The silhouette of papyrus forms the hieroglyph for "green," and the plant—like the color—is closely associated with rituals of rebirth. In the pyramid of Unas, the last Fifth-Dynasty king, luminous green texts were painted down the length of a corridor. The hallway represents the western journey the king had to make before he could take his place with the dawn in the diurnal barque of the sun and be reborn immortal.*

The Arabo-Islamic civilization accorded green unquestionably positive connotations. The color green is the oasis in the middle of the desert, but above all, it is the emblem of the Muslim religion. Tradition says that when the archangel Gabriel appeared to Mohammed, the Prophet was dressed in green, and the angel's wings were green as well. Early members of the Islamic faith departed on their world conquest brandishing green standards. Green turbans are worn by the Prophet's successors and, in paradise, Allah welcomes the souls of martyrs who fly to him in the form of green birds. In Islam, when dervishes and Sufis put on their rags, they undergo a "green death." It is the death of the material world and the birth of the spiritual one. It is a chosen death, and a green death is the gentlest of all deaths. According to their religious cosmology, the terrestrial world is surrounded by an emerald mountain carved with a celestial throne, the color of which is reflected in the vault of the sky. For many years, Arabs believed green to be one of the three colors of the rainbow, along with red and yellow. Green is considered the standard of equilibrium, closer to celestial blue than infernal red, and it symbolizes notions of fertility, youth, and joy.

## THE AMBIGUOUS GREEN OF ASIA

*This late sixteenth-century Turkish miniature represents an episode from the life of Mohammed. The Battle of Badr (named for the wells on the road to Mecca) was the site of an important clash between the partisans of the Prophet and their adversaries. Here we see the angel Gabriel bringing aid to the Prophet who, according to Muslim iconographic tradition, is portrayed veiled. The green outfits distinguish Mohammed and his companions from their enemies. Paris, Musée du Louvre, Department of Oriental Antiquities.*

To dream of green is a sign of good fortune in China; the sleeper can rely on his vitality. But if the color pervades the entire dream, it signifies that he is subject to savage forces and will find himself in great peril. Moreover, if, among the three gods of happiness, the granter of many children is dressed in green, a young girl green as willow tree leaves attracts pity, and the man wearing a green scarf on his head is cuckolded by his wife. Prostitutes are called the "family of the green lamps" and a pervert is known as a "green boy."

In the Mongol pantheon, the color green is considered a blend of white, yellow, and blue. Associated with the Buddha of the North, this symbol of divine energy combines the functions that the three colors bring together: pacification, growth, and destruction.

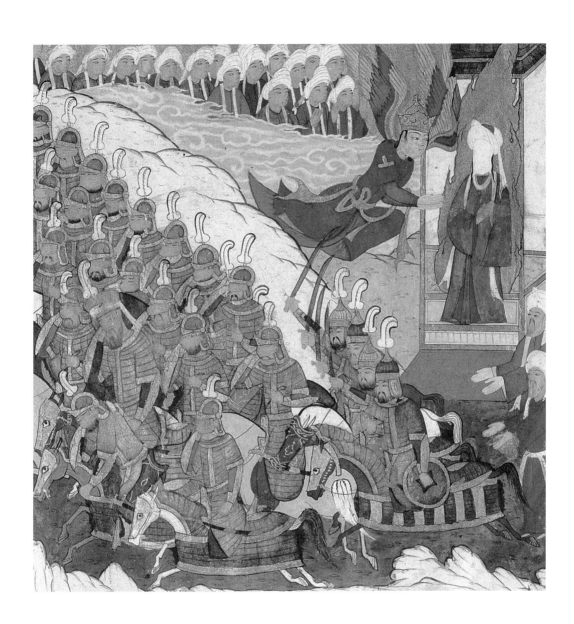

## THE FECUND GREEN WORLD OF THE AMERINDIAN PEOPLES

Pre-Colombian civilizations linked the color green with fertility. For the Aztecs, the quetzal bird's green plumage signified abundance, while for the Maya the emerald was a green sun, a sign of blood, and profusion.

Among the Hopi Indians of the American southwest, the color fits into a whole religious cosmological framework that unites the cardinal points and their corresponding elements. Green, therefore, designates a southwesterly direction, turquoise, bean leaves, the heart of the willow tree, the ewe, and the migratory bird. This bird flies southwest over Hopi country every fall, and its passage coincides with the arrival of ice and snow. When it returns north in the spring, it foretells a rise in the temperature. Shamans seek out blue-green pigments to color the prayer sticks they use in ceremonies promoting the growth of vegetation. Many are painted with malachite found in the San Carlos Mountains, and in the Hopi belief system, these tints evoke the color of new sprouts. But green also means the direction southwest: the typical source of their rain clouds and the migratory path of their avian harbingers of spring. As for the ewe, she gives birth to her lambs with the blossoming of the buds.

## GREEN'S SLOW REDEMPTION IN THE WEST

For many years, green's appreciation in the West was marked by the failure of green dyes, and as a result, it retained connotations of risk, transience, and instability. The color also evokes versatility and change and represents both good and bad luck. It is capable of the best and the worst. It is the color of the unexpected. Card tables are not covered in green by accident, for green symbolizes chance, inconstant love, ardor, jealousy, and disorder. Green, along with yellow, was worn by the insane. Emerald protected, particularly during childbirth, but it also attracted demonic forces and, with them, misfortune. In fairy tales, wicked people were often clad in green, and a devil with green

*Created during the second half of the first millennium B.C., this wool shroud was uncovered in the graveyards of Paracas in Peru. The green threads used to embroider some of the design elements in these anthropomorphic figures were made by double dyeing. As elsewhere, Peru did not have plants that produced green dyes. Lima, National Museum of Archaeology, Anthropology, and History of Peru.*

skin and eyes even features in one of the stained-glass windows at Chartres cathedral.

When true green dyes were successfully realized after the Middle Ages, the color was linked anew to a generous nature. Green became synonymous with growth, fertility, expectation, and hope, calling to mind freshness and youth. The custom of wearing green to celebrate the return of spring began at this time and became popular throughout Europe. During Lent, Bavarian villagers would act out a sacred drama illustrating the battle between summer and winter. Winter was represented by young men clad in furs, while those who incarnated summer were dressed all in green, singing couplets from ancient songs: "Green, green are the fields everywhere I go./And the reaper on the sward never wearies." Others sewed twigs and leaves on their outfits to celebrate the renewal of vegetation. In 1546, the French Renaissance writer François Rabelais (1494–1553) mentioned a game called "caught without green," which consisted of wearing a green leaf throughout the entire month of May. If a person was found without a leaf, he had to pay a fine.

Like blue, green was from then on considered a serene and restful color in the West. Interior designers recommended it for creating soothing atmospheres. Green lights mean go, and in many countries pharmacies are traditionally indicated by green crosses. Green evokes nature, permission, calm, and security.

Since the 1980s, green has also benefited in Western Europe from increased interest and credibility, thanks to emergent ecological and political movements where the color serves as an emblem.

But the capricious nature associated for so many years with the color has engendered a number of abiding superstitions, and even today, green is said to bring misfortune on boats and theatrical stages.

# THE USES OF GREEN

# green earth
## PIGMENTS

GREEN EARTH PIGMENTS ARE ROCKS THAT TAKE THEIR COLOR FROM A HIGH PROPORTION OF GREEN CLAYS (GLAUCONITE, CELADONITE, OR CHLORITE). THEY CAN BE FOUND ALL OVER BUT ARE PARTICULARLY COMMON IN THE REGION AROUND NICE IN SOUTHERN FRANCE; IN VERONA, ITALY; IN CYPRUS; AND IN BOHEMIA. GREEN EARTH PIGMENTS ARE CRUSHED, THEN WASHED TO ELIMINATE IMPURITIES, AND MADE AVAILABLE IN A CONVENIENT SOAPY-TEXTURED POWDER FORM. THE ONLY EARTH PIGMENT ACTUALLY ON THE MARKET IS BRENTONICO GREEN, BETTER KNOWN AS "VERONA GREEN" FOR ITS REGION OF ORIGIN. YOU CAN ALSO USE CERTAIN GREEN-TONED CLAYS AFTER PULVERIZING THEM INTO A FINE POWDER.

The great history of green earth pigments began in the Roman Empire, where they replaced the much more expensive malachite. To paint the landscape murals that adorned prestigious villas, artists imported green earth pigments from Verona, southern France, and Cyprus. They used it in its pure form, experimented with the different tonalities of each pigment source, blended pigments together, or combined them with other pigments (especially Egyptian blue) to produce a variety of shades. For the Fayum portraits made in Egypt, green earths were used to depict clothing, jewelry, and foliage.

The Indian artists of the Ajanta caves were also able to extract an incredibly rich range of tones from green earth pigments, which they used in the complex works painted at this Buddhist site. Years later, Persian painters mastered these materials for their portraits and landscapes as well.

After the fall of the Roman Empire, many of the pigments and the knowledge of how to use them were forgotten in the West, but green earth pigments did not disappear completely, and they could be seen now and then in Carolingian and Romanesque mural painting. Although green earths were probably too drab for an era of vibrant colors, when lightened with lead white, they served as the base-coat undertones for figural complexions. The greenish tint of the flesh tones in thirteenth- and fourteenth-century paintings is due to these long-lasting undertones.

# INSTRUCTIONS

Brentonico green provides solid coverage. When simply blended with water, gum arabic, or casein on rag paper, it appears matte; with the addition of egg yolk, the color becomes luminous. To paint in tempera, crack a chicken egg, carefully separate the yolk from the albumen, and keep the yolk. Pierce it so that the yellow part runs and collect the liquid in a small container, but avoid the fine membrane that encloses the yolk. Dilute with a drop of water. Add a teaspoon of turpentine and a few drops of lemon juice to kill bacteria. Mix well. Then add three tablespoons of green earth pigment and blend. This recipe can be used for all earth pigments, except white ones. In the Middle Ages, artists experimented with certain snail secretions as binders.

The Renaissance artists who developed oil painting techniques derived deep greens from green earth pigments. In his *Libro dell'arte* (*The Craftsman's Handbook*), Cennino Cennini provided recipes for using the substances to their fullest and explained how to dye vellum and rag paper with Verona earth blended with ocher, lead white, a little cinnabar, and bone black, binding everything together with glue. Green earth pigments were used as well to set sheets of gold leaf and augment their brilliance. In seventeenth- and eighteenth-century Western painting, green earth pigments created harmony. Landscape artists (especially Claude Lorrain [1600–1682] and Jean-Antoine Watteau [1684–1721]) used them to render foliage and develop strong beautiful glazes. Green earth pigments were probably also common for painters in pre-Columbian civilizations. Until recently in North America, they played a role in Hopi ritual sand paintings, particularly in representations of the solar symbol.

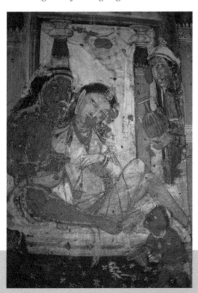

*Painted in the fifth century, this mural adorns one of the twenty-nine caves at Ajanta, northwest of Hyderabad. Sketched on dry support with a technique similar to tempera, these paintings are characterized by a palette of exceptional richness, which accords a significant role to the variety of green shades created from earth pigments found only in the immediate surroundings.*

# malachite

A STONE WITH A LOVELY VIBRANT COLOR, MALACHITE IS DEFINED BY GEOLOGISTS AS A BASIC CARBONATE OF NATURAL COPPER. IT FORMS IN COPPER DEPOSITS, OFTEN ALONG WITH AZURITE, AND USUALLY APPEARS IN ROUGHLY ROUNDISH CONCRETIONS. ITS SURFACE IS PUNCTUATED WITH IRIDESCENT PATTERNS OF MUCH DARKER GREEN. THE BEST-KNOWN QUARRIES ARE IN THE URALS, BUT THE STONE CAN BE FOUND ON EVERY CONTINENT. THERE ARE TWO COMPETING HYPOTHESES ON THE GREEK ORIGIN OF ITS NAME. FOR SOME, "MALACHITE" IS DERIVED FROM THE WORD "MOU," OR "SOFT," BECAUSE IT IS A SOFT ROCK; FOR OTHERS, ITS ETYMOLOGY IS LINKED TO ITS COLOR, WHICH IS SIMILAR TO THE LEAVES OF THE MALLOW PLANT (KNOWN AS "MALAKHE" IN GREEK). IN THE WEST, MALACHITE WAS KNOWN BY THE NAME "MOUNTAIN GREEN."

The Egyptians were very adept at fully exploiting minerals native to their region. In the third millennium B.C., they crushed malachite from deposits in the eastern desert and west of the Sinai to use as pigment. With its luminous glow in the penumbral light, paint made of malachite mixed with egg or acacia sap predominated in tomb decorations and on papyrus. The Egyptians also believed it had curative virtues, and combined it with animal fat for makeup. Cleopatra painted her eyelids with it. For centuries, malachite played a role in Chinese landscape painting. From the fifth century B.C. to the third century A.D., the Chinese used it to manufacture green-colored inks, which became particularly successful when Confucian China rejected polychromy. The official palette at that time was reduced to blue (azurite) and green (malachite), and painters concentrated their efforts on the thousand shades made possible from only these two inks.

While the Greeks used malachite during antiquity, the Romans abandoned it (probably because of its high cost) in favor of green earth pigments, and it is almost absent from Pompeian frescoes. On the other hand, the mineral continued to be prescribed as a medicine, and it was found in an ancient Roman optician's coffer during archaeological excavations of Lyon, France. India imported malachite from Turkistan to use in mural paintings, and it became part of the basic palette for illuminating manuscripts. Tibetan Buddhist artists, who loved vibrant colors, crushed it roughly, like azurite, so

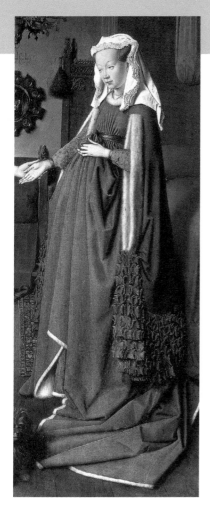

different shades because it proved to be unstable and made colors change. During the course of the seventeenth century, savants attempted to fashion substitutes based on copper. Some were so toxic that people used them as insecticides against grasshopper infestations. At the start of the nineteenth century, malachite was finally replaced in the West by chrome green, and the stone was no longer used, except to carve bibelots and jewelry. However, it remained highly valued by Chinese painters.

## INSTRUCTIONS

Malachite is such an expensive pigment (more than $120 for 3.5 oz.) that people reserve it for small surfaces. To use it on rag paper, just dilute it with a little water, casein, gum arabic, or egg yolk. In the case of the latter, of course, the mixture will take on a slightly yellow tone.

To use the pigment as a watercolor, it must first be reduced to a very fine powder. If necessary, you can crush it with the help of a rotary cutter on a smooth, hard surface (like fireplace marble, for example). Only a few drops of gum arabic are needed per teaspoon of pigment. Blend them to obtain a thick homogenous paste. Next add several drops of liquid honey. Mix again, collect the paste with a knife, and place it in a small container. When it dries, just run a moist brush across the surface.

as not to dull its color. Medieval European painters also turned to malachite to embellish their illuminations with its magnificent green tones. Its bluish nuances were particularly prized by Irish miniaturists. From in the Renaissance until the end of the eighteenth century, painters appreciated what malachite had to offer but avoided blending it with other pigments to create

*When Jan Van Eyck (1385–1441) painted* The Arnolfini Wedding *in 1434, Flemish painters used copper derivatives and malachite for their greens. Compendia of formulas circulated in Germany proposing different ways of binding ground malachite with oil and improving its compatibility with other pigments. London, National Gallery.*

# verdigris

USED SINCE ANTIQUITY, VERDIGRIS IS AN ARTIFICIAL PIGMENT MADE BY TREATING COPPER SHEETS WITH THE ACIDIC VAPORS FORMED BY THE FERMENTATION OF GRAPE MARC. THE CHEMICAL REACTION GENERATES A CORROSIVE GREEN CRUST THAT, AFTER IT HAS BEEN GRATED AND DRIED, CAN BE USED AS A PIGMENT. VERDIGRIS, IN TURN, MAY BE DISSOLVED IN VINEGAR, AND THAT SOLUTION, ONCE FILTERED AND CRYSTALLIZED, YIELDS VERDET, A DEEPER AND MORE INTENSE SHADE OF GREEN.

In ancient times, verdigris came from vineyard regions where the wine necessary for its manufacture was available. Previously heated strips of copper were buried in drums of marc for several weeks and sometimes placed in drying kilns to accelerate the reaction. The green deposit that formed on the strips was carefully collected, dried, and packaged in little leather bags to be sold commercially.

This pigment provided less costly access to blue-green colors that no other pigment could supply. But it did present some shortcomings: it resisted moisture and air poorly, did not mix well, and could even ruin other colors it touched. Although it was considered unstable, verdigris has been recovered intact in Pompeian frescoes.

The Middle Ages were the high point for verdigris. Beginning in the fifth century, Celtic monasteries used it extensively in their *scriptoria* for illuminations. Collections of medieval formulas explained how to make it. One of them, dating from the end of the thirteenth century, suggests macerating copper filings in vinegar for either three days or nine months!

The rise of oil painting led to the decline of verdigris, for it proved to be even more unstable in oil than in water. And while it created magnificent colored glazes, its reputation was such that, in his *Treatise on Painting,* Leonardo da Vinci frankly advised against its use. However, it remained very popular, as much with miniaturists working in sixteenth- and seventeenth-century Europe as with those who painted in the ateliers of the Safavid and Mongol empires. In the latter half of the nineteenth century, verdigris was replaced by chrome green.

## INSTRUCTIONS

It is easy enough to make verdigris, but exercise caution! It is a toxic product and must be handled carefully to avoid ingesting or inhaling it. Wear gloves and a mask. Salvaged copper plumbing bits will fit the bill perfectly. Scrape them with a file. When the surface is covered with scratches, deposit them in a glass receptacle and pour very hot wine vinegar on top. Let it rest for two weeks. When the verdigris crust forms, retrieve the pieces of copper, grate the deposits, and let them dry. Commercially available verdigris—which has a beautiful turquoise tint—is sold in little irregular flakes that should be crushed before adding a binder. Verdigris mixes especially well with egg yolk, gum arabic, and casein. This limpid pigment can form glazes, those very thin fluid coats of paint that allow the artist to shade a previous layer of paint. Given that verdigris alters pigments it contacts, it must be used alone. Take a plain white plate to use as your palette, so that you can see the tints clearly. Dilute a little verdigris (reduced to a very fine powder) with a little commercially available gloss gel. Spread it with a firm brush on the plate. Let it dry. Repeat the operation if the shade is not deep enough.

*Thirteenth-century Irish manuscript illuminators drew their inspiration from the art of metal. Perhaps they were dreaming of silverwork and jewelry set with emeralds when they used verdigris to color the interlaced designs and intricate spirals peopled with animals and human figures. Here a detail from Saint Cuthbert's Book of Gospels, better known as the Lindisfarne Gospels. London, British Library.*

She arrived on time, wearing a raincoat, a gray skirt, and a white sweater. "Don't you ever wear anything that resembles color?" asked Roddy.

Laurie Colwin (1944–1992),
*Passion and Affect*

# brown and BLaCK

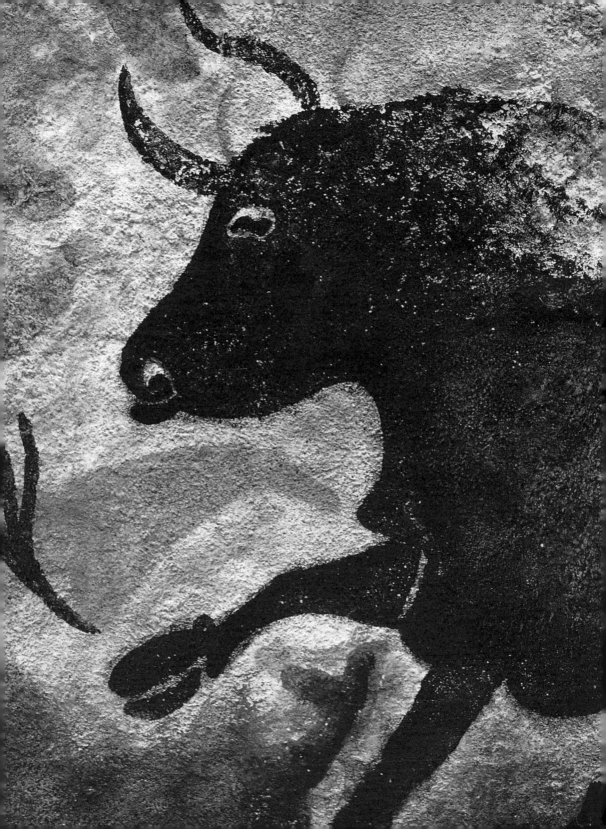

When light and shadows broke through the obscurity of nothingness, the world came forth from chaos. Emptiness, the end of time, returned to the shadows. But without a doubt, they also took in part of the primordial chaos because, in the human mind, darkness, far from being nothing, is actually full of life.

The concept of the dark, with all its lurking dangers, is etched deeply in human consciousness, and it arouses a universal fear. The color black evokes the perpetual night of death.

The Sudanese vocabulary of signs depicts a motif describing "black space." It has three meanings: an exhalation from the mouth, an exhalation from the nose, and flatulence. The dark is also the physical gravity and shadowy part of each person's soul.

*Beginning in the Upper Paleolithic era, dark manganese oxide, charcoal, and calcite (white chalk) expanded the palette of pigments—until then limited to yellow and red ochers—that were available to our prehistoric ancestors. At the same time, figurative painting appeared. Whether it incarnates the male or the female principle, this figure of a bison, drawn with a fistful of charred wood fifteen thousand years ago on the rock face of a cave in Lascaux, possesses an incomparable monumental dimension.*

The Mbuti, a tribe of
Pygmies who live in
Congo's equatorial
forest region, ignore
material possessions
but excel in an art
form that draws from
all the resources in
their environment.
Using silt and brown
earth pigments,
they decorate
bark panels with
geometric designs.
Paris, Musée du
Quai Branly.

# THE EDGES, LIMBO, SPIRITS, AND DEATH

Each culture's perception of the dark, that object of fascination and fright, is fraught with deep, ancient emotions. Black is simultaneously death and the womb of all beginnings, the absolute silence of extinction and the tumultuous rustling that accompanies birth. Black is rich in fecund contradictions.

## AFRICA

African cultures frequently include dark shades with the color black and often perceive them negatively when these somber hues evoke—as they do for the Kongo of Central Africa—the antisocial, the wicked, sorcery, and the destruction of death. Therefore, a person whose life had been riddled with misjudgments and grave faults is buried in a black shroud and not a white one. For the Hausa in Nigeria, a black heart characterizes an angry man, a cheat, and an enemy, while a "black belly" represents a sad man. In Ghana, the gray color of ashes exemplifies offenses and impostures, and in the language of weaving, bands of black color generally reflect Original Sin, the act of the first woman who spread disorder and sullied the earth. Supreme danger rests in the black gods, who are particularly feared. The Hausa dread them. These demented deities strike death, paralyze, and render people insane. But if the darkness is menacing, it can also be protective. The color black often buttresses the momentous circumcision rite that marks the beginning of social life for boys in many African cultures. It allows them to remain invisible during the period of retreat preceding initiations. The Manja of the Central African Republic cover the bodies of future initiates with charcoal, while in Zambia, the Ndembu rely on black earth pigments. For the initiates, these paints also symbolize the death of one stage of life and the birth of another. Young boys become new men, and the culmination of the initiation rite is signaled by painting their bodies white.

Darkness conceals the stalker of game as well, and those same black gods whose power terrifies the Hausa serve as protective divinities for the clan of hunters, who sacrifice a black goat or black chicken to them.

Darkness also protects a person through life from the ever-present danger of evil spirits by allowing him to hide in night's shadows and thereby escape their wicked attentions.

Dark hues can also epitomize maturity—the color of adult skin and the seeded fruit. Black-colored clouds bring rain and the moisture of abundance. The people of Uruk in present-day Iraq use the term "black" to signify both very ripe fruit and arable land. In northwestern Africa, a young woman may don a black dress after seven days of marriage. The color of fertile soil, this garment bears witness to her transformation and her dreams. Maturity finds its conclusion in old age, which opens the way to death and offers access to the secrets of the ancestors. According to the religious cosmology of the Bwa who live in Burkina Faso, old age relates to the mythical time of Creation and to the ancestral smith and transformer, the first being and the sun's counterpart, black as the metal extracted from the sacred forge. In Gabon, ancestral skulls are preserved in sanctuaries watched over by black stone figurines. Among the Ndembu people, when a person dies without descendants, they draw a black line on his body extending from his navel to his sacrum. This mark signifies that the deceased must die "for ever."

## INDIA

In ancient India, the concept of the color black can best be illustrated by this legend: Six travelers were lost one day in a forest. They were at the point of perishing when they came upon a tree heavy with fruit. The white man wanted to collect the fallen fruit, the red man to gather them from their branches, the yellow man to take a few branches, the gray man to break the branches, and the blue man to cut the tree. As for the black man, he wanted to uproot the entire tree.

In Sanskrit texts, somber colors (dark blue and green, browns mixed with gray, maroons, and black, often combined with blue) were reserved for the inferior castes. If black could be defined as the color of the sky, the lotus stalk, or even a forelock of hair, then according to the precise rules that governed Indian painting, it also illustrated inertia, impurity, baseness, evil, and terror. Therefore, Kali, the fearsome divinity who, in the form of the goddess Durga, once demanded human sacrifices, was always represented by the color black. Black is the color of death. However, for many farming peoples, death can also be interpreted as the beginning of a new life, and so they would sacrifice black bulls and horses for the annual flooding of the Indus River in order to encourage abundant harvests. Kali can also be beneficent when she assumes the role of the Universal Mother, the Hindu goddess of fertility. This black is perceived as an undifferentiated color and is therefore capable of giving birth to all the others. A similar connection is encountered in the literature and folk arts of Thailand, where not only death but also menstrual and placental blood are often associated with black dogs. Dark colors frequently play a role in magic. In India, a lover would use a black thread to attach a rival's hair to three rings before burying them under rocks and pronouncing the following incantation: "As from a tree they separate a liana, I separate from my rival her happiness and her radiance; like the immoveable mountain, may she remain forever seated in her parents' home." But, as often is the case with magical spells, that which attracts evil can also repel it. And so they outline children's eyes with kohl to safeguard them from wicked spirits. In addition, people add a little charcoal to milk for protection because its whiteness can lure the forces of evil. These customs continue in a number of regions, particularly in Rajasthan.

## Asia

The civilizations of the Far East associate dark ones with destruction, but these colors also bring to mind the disorder necessary for the appearance of life. China linked the color black to kidneys, water,

winter, the salty taste of pork, and the direction north (represented by a black tortoise). The legendary emperor of the North, Zhuanxu, also commanded the seas and winds. He compelled women to obey men and had numerous children, who spread malaria, hid in a home's nooks and crannies, and caused boils. When China's first emperor, Qin Shi Huang, (c. 260–210 B.C.) overturned the red Zhou dynasty, he chose the color black as the emblem of his reign, because black water quenches red flames. Several years after his death, however, the Han dynasty reestablished the color red as an insignia of power in 206 B.C.

*Vishnu, the major divinity in the Hindu pantheon, manifests himself as the supreme god, as well as in the guise of various other forms. One of them, called Aniruddha, is identifiable by the color black or dark blue, as is evident in this painted sculpture from the Mahakal Temple located in Ujjain, a city in the Deccan region of India.*

*In the Eastern Highlands of Papua New Guinea, the Asaro people construct spectacular ritual masks with mud and plant fibers, sometimes complementing them with nailed finger sheaths made of bevel-edged bamboo stalks. During incantation ceremonies, these elements restore the community's cohesion and reinforce its fertility.*

In Japanese court life during the tenth and eleventh centuries, wearing black or somber-colored attire was perceived as bearing misfortune. Only those willing to exile themselves to the fringes of society, or those who had taken ascetic vows, would dare to do so. But country folk celebrated a very special ritual, which was still considered acceptable in mountain villages of central Japan during the eighteenth century. At the end of winter, the peasants would don black mud-dyed cotton outfits and engage in licentious couplings. This custom was probably meant to promote vernal germination.

## InDonesia

In the religious cosmology of Bali, where colors are attributed to the gods, Vishnu, who personifies the direction north, is linked to black and even dark blue or green. Therefore, dark or black fabrics are draped behind a beast sacrificed to Vishnu. The color black is also associated with depth, the subterranean world, demons, disaster,

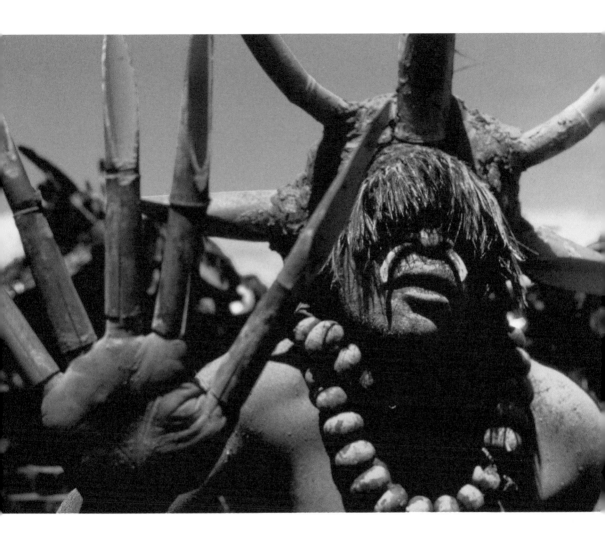

illness, and the left hand, but certain ceremonial textiles combine black and white patterns to illustrate the equilibrium of the world and its perfect harmony.

## oceania

In the dialects of Oceania, the term for the color black derives from the word for "charcoal," and refers to dark colors in general, from deep red to indigo. They use the word "yellow" for brown tints, and it applies equally to shades ranging from light orange to brown and sometimes violet. On the other hand, they have a very precise vocabulary for skin tones, and they use a particular term to describe the body when it is covered with soot during mourning periods, as is the custom on the archipelago of Vanuatu. The Maoris have numerous terms at their disposal to indicate the color black, and these distinctions result from the four physical types that exemplify their people. Therefore, they use different words to characterize the color of a person with dark skin and curly hair from another with the same shade of skin whose hair is smooth.

Among the Yafar of New Guinea, somber shades evoke a state of growth, potency, and vigil, whereas for the neighboring Umeda people, dark tones correspond to the ultimate stage in the process of growth (wilted flowers, dried-out harvests, old age), or to a peripheral position in the social or animal world, like the cassowary, a flightless bird that lives in the deep bush. The Asaro link dark shades to masculine vigor.

## amerindian peoples

For the Kogi Indians living in the Sierra Nevada de Santa Marta in Colombia, the color black is linked to the west, the birthplace of the night, and is perceived as negative and dangerous, as is everything of a dark hue.

Among the Hopi, the color black is associated with the zenith and numerous other entities, like the swallow, or the sunflower when its

seeds turn brown after it blooms, or the brown rabbit's foot used in ceremonies for stopping the wind. The color gray plays a special role in Hopi cosmogony, for it is considered the sum of all the colors. It embodies what could be called the "worldly place," the residence of the god whom the Hopi believe controls the growth of the seeds of all life. He is seated on a flowered hill surrounded by all the plants in creation: corn, citrus fruit, melons, cotton, beans, etc. Finally, if a blue-green color is linked to femininity, black designates masculinity, and the association of the two shades helps to reinforce magical rituals of fecundity and fertility.

## PHARAONIC EGYPT

Intimately connected to the cycle of rebirth, ancient Egyptian civilization named itself "the Black Land," probably in reference to the darkness of original time where the non-light contained the seeds of life to come. From time immemorial, statues representing the divinity were coated with a perfumed bituminous unguent. The color black also corresponded to the world of the grave and to mummification. Anubis, who watched over the dead, was depicted as a black jackal. And when the god Osiris was associated with the soil in anticipation of planting season, he was portrayed with black skin.

## ANTIQUITY

In the Greco-Roman tradition, the goddess Nyx, daughter of the primordial Chaos, personifies the night and the elemental obscurity of the world. In that capacity, she is a formidable divinity. But if she engenders the day, the air, and sleep, she is also the mother of those abstract and mysterious entities and forces most feared by the ancients: the Furies and the Fates, the mistresses of the threads of human exis-

*In ancient Egypt, the art of dance was often linked to fertility rites meant to stimulate the growth of vegetation. This dancer's slender and lithe silhouette was probably traced with a lampblack-based ink some time in the sixteenth century B.C., during the Seventeenth Dynasty. Turin, Italy, Museo Egizio (Egyptian Museum).*

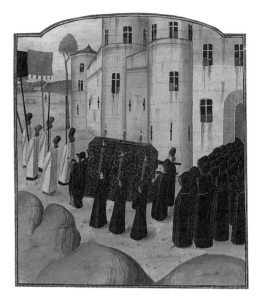

This illumination adorns the fifteenth-century Anciennes Chroniques d'Angleterre (Ancient Chronicles of England) compiled by Jehan de Waurin (d. c. 1474). The black habit indicates mourning and identifies the members of the clergy, but it was not until the eighteenth century that their black soutane (which derives from the Italian sottana, meaning "undergarment") became the obligatory attire for priests. Ms. Fr. 77, Fol. 253, Paris, Bibliothèque Nationale de France.

Opposite page: When Horace Vernet (1789–1863) painted his Ballade de Lénore (Ballad of Lenore) in 1840, he used the full range of black hues to express the subject matter's unfolding drama. The black pigments were created by burning peach and plum pits, young vine shoots, willow and beech bark, ivory, or, in their absence, deer horn trimmings, cork... and, of course, there was also chimney soot and the deposits left by candle flames. "Animal"-based blacks offered the best results for oil painting. Nantes, Musée des Beaux-Arts.

tence. Nyx also gives life to death. Artemis is sometimes represented as a black goddess who slays with her arrows and causes death for women in labor. But in Eastern lands, she also personifies the devotion rendered to the deeply ancient Neolithic feminine divinities who ruled the bowels of the earth and the forces of fertility and fecundity.

## THE WEST

During the Middle Ages, the color black represented ambivalent values. In Christian symbolism, the blackness of night related to death and to the passage toward resurrection. Allegorical illustrations depicted Night as a winged woman with dark skin, clad in a great somber veil and carrying two sleeping children in her arms: on the right, a white one named Sleep and on the left, a black child, Death. The color black represented affliction and penance. They draped black bunting in church during Advent and Lent. But, above all, black was the impenetrable and dangerous color of sin, fallen angels, hell, and the devil. Medieval Europeans were afraid of black and somber colors. Dyers had not yet mastered the techniques to create rich black colors for apparel, and so black fabrics were only fit for the poor. When blue became the most desirable color in the thirteenth century, the wealthy spent their fortunes to obtain blue-tinted textiles for themselves, while black and dark shades became the colors of the Church (priests and monks) and of Justice (magistrates and public officials). But in the first half of the fourteenth century, a proliferation of laws and decrees appeared compelling the populace to dress in black. Actually, exotic blue dyestuffs were very costly to import, and it also became an issue of maintaining Christian traditions of virtue. The rich submitted grudgingly to the restrictions and then demanded perfect black textiles, which dyers

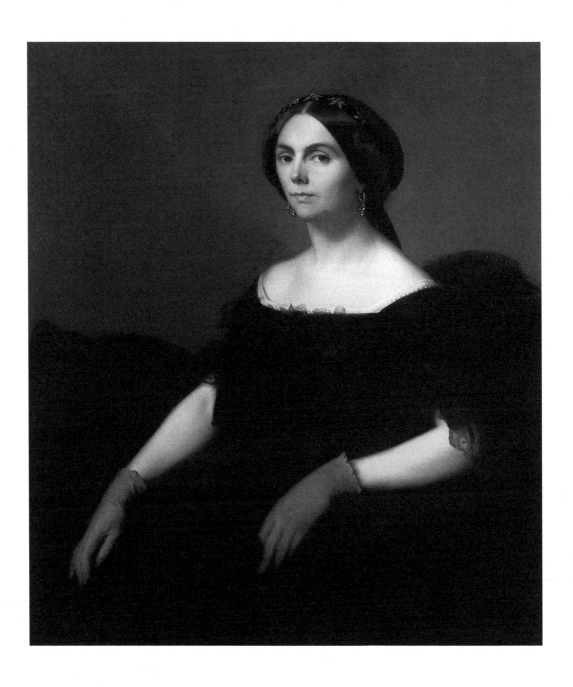

were finally able to provide in the second half of the fourteenth century. Their recent successes with blue dyes had probably helped their techniques with black ones. The vogue for black was launched, and all the social classes followed. The fifteenth century became the great era for black attire. In the sixteenth century, the Reformation praised somber dress as a sign of humility and modesty and intensified support for the color. Now Western society manifested both the regal black of aristocracy and the moral black of religion. Catholic black coexisted with Protestant black.

In the course of the sixteenth century, black became the obligatory color for mourning, a ritual with ever stricter rules. This fashion cemented the fortunes of the textile industry, but many were ruined in 1716 when an order from the Regent, Philippe II of Orléans (1674–1723), halved the duration of the mourning period for the court and for families.

To this day, somber mourning clothes are worn in Christian lands across the Mediterranean world, and the social codes sometimes remain quite austere. During burials one can see people dressed in black gathered around the grave, then a concentric rank dominated by dark blue and brown garments, and then finally, still farther back, people less directly touched by the bereavement dressed in lighter colors.

Greek women express their sorrow with the following plaint:

> My tears now burn
> And have dyed my handkerchief black.
> I have washed it in nine rivers
> But I can never regain its colors.
> I plunged it then into the deep current
> But it still remained black,
> While a partridge bending over to drink
> Saw its wings turn black.

*The attire of the Comtesse de Goyou, painted by Hippolyte Flandrin (1809–1864), embodies the values of the nineteenth-century bourgeoisie. Black fabrics gained legitimacy with the Reformation. This new appreciation for black spread across Europe, borne by Protestant nations, the spearheads of the Industrial Revolution, and little by little the somber costume became a lasting symbol of elegance imbued with austerity. Montauban, Musée Ingres.*

The increased appreciation for black that had begun in the fourteenth century not only endured but also experienced a boom in the course of the nineteenth century when this color (paradoxically) incarnated both bourgeois elegance and anarchist revolt. In Western society a black tuxedo and the classic "little black dress" still reflect the standard for evening wear today. Black, like navy blue, has become a color for all occasions.

## ISLam

Born of the desert, the Arabic civilization commands an ample vocabulary for browns and related colors, terms often derived from words referring to the earth, dust, and ashes. The word for the color black is used to describe somber hues from raven plumes to mature dates. The root of the word connotes the idea of power and strength, but in Arabic culture, it is often an infernal strength, evoking vengeance, sadness, and death. Those with a base and vulgar nature are said to have a "black heart." The color black may be so feared that, as a precaution, Arabs sometimes turn to antiphrasis and, for example, use the term "white" when speaking of charcoal or tar. The color has also fed a number of superstitions. At the beginning of the twentieth century in Morocco, people still appealed to a legendary female character known as Lalla Aïcha el Bahria, who possessed a double status as a saint (she is described as wearing white) and as a jinn with awesome evil powers. In her latter form, Lalla Aïcha is depicted as a seductive and alarming black-skinned woman.

The color black reached a historic level with the Abbasid dynasty, which lasted from 750 to 1258 A.D. They venerated Ali, the Prophet Muhammad's son-in-law, whose assassination gave birth to the Shiite Muslim movement. In his honor, the Abbasids imposed the color black on every aspect of court life in Baghdad. Official clothing, royal flags, and even coffers containing official documents were colored black to celebrate the martyr. To wear anything other than black for audiences at the palace meant rejecting the authority of the Abbasid caliph. Black remains a central color today throughout Shiite Islam.

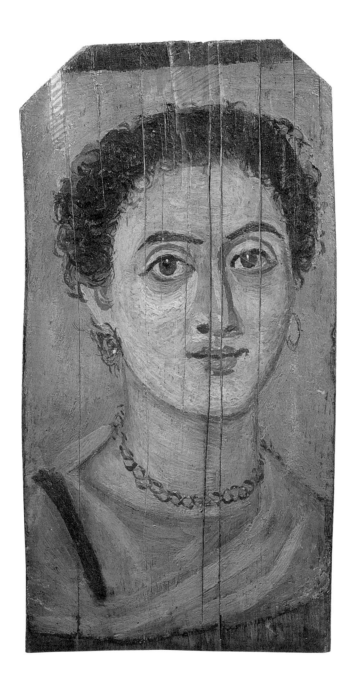

More than six hundred portraits on wooden panels have been recovered from the necropolises of Fayum. These encaustic, or wax-based, paintings were inserted into the bandages wrapped around mummies. In this example, dating from the second century A.D., the young woman's hairdo and the shadows that give depth to her facial features were shaped with soot or pigments made from burning ivory or wine sediment, sometimes mixed with white (chalk or lead white) to lighten the color. In this era, it was common to create a portrait during the subject's lifetime in anticipation of the person's future funeral. Paris, Musée du Louvre.

Above all, black is the color of the Kaaba, the spiritual center of the Muslim world located in Mecca. This immense black stone building covered with a black veil (*kiswah*) contains a black meteorite, brought to earth by the archangel Gabriel. Tradition states that the Kaaba had been built by Adam, after he was expelled from his earthly paradise. Destroyed by the Great Flood, the Kaaba was then reconstructed by Abraham and his son Ishmael. But Mecca had long been a sanctuary. Pre-Islamic tribes had come there for centuries to worship feminine and maternal deities, and the Kaaba's black color may be linked to an ancient cult venerating fertile soil.

# Painting the Darkness

## origins

In his *Evolution Man: Or, How I Ate My Father*, British writer Roy Lewis (1933–) describes his version of humanity's first use of black pigments:

> "Hey! Hey!" yelled Alexander.
>
> "What were you in the middle of doing?" snarled Uncle Vanya.
>
> "I was…I…simply," said Alexander, sobbing, and he collapsed. He held in his hand a long, lifeless ember, and his entire body was striped with black.
>
> "Outrageous! Outrageous!" thundered Uncle Vanya.
>
> "But what's going on?" asked Father, coming forward to see.
>
> We all came closer and uttered a cry of surprise. There, on the rocky floor, was the shadow of Uncle Vanya, but separate from him, immobile. Without any possible doubt, it was his shadow: no one could mistake those vast stooped

shoulders, those hairy legs, that curved back, those fuzzy
buttocks, that prognathous jaw, and, above all, that ape-like
arm extended in a typical accusatory gesture. And here,
the shadow was there, immoveable and fixed in the most
astounding manner, in the middle of our shadows, which
danced and trembled in the firelight.

"What is it?" demanded Uncle Vanya in a terrible voice,
even though there could only be one disastrous answer.

"Figurative art," sobbed Alexander.

Without a doubt, our prehistoric ancestors discovered charcoal,
lampblack, and soot at the same time as fire. Although they only fig-
ured sporadically in Paleolithic rock paintings, these pigments were
then integrated into the palettes of all artists, whatever their era or
culture, and rounded out the range of brown earth pigments. Artists
depended on charcoal to execute sketches because the pigment was
impermanent and therefore easy to alter and correct. But vegetable
blacks also played a role in the realization of paintings. Charcoal's
tonalities differed depending on what substance was combusted.
Artists took advantage of these subtleties and diversified their palette
of dark shades by increasing the variety of products they burned. In
addition, they discovered new sources of black pigments.

## PHaraoNIC EGYPT aND aNTIQUITY

Ancient Egypt turned to vegetable blacks and soot to depict wigs and
to emphasize details and decorative lines in their artworks. But in the
Old Kingdom during the third millennium B.C., painters used calcined
ivory or bone fragments (first cleaned of their fat and blanched) and
even deer-horn trimmings to create black pigments for their landscape
murals. These formed "ivory black" and "bone black," which provided
brown or very light gray tones.

Around the Fertile Crescent, artists also accessed bitumen, a
viscous black substance that surfaced on the soil above the layers of
oil. Bitumen was used to represent the pupils in ancient Near Eastern

*Following spread:
The palette favored
by the Dutch artist
George Hendrik
Breitner (1857–1923)
is characterized by
saturated and muted
tones. Perhaps he
even used a little
bit of bitumen in
his* Clair de Lune
(Moonlight), *painted around
1888. In the
nineteenth century,
many Romantic
painters heat-
blended hydrocarbon
with linseed oil and
wax to achieve a
shiny brown color.
Unfortunately,
some would use it
excessively to darken
their canvases.
Today many of
these works have
been ruined by
bitumen paint,
a coal-tar-based
substance that never
completely dries.
The viscous material
would seep through
the paint layers and
cause the surface to
crack, blister, and
tarnish. Théodore
Géricault's (1791–
1824)magnificent
1819 work* The Raft of
the Medusa *provides
a sad example of
such damage. Paris,
Musée d'Orsay.*

statuary. Much later, in the Islamic era, they coated chased metal with it so as to highlight the finely etched designs.

During antiquity, artists valued the bluish nuances provided by "vine black" and "wine black," which were formed by burning vine shoots and grape marc. These pigments formed part of the decoration of Etruscan tombs. Painters extracted delicate gray-blue tones to use in the Fayum portraits.

## European Painting since the Middle Ages

Medieval painters often turned to vine black, which they called *nigrum optimum,* the "best of blacks." Soot (*atramentum* in Latin) provided an entire palette of grays. In addition, soot blended with gum arabic formed bistre, which became celebrated in Western art through the ink-wash drawings created by the seventeenth-century Dutch artist Rembrandt van Rijn (1606–1669). At the end of the eighteenth century, European watercolorists developed the style of painting with sepia, a pigment obtained by drying the dark brown liquid secreted by cuttlefish. Some also mixed it with oil, but this approach was not very common. A little later in the nineteenth century, painters rediscovered bitumen, sold commercially as "bitumen of Judea," and used it extensively to darken their tableaux.

## African Art

In Africa, the Dogon coated their ceremonial masks with a paste made of charcoal and a concoction of tannins. The Igbo in Nigeria added abstract motifs to the walls of their cult sanctuaries with a black paint based on charred wood. They sometimes added an extraction of leaf sap to give the pigment a light sheen. The Nganga of the Congo adorned their sacred places, particularly those that housed young pubescent girls during initiations, with a charcoal derived from a local tree. When it was burned, it formed a dark brown pigment. They then added resin to improve its appearance and quality.

## oriental art

China developed a rich tradition of monochromatic landscape paintings, which were often created with a black pigment derived from charred rhinoceros horn. This substance allowed an artist to translate the subtleties of perspective into gradations of the color black. Darker tones were used for the foreground, while lighter and lighter grays expressed the sense of distance.

A soot-based black pigment also became popular for decorating kites, where a swallow figure breaks free from a background that has been blackened with soot collected from the bottom of pots. It became common to call this type of drawing a "pot-black background."

## amerindian art

Analyses conducted on Maya murals at Teotihuacán revealed that the grays resulted from a blend of vegetable blacks and chalk. Unfortunately, these two very powdery ingredients wore away faster than other pigments in the paintings, and surfaces that were once colored gray today appear profoundly altered.

In North America, the Inuit of the Pacific Northwest used ashes or vegetable blacks to add somber tones to their carved wooden ceremonial masks. These pigments were later replaced by gunpowder.

In Canada, native peoples turned to bone black to decorate their caribou skins with drawings of human and animal eyes.

*For his bamboo painting, a Chinese master artist of the Yuan era (1274–1368) utilized a brush to apply the ink. He superimposed several layers to intensify the impact of the foreground elements, but diluted the ink to create the grays that provide the illusion of distance. Paris, Musée National des Arts Asiatiques Guimet.*

In the deserts of the American Southwest, the Navajo used diverse pigments to color the grains in their ritual sand paintings. Charcoal made from calcined wild oak roots provided the black shade. And when it was blended with white sand, it created a subtle array of pastel blue tones.

## Australian art

In Australia, Aboriginal artists frequently replaced black made from manganese, a hard-to-find oxide, with vegetable blacks. Certain of their paintings are characterized by entirely black backgrounds; for these artworks, they recycled carbon from the considerable supply of old electrical batteries jettisoned by pilots during World War II. Since then, they have systematically reused flashlight batteries. In the Transvaal region of South Africa, women also turned to the same source to make the black paint they used to decorate the facades of their homes.

# Black Ink

People everywhere have used black pigments (created by various means of combustion) to send messages. In North America, the Chippewa drew charcoal ideograms (of canoes, teepees, etc.) on birch leaves and birch bark and placed these signs in precise locations along with sticks pointing in specific directions. Anyone who then came upon this spot could understand the path taken by his predecessors, but would also know, by reading the ideograms, how many people had been in the earlier party, how many nights they had slept at this place, or whether there were any children or sick persons in the group. But charcoal powder was ephemeral. Since the birth of writing, humans worked hard to develop colored liquids solid enough to ensure the durability of communications. The answer was ink, whether it was used for writing or drawing. Black pigments turned out to be particularly valuable ingredients in its manufacture.

## chinese recipes

Beginning in the third millennium B.C., lampblack inaugurated the rich tradition of Chinese writing arts. The synthesis of ink was truly a work of genius because it was very difficult to blend water and carbon particles thoroughly into a homogenous whole. Its production led to the rise of a veritable industry around 1500 B.C. Several hundred little oil lamps were set up in a room protected from air currents by bamboo curtains. The flames left soot deposits on the interior walls of funnel-shaped vessels, which had holes on their tops to allow for the evacuation of gases. Every half an hour, the soot was collected with a feather. The substance then had to be bound with a sufficiently fluid liquid to make the actual ink. The secret to their success consisted of blending the soot and the water with animal glue (gelatin made from stag, fish, or cattle). The result was the renowned "china ink," also known as "india ink." They later added vegetable oils, like rapeseed and sesame, and various other ingredients (musk, camphor oil, spices, or medicinal herbs). The ink paste was placed in molds shaped like animals, bells, and even sticks. When it dried, it was coated with sugar syrup so that the ink would not crumble. A calligrapher had only to thin out as much as he needed by turning the end of the stick into a stone hollow containing a few drops of water.

Other ink recipes were devised: burning pine wood or pork fat, the adjunction of crushed pearls, iron sulfate, and charcoal powder (for "stone ink"). Inks were aged for several years to improve, like wine. Always on the lookout for pigments capable of conveying all the gradations of grays and blacks, artists would taste the inks in order to judge their quality by their flavor.

## the inks of antiquity

In Egypt, lampblack-based inks were produced with a gum arabic binder, which also rendered the tiny particles of charcoal compatible with water. The earliest examples of papyruses composed with this type of ink date from 2600 B.C.

In ancient Greece and Rome, they perpetuated the usage of lamp-black-based inks, but also relied on a black lake that had been invented to color leather black. This pigment was based on a mixture of vegetal tannates and iron or copper salts.

## THE INKS OF MEDIEVAL EUROPE

Unfortunately, the inks invented in ancient times were too thick for the bird quill styli favored by medieval scribes, so new inks based on nutgalls, gum arabic, and iron sulfate were eventually developed. Known as "iron-gall nut ink," this fluid and concentrated liquid was perfectly adapted to writing. Medieval texts have lasted till our day thanks to its durability and neutrality. (This well-proportioned mixture did not erode support structures such as paper or vellum.) During the Renaissance, they considered improving the formula by adding turpentine or vitriol. However, these very corrosive ingredients ruined the paper of many documents, especially double-sided drawing studies created by Michelangelo. Inks based on flame black were still used on Rumanian glass by nineteenth-century artists, who thinned it with glue containing alum. Using brushes made with supple cat-tail hair, painters used this ink for the outlines of their icons.

*The sacred practice of copying the Koran gave rise to the particularly rich art of Islamic calligraphy. Written in a hieratic style known as Kufic, this page was created in Tunisia, probably in Kairouan, between the ninth and the eleventh centuries A.D. The angular letters were drawn on the parchment with a qalam (a trimmed reed) dipped in a silky brown ink. The lighter-colored marks correspond to vowels and various types of punctuation. Turin, Italy, National Library.*

## THE INKS OF THE ARABO-ISLAMIC WORLD

The Near East perfected flame black inks by adding iron sulfate to them. Moreover, artists crushed the pigment finely, which gave the ink a velvety appearance. This "Oriental ink" was commonly used for the calligraphy of the Koran. In the Maghreb, they invented a soot-based ink, derived from burning particularly oily wool taken from the caudal part of sheep. The tufts of wool—and a little salt—were placed in a terra-cotta receptacle set over a fire. The ashes were pulverized with a stone and sprinkled with water. The mixture was then returned to the flames. This process resulted in a paste which, after cooling, became hard and homogenous. Whenever it was needed, pieces were broken off and diluted. Depending on the amount of water added, one could

وا جـ د و بـ ا لهـ ـم ما سـ طـ ا نـه

ر قـ يـ ة و مـ ر د ا بـ ا ط ا لـ ـل

فـ ـو ز بـ ه فـ ا لـ ه و حـ

لا تـ ظلمـ ـو لهـ ـم ـم بـه

يـ ـقـ و مـ ا مـ ز كـ سـ ل ا لـ ـه

فـ ا لـ ـم و لا تـ ظلمـ

ز و با ز حـ و نـ ا لـ ـا لـ و فـ ا

لهـ ا و تـ و لـ ـا خـ ا لـ ا لـ ـه ـو

لـ سمـ ع ـا لـ ـم ـه و با ز و

obtain a black or brown ink. When this ink was used by calligraphers in Morocco and throughout Muslim Africa to create copies of the Koran, they would sometimes thin it out in some water before swallowing it, thereby ingesting the divine word.

# THE DIFFICULTY OF BLACK DYES

"I am black…as the tents of Kedar, as the curtains of Solomon," sings the Shulamite in *The Song of Solomon.* She was as black as Bedouin tents woven from the wool of black goats. Working with black wool directly provided by animals is, in fact, the simplest way to obtain dark-colored textiles. Making beautiful black dyes, on the other hand, was a gamble. Although people developed various dyeing techniques, these were always problematic.

## THE FIRST BLACK DYES

However, it seems that black dyes have been in use since Neolithic times. Stone Age humans probably noticed that certain woods assumed a black hue after being in contact with mud, and they took advantage of this transformation. Today, we know that tannins contained in certain tree species (the bark of alder, chestnut, oak, and walnut trees, to name a few) interact with the metal oxides present in the mud to color things black. The most ancient black textile dye was based on a colorant made of iron and tannins.

Guidelines for dyeing techniques are rare in the Old Testament, as dyeing did not represent a distinct profession at that time. Dyers were also laundry workers and fullers. We know, however, from the Talmud, that the ancient Hebrews obtained beautiful blacks by layering successive indigo, madder, and saffron dyes. They were also aware of nutgall dyes.

## In Africa

Many African textiles were colored black with wood charcoal or flame black, but these really were more paints than dyes. Because the designs were not intimately integrated into the actual fibers of the fabric, the patterns rapidly disappeared.

On the other hand, many plant species were exploited to create black dyes: gum-tree pods, which produced a syrupy and bituminous concoction known as "thick black" when they were boiled; the pods and seeds of the genus *Piliostigma*; and the leaves and the bark of certain lianas. To color wood black, they sometimes resorted to black dyes made from ebony bark.

In Western Africa, they traditionally obtained brown dyes by using dye-producing mud (the *bogolan*) or the bark of the acacia tree. In Nigeria, the Hausa tinted the skins of animals (goats, sheep, gazelles, antelopes, donkeys, iguanas, and even frogs) black with the following recipe: iron ore slag was left to soak in a bitter solution of millet flour. They then added a little honey and boiled the mixture with the hides.

## In the Arabo-Islamic World

Even though the shiny wool from black camels could not rival silk, dyers in the Near East developed techniques using iron sulfate to dye these textiles. This product reacted with nutgalls, with the sap from the terebinth tree, and even with laurel bark juice supplemented with pomegranate bark.

## In North America

The native peoples of North America, especially the Cree, decorated their clothing with porcupine quills removed from the backs of animals and then tinted various colors. They used a charcoal concoction to make black dyes. The women then smoothed down the quills before

braiding them into different patterns. The Navajo created black dyes by boiling sumac twigs and leaves for five or six hours and then adding crushed ocher and pine nuts at the end of the cooking process.

## In Asia

The fruits of the tamarisk shrub, which are eaten in Asia, were also used to make black dyes in Laos and Thailand. In Japan, they turned to a local variety of nutgall. The techniques for black dyes had been mastered since medieval times, and dyers could generate solid grays, browns, and blacks without any problems. They also used acorns and chestnut husks with an iron mordant. The richness of the tones imparted by these ingredients was repeatedly extolled in Japanese literature.

## In Polynesia

In Polynesia, people used smoke from fires to give woven bark cloth a fast brown tint, and they sometimes evened out and fortified the color by immersing the textiles in mud. They also relied on oily soot derived from burning the fruit of the oil palm tree.

The Maori were aware of the tinctorial properties of certain muds. They buttressed the volatile blacks produced by the bark of a local tree by soaking the tinted textile in the mud for several days, then in swamp water.

## In the West

For many years, dyers in Western Europe were confronted with the ugliness of their black dyes. Made with flame black, the dyes produced ephemeral, patchy, and dirty results; created with the bark or roots of the walnut tree, they resisted neither age nor laundering. Nevertheless, these elements allowed craftsmen to save unsuccessful dyeing by plunging the textiles into another dye bath to turn them dark. Only one tinctorial substance produced a true black: nutgall. But nutgall dyes were expensive to produce, and were often fraudulently replaced with

*The different stages in the manufacturing of inks meant for writing, calligraphy, and painting were scrupulously monitored in Asia. In China, the state named ink administrators responsible for inspecting the process. The inks were dried in molds, which were often carved with motifs so that the sticks or small flat tablets would reveal delicate relief designs when they were removed. Here is an exquisite Japanese ink plate meant for calligraphy.*

*moulée*, a fugitive colorant created from the metallic dust filings found under grindstones. It also had to be mordanted with vinegar.

During the Renaissance, when the prohibitions against combining dyes were slowly lifted, the ingredients that had once generated such dreary colors were reused, this time as overdyes. Now they were added, for example, to a first blue dye bath made with woad or indigo, or even to a red dye bath made with madder. Craftsmen also exploited the rich tannins inherent in logwood. Finally, dyers were able to achieve deep, warm, and uniform blacks, but they remained costly because they required large quantities of raw materials and a workforce capable of balancing the intensity of the red and the blue dye baths to obtain a neutral black result, and not one with bluish, greenish, or reddish-brown undertones.

By the eighteenth century, black dyes had progressed so much that artisans could produce more than forty different tonalities, including silvery gray, thorn gray, Moorish gray, rat gray, dying ape, and dying Spaniard gray.

# BLACK ON THE SKIN

The skin is a blank canvas for markings and makeup all the way to full body painting and even the most deeply etched tattoos.

## EPHEMERAL ADORNMENTS

The use of kohl dates from the Great Flood. After so many days of rain, the survivors on the Ark could no longer bear to look at the light. God said to Noah: "Make them all darken their eyes with kohl." And so it was done, and they could see.

Kohl, a black pigment, is generally applied as makeup around the eyes to intensify one's gaze. It is extremely popular with married women in Arabo-Islamic countries. They make it from crushed pieces of antimony, which they grind in a small mortar and reduce to a very fine powder. Kohl is also used for babies. People put it on their navels

*The word "tattoo" came from Captain James Cook (1728–1779), who brought it back to England from his voyage to Polynesia at the end of the eighteenth century. It combined the Tahitian terms Ta (a design drawn on the skin) and Atoua (spirit). Europeans were fascinated by the rich, complex tattoos worn by many peoples. (Here we see a woodcut from a nineteenth-century volume.) If the origin of these indelibly drawn body markings has been lost in the mists of time, their main function has been to counter harmful powers, as was the case in pharaonic Egypt. Tattoos also identified the individual within the context of his community (chief, shaman, etc.), or even signified the accomplishment of certain initiation rites. From the Indochina peninsula to Canada, from Maori leaders to Fulani fiancées, the great majority of tattoos were made with lampblack-based inks. Collection Jonas.*

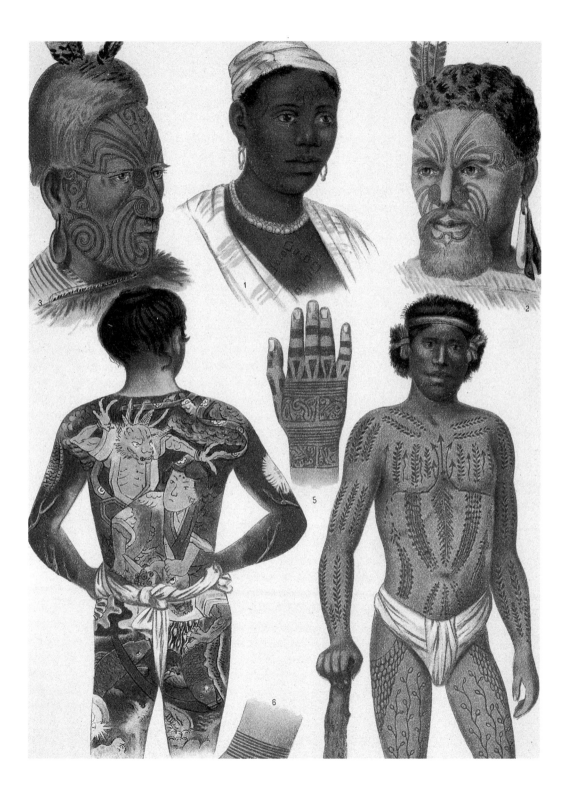

after the umbilical cords are cut. They also blend it with oil and blacken the babies' eyebrows with the mixture to repel the evil eye. It is said that those who use kohl on their eyes will never develop trachoma, an ocular inflammation commonly resulting in blindness. In addition to kohl, North African women turn to a colored paste called *hargous*, based on nutgalls that are crushed and then blended with a little soot, burnt oleander, and oil. They used it to draw designs between their eyebrows and on their chin for marriage or circumcision ceremonies.

In India, after the birth of a child, they pay homage to a cult of the goddess of the sixth day. Using smoke from the lamp that served in the ritual adoration, they prepare a black makeup. With this substance, they then mark the parts of the baby's body evil spirits most covet: the soles of the feet and the palms of the hands.

In Africa, while black is often incorporated into the practice of witchcraft, the color is perceived very differently when it defines a person's skin. For the Nuba of southeastern Sudan, black connotes masculine beauty, and the body is sometimes glorified with applications of black unguents made from charcoal or from the sap of previously mashed fruit. These embellishments are reserved for men and are supposed to render them stronger and protect them from the evil eye. When it comes time to marry, the young men from the Tiv tribe compete with each other creatively to attract a bride. They design fantastic shapes on their shaved skulls by leaving some tufts of their hair intact and adorn their bodies and faces with complex patterns, drawn with black dyes derived from gardenia seeds.

For the Pygmy hunters, black is the color of camouflage. Before great expeditions, they cover themselves with black markings made from the ashes of trees chosen for their magical properties. These patterns are meant to render them invisible to the prey.

When ceremonies involve quick changes in adornment, ephemeral body art has the advantage of erasing easily. The Kayapo of the Amazon decorate themselves simultaneously with two distinct types of paints. The first was composed of charred wood and water. For the second, they mashed the pulp and pips from the fruit of the *Genipa americana* tree. Once it comes in contact with the skin, the plant juice

begins to oxidize and, after several hours' time, black patterns appear on the body. Therefore, during the early part of the ritual, only the charcoal-drawn motifs were visible. They then fade away, while the second patterns slowly emerge.

During ritual celebrations of the emu, the tribe's totemic animal, some Arunta people apply designs on their bodies with a charcoal and fat mixture because the pigment's color evokes the bird's plumage.

Farther north, the Yafar of New Guinea prepare a dark gel mixture composed of charcoal, sago (a flour derived from the pith of certain palm trees), and various vegetable juices. Officiants use this paste during complex ritual ceremonies.

In the Vanuatu archipelago, the inhabitants of Espiritu Santo (also called Santo Island) reserve body painting for just two occasions: mourning and war. The former is expressed exclusively through black images made with charcoal, and the latter with red designs. In the context of death, black pigment provides a protective function by concealing the living from attacks by the dead, who hover nearby. The men apply charcoal powder to their foreheads, the tip of their noses, and their cheeks using a thumb on oiled skin, until they achieve a waxy appearance.

In Port Orly, women cover their whole bodies with soot for feast days, while children freely draw on themselves any pattern that comes to mind.

In ancient China, black pigments, especially soot, had been used as makeup. Women blackened their eyebrows with it and traced black triangles on the edges of their cheeks. Under the Tang (618–907 A.D.), they drew a black dot between their eyes and a crescent at the ends of their eyebrows. Some also painted their lips and teeth black.

## Tattoos

Dark saps extracted from plants were sometimes used for tattooing, especially in South America. Using a type of fruit juice, the Yanomani people in northwest Brazil tattooed a black pattern on young pubescent girls from the corners of their mouth to their chin. These tattoos

were meant to permanently block any mysterious or demonic forces present in a girl's menstrual blood that could endanger her future husband.

Flame black and soot, however, were the preferred materials for creating tattoos. But regardless of the pigment, tattooing provided proof, through enduring ornamentation, of the recipient's great courage for tolerating this painful procedure, the stability of their social status, and an embellished and appreciated body.

Inuit tattoos were made with ivory, bone, or copper needles, or even whale or caribou tendon fibers, coated with soot. These particularly uncomfortable tattoos were applied to a woman's face, arms, and hands. The more tattoos, the more she was considered as brave by her community. In Micronesia, tattooers on the Marshall Islands make a black pigment from the soot of burned oil palm tree kernels mixed with palm oil, which allows the substance to dry more rapidly. The most desirable color was the fuliginous black of the black noddy, a sea bird in the tern family.

Soot from the bottom of pots was also used in Berber tattooing. In days of old, mothers would often give their infants protective tattoos, thereby indelibly stamping them with a shield against the powerful effects that looks of envy and resentment could have on such particularly vulnerable creatures. For the young girls, the facial tattoos were distinct to each community. There were others as well, more secret ones, which this poem celebrates:

> A tattoo on her bosom, oh how dark,
> Had burned my heart before I had loved her…

*Tattoos are an important element in ethnic identification in the High Atlas region of Morocco. But they are also considered an adornment, like the kohl design that highlights the features of this young Berber woman.*

# THE USES OF BROWN AND BLACK

# Brownish earth pigments

LIKE THE OCHERS AND YELLOW AND RED EARTH PIGMENTS DISCUSSED EARLIER IN THIS BOOK, THESE BROWN AND BLACK PIGMENTS CONSIST OF CLAYS COLORED BY IRON OXIDES. MOREOVER, UMBER EARTHS CONTAIN MANGANESE OXIDE. THEY CAN BE FOUND ON EVERY CONTINENT IN THEIR RAW STATE, BUT SOME ARE CALCINED TO DESTROY ANY ORGANIC IMPURITIES AND STIMULATE THE DEHYDRATION THAT DEEPENS THE PIGMENT'S TONALITY. THE LATTER ARE CALLED "BURNT EARTHS." THERE ARE TWO HYPOTHESES ON THE ORIGIN OF THE TERM "UMBER EARTHS." ACCORDING TO ONE EXPLANATION, THE NAME DERIVES FROM THEIR USE—SHADING. (THE LATIN FOR "SHADOW" IS "UMBRA.") OTHERS BELIEVE IT COMES FROM UMBRIA, THE ITALIAN PROVINCE THAT IS HOME TO MANY SUCH PIGMENTS. BUT EVERYONE SEEMS TO AGREE ON THE FACT THAT THE BROWN EARTHS FROM CYPRUS OFFER THE BEST QUALITY.

Like yellow and red ochers and earths, brown earths have been used throughout history and across cultures. However, while red earths have played a role in body decoration and funeral rituals since approximately 100,000 B.C., it seems that the use of brown (and yellow) earths only became widespread in the Upper Paleolithic era. In the West, the earliest traces of these pigments are found in cave paintings dating from around 40,000 B.C.

Umber earths were used sparingly during antiquity. Sienna earths and vegetable blacks were preferred. But brown earths helped create the complexion of people in the Fayum portraits, especially those depicted with bare shoulders. Burnt earths, according to certain ancient Roman authors, were discovered because of a fire in Piraeus, Greece, during which coatings created with light brown earths turned dark brown.

In Western painting, brown earths mixed with oil were principally favored by seventeenth- and eighteenth-century artists, who preferred the burnt variety. During this same period, painters of buildings also used these pigments as undercoats on wood intended for decoration. Umber earths were sometimes disparaged because they aged poorly within the pictorial layers, and produced dark salts that blackened the works of art.

## Instructions

Among the dark earths listed below, only burnt umber earth CCCN comes closest to the color black, but all are characterized by yellow, red, and green nuances. Therefore, you can produce a multitude of shades by adjusting the quantity of pigment and the type of binder. Egg yolk, for example, reinforces the yellow tint of raw umber earths, while it has a tendency to redden burnt umber earths from Cyprus.

These inexpensive pigments are concentrated and opaque, and particularly suitable for covering very large surfaces. A recipe known since the eighteenth century recommends dissolving 400 grams of iron sulfate in 10 liters of boiling water. Then add 50 grams of linseed oil and, whisking vigorously, 500 grams of very finely ground rye flour. (You could attach a paint stirrer to a drill to help this process). Cook for 15 minutes and add the pigment in stages until you achieve the desired shade. Do not exceed two kilos of pigment. Mix well and cook for another 15 minutes, stirring until it is perfectly homogenous. Apply to a clean, dampened wall.

# VEGETABLE BLACK

THE CHARCOAL PRODUCED BY BURNING VEGETAL MATTER FORMS A BLACK PIGMENT WHOSE EXACT TONALITY DEPENDS ON THE MATERIAL THAT IS CALCINED. IN THE WEST, YOU CAN USUALLY FIND VINE BLACK, WITH ITS DELICATE BLUISH-GRAY TONES, WINE BLACK, WHICH ALSO CONTAINS BLUE HIGHLIGHTS, AND PEACH BLACK, WITH ITS REDDER TONES. VEGETABLE BLACKS HAVE BEEN AROUND AS LONG AS HUMANS, AND BLACK PIGMENTS HAVE BEEN EXTRACTED FROM A MULTITUDE OF PLANT SOURCES.

Charcoal black was less common in prehistoric painting than yellow and red ochers, but analyses of the cave art found in Niaux in southern France have shown that these drawings were produced with charcoal sticks (or fusain) made, no doubt, from the ends of conifer wood torches.

These preliminary sketches were intended to help place the definitive figurative elements, and pigmented paint would have covered over the outlines. But wood charcoal actually became part of the composition of certain images, and in these cases, the material was finely crushed and then blended with animal fat.

Vegetable blacks were the source of most black pigments used in painting, from pharaonic Egypt to the nineteenth century. And, when they were mixed with lead white, they provided an entire range of grays. Often used to trace freehand designs, they were a common element in frescoes, especially those executed by Indian artists during the first millennium A.D. and by the Italian Primitives of the thirteenth and fourteenth centuries. In addition, wood charcoal was invaluable for producing blueprints. When it was ground against a perforated board, it left traces that allowed for the identical reproduction of particular design elements. Painters from Central Asia and Tibet put these stencils to good use between the fifth and eleventh centuries.

Vegetable blacks have been used in many contexts by many cultures. Sculptors of ritual Yup'ik masks (Inuits living in southwestern Alaska) blended the material in stone hollows with a little water and seal blood to fabricate a black paint and then applied it to the carved wood with a squirrel-tail brush. Burned coconuts provide the charcoal used to paint woven bark cloth in Polynesia. In Tonga and the Fiji islands, fabricating charcoal is a veritable ritual. During the ceremony, the women charged with the responsibility must abstain from sexual relations, and pregnant women are excluded. Another source for charcoal comes from burning sugar cane. In Angola, Chokwe sculptors blacken their carvings through pyrography. They apply a red-hot machete to the wood to generate a superficial fire, thereby rendering the use of black pigments unnecessary. Small objects may also be passed directly over the flame for the same purpose.

## INSTRUCTIONS

Calcining, or roasting, vegetal matter to make charcoal must be done in a closed environment. Cennino Cennini advised extinguishing the embers at the end of the combustion by pouring water on them. Other authors have suggested using wine or vinegar.

To make vine black, the young vine shoots should be harvested at pruning time. Marc black is achieved by burning marc brandy that has been dried in a stove. According to the ancient Roman writer and architect Vitruvius, the black will be even better if the wine is good, and using the finest wine can yield an imitation indigo. Finally, you can generate quite lovely blacks by burning peach, cherry, or apricot pits, or even almond shells.

Whatever the source material, the charcoal must be carefully ground, first in a stone mortar, then with a molette on a marble plaque. The finer the grains, the more delicate the resulting tones.

# Lampblack or flame black, soot, and bistre

"LAMPBLACK" AND "FLAME BLACK" ARE NAMES GIVEN TO A BLACK PIGMENT COMPOSED OF FINE CARBON PARTICLES, FROM THE COMBUSTION OF SMALL QUANTITIES OF RESINOUS OR OILY VEGETAL SUBSTANCES (BEESWAX CANDLES, FOR EXAMPLE). SOOT IS THE SAME PRODUCT, BUT ARTISTS OFTEN RESERVE THIS TERM FOR THE CARBON PRODUCED BY FLAMES (ESPECIALLY PINE FIRES). BISTRE IS MADE BY COMBINING SOOT AND GUM ARABIC.

Black pigments derived from lampblack or flame black have been used since the dawn of humankind as much in painting (fresco, tempera, and watercolor) as in dyeing and, as we have seen, as inks and for tattoos. The techniques have varied depending on the culture. Before recorded history, the inhabitants of Japan colored their fabrics by rubbing soot, pollen, earth pigments, colored oxides and, then later on, cinnabar into them to incorporate the different tints. The memory of these ancient techniques has endured through such Japanese color terms as "ash-rubbed," "earth-rubbed," and "rust-rubbed" (for cinnabar). Over time, people improved the binding properties of pigments by blending them with a paste based on ground soy grains.

But the resultant dyes remained uneven and poorly resistant, with the exception of those made with soot, which withstood aging and washing. The Ajanta murals in India (painted in the second half of the first millennium A.D.) were first sketched out with small black sticks made of lampblack mixed with clay and cow dung, or even thickened with rice broth. Lampblack was first gathered from the sides of a pot placed over an

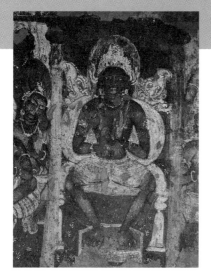

oil-fed wick. Even today, the Hindu artisans who dye-stamp textile designs often employ a very diluted concoction of water, sugar, and soot derived from kerosene lamps to draw guidelines on the textiles so that they can correctly position their patterns. This ephemeral black color has the advantage of disappearing after the first wash. The Araucanians, an Amerindian people, dye textiles a deep but fugitive black by boiling them in large cauldrons with lampblack.

Mbuti women in the Congo paint their loincloths with soot collected from cooking utensils and mixed with the juice of a local fruit that acts as a fixative. Women in the Transvaal blend soot and silt dug up from the banks of a neighboring river and use it for their architectural decorations.

## INSTRUCTIONS

You can collect lampblack by placing a pane of glass over a candle or an oil lamp. A chimney wall can furnish soot. These pigments are sometimes disparaged for being too oily and turning mixtures muddy, but they make excellent inks. The following recipe, inspired by an eighteenth-century process, combines lampblack and vine black.

Measure out 420 grams of gum arabic, 400 grams of lampblack pigment, and 90 grams of vine black pigment. Carefully combine the ingredients, slowly adding water until they have the consistency of cake batter. Pour this into several small molds and let dry in the shade. When the substance begins to harden, press a couple of round cavities—about ⅜" (1 cm) deep and ⅝" (1½ cm) wide—in each bar, and let it finish drying. When the ink is perfectly hard, remove them from their molds and coat each block with a mixture of thick sugar syrup dissolved with water. When you are ready to work with the ink block, just add a few drops of water to the specially-made hollows, and thin out a little bit of ink with a brush. Then you can use either a brush or a pen. You can also add a tiny amount of essential oils to the recipe if you want to perfume the ink.

*This image from Cave 2 at Ajanta shows the Buddha seated in Tusita Heaven just as he is about to be reborn on earth.*

# nutgall

A NUTGALL (ALSO KNOWN AS A GALLNUT) IS A HYBRID CREATED BY THE INTERSECTION OF THE ANIMAL AND PLANT WORLDS: IT IS FORMED BY AN INSECT (USUALLY FROM THE FLY FAMILY) THAT LAYS ITS EGGS IN THE BUDS AND LEAVES OF CERTAIN SPECIES OF OAK TREES. TREE SAP EXUDES FROM THE HOLE PIERCED BY THE INSECT, ENVELOPS THE LARVA, AND FORMS THE NUTGALL AS IT DRIES. NUTGALLS MUST BE GATHERED BEFORE THE END OF THE SUMMER, WHILE THE INSECT LARVA IS STILL INSIDE, BECAUSE IT THEN CONTAINS THE MAXIMUM AMOUNT OF TANNIN (UP TO 70 PERCENT). THIS TANNIN RENDERS THE NUTGALL A POTENT COLORANT. THE GALLS ARE THEN SET OUT TO DRY, AND THEY CHANGE FROM BROWN TO A YELLOWISH WHITE. THEY ARE HARVESTED THROUGHOUT THE NEAR EAST AND IN MEDITERRANEAN COUNTRIES.

Dyeing with nutgalls has been practiced in the Mediterranean world since antiquity. Textiles tinted with nutgalls by the ancient Hebrews during the first century A.D. have been discovered near the Dead Sea. The tannin-rich nutgall was a valuable substance in tanning leathers, rendering the skins rot-proof and less permeable to water. Finally, the nutgalls provide the essential component in "iron-gall nut ink," which, as the name indicates, contains gallotannic acid and ferrous sulfate.

It served in Egypt and China from around 2500 B.C. and was still used in the West at the beginning of the twentieth century. The majority of Western documents since the beginning of the Middle Ages have lasted to our day thanks to this extremely resistant ink. Nutgall, a basic element for a number of artisanal crafts, therefore became an early object in international commerce. During the Roman Empire, the area around Aleppo,

## instructions

You can easily find nutgalls in local Asian markets. Break them apart, then pulverize 20 grams of nutgall until it is reduced to a fine powder. Add 10 grams of cream of tartar. Cream of tartar is not needed to prepare the fabrics for dyeing, since the tannin contained in the gall suffices, but it does brighten the resulting color. Add water to form a paste, and let it rest for several hours. Dissolve this paste in a pot with 10 liters of water, and introduce 500 grams of fibers or fabric. Heat gently and let it boil for an hour, stirring often. Remove the material and let it cool.

If the resulting black does not seem dark enough, add 10 grams of iron sulfate to the dye bath. Reintroduce the material when the water temperature reaches 40° C (104° F) and let it boil again for 15 minutes. Remove the material, wash it, and rinse it thoroughly. The final color will be very resistant to light and launderings.

To make ink with nutgall, finely crush 30 grams of the substance. Cover the powder with water and let it macerate until a mold begins to form on the surface of the liquid. Filter it and boil the juice for five minutes. Set aside. Melt 30 grams of gum arabic in 10 grams of water. Let both solutions rest separately overnight. The next day, reduce 20 grams of iron sulfate to powder in a mortar and dissolve it in 10 grams of water. Add the gall juice, and then introduce the syrup of gum arabic. Blend it all together carefully.

Syria, developed into an important export center for nutgalls harvested in Asia Minor and as far away as Kurdistan. By the end of antiquity, the principal producer regions were northern Mesopotamia and southern Armenia. In the medieval era, galls were imported especially from Smyrna, the Greek islands, and Istria, but they were harvested for local usage throughout the entire Mediterranean region. Only nutgalls provided deep resistant black colors. Medieval Europeans ignored their actual nature and called them "oak apples." As an expensive product, they were used exclusively for the most precious of fabrics. Nutgalls were generally imported from afar, and many were needed to generate a small amount of colorant. Moreover, it was difficult to master the addition of iron. Too little, and the color would not take. Too much, and it would corrode the fabric.

The eighteenth century was the great era of nutgall dyeing in Europe. For the manufacture of printed textiles, it was blended with antimony and vinegar, containing dissolved iron filings. It was also used as a mordant preparing fabrics to be dyed with Adrianople red, and for many years, it remained the only ingredient that could turn silk frilly.

# european chestnut
*Castanea sativa* Mill.

THIS LARGE TREE, WHICH CAN REACH A HEIGHT OF ABOUT A HUNDRED FEET, POPULATED MANY OF THE FORESTS IN EUROPE'S LOWER TEMPERATE MOUNTAIN REGIONS. IT WAS CULTIVATED IN NORTH AMERICA, EUROPE, AND NORTH AFRICA.

The chestnut tree was commercialized for three reasons: its lumber was the basis of high-quality woodwork; chestnuts and chestnut flour saved many people from famine, particularly French people living in the Massif Central and in Corsica; and finally, and most importantly, trees over fifty years old were rich in tannins, which were highly desired by dyers and tanners.

These two trades needed substances for mordanting and for tanning leather. One product perfectly suited these demands: alum, a potassium aluminum sulfate extracted from rocks, was used universally.

The preparation and sale of alum have been part of international trading since ancient times. Genoese merchants imported it from Egypt, Syria, and Asia Minor to the great cloth-producing and wool-producing centers of Medieval Europe. But, as it came from afar and required a long purification process, alum was a costly mordant, reserved for the dyeing of luxury goods. In addition, during the fifteenth century, alum imports from Asia Minor were interrupted because of Turkish conquests. Dyers were confronted with an almost total shortage, and they looked to replace alum with local products. For ordinary textiles, they used mordants like tartar, recovered from the sides of wine tuns, lime, vinegar, and urine. But it turned out that chestnut ashes provided the best mordants, and the tree species began to be commercialized extensively.

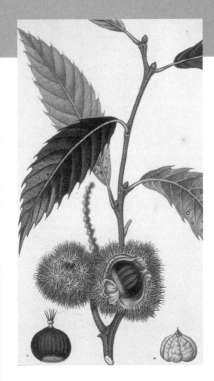

Moreover, chestnut tree leaves supplied beige and brown colors and, with the addition of iron, grays and blacks. In the Ottoman Empire, they combined yellow dyes derived from chestnut leaves with indigo to make greens.

At the beginning of the nineteenth century, the discovery of processes for extracting tannin led to an intensive use of chestnut wood by the tanning industry. In the meantime, dyers learned how to use it for the first bath (they turned to camwood for the second bath) in order to dye cotton black. Chestnut groves were vastly developed until 1950. Unfortunately, overexploitation and diseases decimated the forests, and the chestnut tree increasingly became the poster child for a tree species on the path to extinction.

## Instructions

The bark, leaves, and burs of the chestnut tree can produce dyes. Using leaves gathered in the spring, you can create beige tones. Those collected at the end of the summer provide a warm brown. You can use fresh or dried leaves. Crumble 300 grams of leaves and let them soak in a pot of water for three days. Once they have soaked, add more water, for a total of 10 liters. Add the fibers or fabric, slowly heat the pot, and boil it for 1½ hours. To achieve a well-mixed dye, keep a watchful eye and stir regularly. Let the material cool in the bath. Rinse. If the resulting tint is not dark enough, start the process again, this time adding a brew made of branches broken into little pieces and boiled in water for an hour. Boil the whole mixture for 30 minutes. The branch infusion can be used as a mordant for a great number of brown, black, and gray dyes, but it adds a yellow tint. Colors derived from the chestnut tree are lightfast and laundry-resistant.

# persian walnut
*Juglans regia* L.
## and walnut hull brown

TH PERSIAN WALNUT TREE (ALSO KNOWN AS THE COMMON OR ENGLISH WALNUT) GROWS ABOUT FORTY-FIVE FEET HIGH. ALTHOUGH NATIVE TO ASIA MINOR, THE SPECIES WAS INTRODUCED TO WESTERN EUROPE LONG AGO. ITS LEAVES SUPPLY COLORFAST BROWN DYES, AND THE HUSKS THAT ENVELOP THE HARD SHELLS SURROUNDING THE ACTUAL NUTMEAT CREATE WALNUT HULL BROWN.

At the end of the first century B.C., the Roman poet Ovid evoked the coloring strength of the walnut hull in his poem *Nux* (*The Walnut Tree*): "But the sap of my fruit takes revenge on my abductor, who has blackened his fingers by touching my bark. This sap is my blood, and the imprint of this blood is indelible."

According to Pliny, the Gauls used walnut hulls to dye wool brown and black. Young hulls were also used to color hair red. Like the chestnut tree, walnut wood was exploited during the medieval era to replace alum.

Although the leaves and bark of the walnut tree supplied black dyes that were less costly than those supplied by nutgall, they were also of a clearly inferior quality, unless the dyeing technique was completely mastered. The dye penetrated the fibers poorly, the fabric was often shot through with brown or tawny streaks, and the color resisted neither light nor laundering. Dyers tended to mordant their dye baths strongly with iron to compensate for the shortcomings of this unstable black (also called "false black"), but this approach rendered the fibers very fragile, and the textiles would rapidly deteriorate. Such dyes were designated as "corrosive blacks," and their practice was closely monitored by dyeing guilds. Guillaume Antoine Olivier (1756–1814), who visited the Ottoman Empire for the French government at the end of the eighteenth century and released a highly detailed account of his voyage (*Voyage dans l'Empire*

*Ottoman*, published in 1801 in Paris), recounted that young walnut shells produced bronze tints. Certain North American Indian tribes calcined walnut tree bark and roots to create deep and durable black dyes.

Today, walnut bark is still used across Africa for oral hygiene, as it clears teeth of impurities. Chewing it also restores redness to the gums, while at the same time fortifying and emphasizing the teeth's whiteness.

## INSTRUCTIONS

Pick the leaves at the end of summer and collect the hulls while removing the autumn nuts. These leaves produce brown shades with red undertones. They can also be used in dried form.

Put 300 grams of crumbled leaves to soak in a liter of water for three days. Prepare the fibers on the day of dyeing by dissolving 200 grams of alum in a pot with 10 liters of water. Add the fibers and boil for an hour. Let the fibers cool in the bath. Then add the macerated leaves along with their soaking juices to the pot, slowly raise the temperature, and let it boil for 1½ hours, stirring regularly. Once again, let the material cool in the pot. If the color is not dark enough, boil it for another 15 minutes.

Creating walnut hull brown requires a very long fermentation period. For a truly concentrated hull brown, you need to prepare two years in advance. Pile up the husks in a big ceramic pot. Cover with rain water and let them macerate, adding water regularly. The resulting dark liquid gives wool a deep brown color. You can use it to color a mordanted fabric (with alum) by spreading the diluted juice on the material with the help of a brush; however, this superficial tint will be less resistant than one obtained by boiling. Walnut hull brown can also be added to a dye bath and simmered for an hour to obtain darker or lighter tawny shades, depending on the amount of colorant in the water. Macerated green (unripe) walnut hulls can also be used at the end of a month-long fermentation period by following the same procedure. This material produces delicate greenish-gray tones.

# mud

DEPOSITS RICH IN METAL OXIDES AND DECOMPOSING ORGANIC PARTICLES OFTEN FORM IN STAGNANT WATERS. THIS MUD IS SUITABLE FOR TINTING FABRIC OR WOOD IN BROWN, GREENISH, GRAY, OR BLACK TONES. MANY PEOPLES AROUND THE WORLD USE THIS COLORFUL SILT.

Dye-producing mud is an integral element in the range of products used for coloring in Africa. The Senufo, who live in southern Mali, Burkina Faso, and the northern Ivory Coast, rely on it not only to paint their textiles brown and black, but also to decorate their pottery and the walls of their huts.

In Nigeria, the Hausa immerse their hunting outfits in the silt, which they call the "earth river." The resulting brownish tone allows the hunters to blend into the vegetation and become invisible to the prey. Using mud from the backwaters, they are able to turn the white wood for their masks matte black.

Mud-dyeing occupies a special place in the Bambara culture of West Africa, and the technique is used to color the fibers of certain loincloths known as *bogolan*. This ritual attire is invested with strong symbolic power. The brown patterns are exactly the same shade as the mud extracted from the ponds. These ponds are, therefore, considered sacred sites in each village, and the place where the souls of all unborn children come together. They sometimes call these sludge pits "the lands of copulation." Brown is also the color of the "black water" in which God himself likes to lie and which bears the imprint of His power. Also, when a hunter, a mask bearer, or a young Bambara woman dresses in bogolan, he or she symbolically puts on the spirit of the beings and events that presided at the creation of the world. The young woman is protected by the divine powers for future childbirths and is bathed, according

# INSTRUCTIONS

Remove about 10 liters of mud from a pond or riverbank. Add a little bit of vinegar in which you have soaked some nails for several days. Introduce the dampened fibers or fabric, slowly raise the temperature, and maintain a boil for 30 minutes, stirring constantly to obtain a unified tone. If the resulting tint is too pale, then repeat the operation as many times as necessary.

To create design on a uniform background, sift the mud in a chinois or fine sieve so as to eliminate the maximum amount of water, and then thin out the residue with the vinegar solution obtained from the rusty nails. The liquid should not be very fluid, but it should have the consistency of paint so that you can dip your brush. Now you can draw your desired design on a clean fabric. When the mud has completely dried, brush it off the fabric. The pattern will now appear in a black-brown hue, depending on the type of mud used.

Dyes made with mud resist some laundering, but they lose their intensity fairly quickly.

The Makah Indians of the Pacific Northwest immerse their cedar-bark baskets in the mud to color them black. Native peoples living in Oregon practice a similar technique for their hazelnut stalk baskets, but here they reinforce the blackening power of mud by adding charcoal.

to Bambaran beliefs, in virtual moisture associated with fertility.

The water and wet earth are, in fact, two fundamental elements that made life possible at the dawn of time. The idea of birth is therefore already inherent in these materials. In Asia, mud was also used in a ritual fashion to dye the threads for ikat, fabrics characterized by very specific weaving techniques. People in Thailand take mud from ponds where buffalo wallow for a mordant to fix yellow, blue, and black colors.

*Women from Sumba, an Indonesian island, combine the coloring properties of lampblack and charcoal with those of mud to darken their ikat threads. Salty sea water also plays a role in certain dyeing preparations.*

# index

# BIBLIOGraPHY

**Abu-Rabia, Aref.** *The Negev Bedouin and Livestock Rearing, Social, Economic and Political Aspects.* Oxford: Berg Publishers Ltd., 1994.

**Adam, Leonhard.** "The Abstract Art of the Aranta," in *Anthropos*, vol. 55. Fribourg, Switzerland: Anthropos-Institut, 1960.

**Andersen, Johannes C.** *Maori Life in Ao-Tea.* New York: AMS Press, 1977.

**Aufrère, Sydney H.** "Les couleurs sacrées en Égypte ancienne: Vibration d'une lumière minérale," in *Techné*, nos. 9–10. Paris, 1999.

**Aumont, Jacques.** *Introduction à la couleur: Des discours aux images.* Paris: Armand Colin, 1994.

**Bahuchet, Serge, and Guy Philippart de Foy.** *Pygmées, peuple de la forêt.* Paris: Denoël, 1991.

**Baker, Patricia L.** *Islamic Textiles.* London: British Museum Press, 1995.

**Balick, Michael J., and Paul Alan Cox.** *Plants, People and Culture: The Science of the Ethnobotany.* New York: Scientific American Library, 1996.

**Bardfield, Thomas, ed.** *The Dictionary of Anthropology.* Oxford: Blackwell Publishing, 1997.

**Beattie, James Herries.** *Traditional Life-ways of the Southern Maori.* Dunedin, New Zealand: University of Drago Press, 1994.

**Becher, Hans.** *The Surara and Pakidai, Two Yanoama Tribes in Northwest Brazil.* Hamburg: Museum für Völkerkunde, 1960.

**Beckwith, Carol, and Angela Fisher.** *African Ceremonies* (2 vol. set). New York: Harry N. Abrams, Inc., 1999.

**Bedi, Ramesh, and Rajesh Bedi.** *L'Inde sacrée des Sadhus.* Paris: Albin Michel, 1991.

**Beguin, Gilles, and Sylvia Colinart.** *Les Peintures du bouddhisme tibétain.* Paris: Réunion des musées nationaux, 1995.

**Benoist, Luc.** *Signes, Symboles et Mythes.* Paris: Presses universitaires de France, 1991.

**Bergeon, Ségolène, and Élisabeth Martin.** "La technique de la peinture française des xvii$^e$ et xviii$^e$ siècles," in *Techné*, no. 1. Paris, 1994.

**Berger, Patricia Ann, et al.** *Mongolia: The Legacy of the Chingiss Khan.* London: Thames & Hudson, 1995.

**Bernard, Patrick, and Michel Huteau.** *Yunnan-Guizhou: Couleurs tribales de Chine.* Xonrupt-Longemer, France: Anako Éditions, 1989.

**Berthier, Brigitte.** *La Dame-du-bord-de-l'eau.* Nanterre, France: Société d'ethnologie de la faculté de Nanterre, 1988.

**Berthier, Laurence.** *Fêtes et Rites des quatre saisons au Japon.* Paris: Publications orientalistes de France, 1981.

**Bertrand, Régis, and Danielle Magne.** *The Textiles of Guatemala.* London: Studio Editions, 1991.

**Bettelheim, Bruno.** *The Uses of Enchantment: The Meaning and Importance of Fairy Tales.* New York: Vintage Books, 1977.

**Bihl, Catherine.** "Matériaux et colorants," in *Masques eskimo d'Alaska.* Saint-Vit, France, Éditions Amez, 1991.

**Birket-Smith, Kaj.** *The Eskimos.* London: Methuend, 1936.

**Blomberg, Nancy J.** *Navajo Textiles: The William Randolph Hearst Collection.* Tucson: The University of Arizona Press, 1988.

**Bloom, Jonathan M., and Sheila S. Blair.** "Colour: Islamic World," in *The Dictionary of Art*, vol. 7, edited by Jane Turner. New York, Oxford University Press, 1996.

**Blum Schevill, Margot.** *Maya Textiles of Guatemala: The Gustavius A. Eisen Collection, 1902.* Austin: University of Texas Press, 1993.

**Bollon, Patrice, François Buot, and Philippe Marchetti.** "Comment notre vision des couleurs à évolué," in *Ça m'intéresse*, no. 230. Paris, April 2000.

**Born, Wolfgang.** "Le mollusque et la pourpre," in *Cahiers Ciba*, no. 5. Basel, Switzerland, September 1946.

———. "La cochenille," in *Cahiers Ciba*, no. 10. Basel, Switzerland, July 1947.

**Bosse-Platière, Antoine.** "Lumineuses ocres jaunes ou rouges…," in *Les Quatre Saisons du jardinage*, no. 114. Mens, France, 1999.

**Boucher, François.** *20,000 Years of Fashion: The History of Costume and Personal Adornment* (Expanded Edition). New York: Harry N. Abrams, Inc., 1987.

**Boulimier, Georges.** "Préhistoire de l'usage des matières colorantes, À la source du symbolisme," in *Voir et nommer les couleurs.* Nanterre, France: Laboratoire d'ethnologie et de sociologie comparative, 1978.

**Bradfield, Richard Maitland.** *A Natural History of Associations: A Study in the Meaning of Community* (2 vols.). London: Duckworth, 1973.

**Brandl, Eric Joseph.** *Australian Aboriginal Paintings in Western and Central Arnhem Land.* Melbourne: Australian Institute of Aboriginal Studies, 1988.

**Braque, Georges, ed. by Henry Bauchau.** *Journal d'Antigone, 1989–1997.* Arles, France: Actes Sud, 1999.

**Braun, Barbara, and Peter G. Roe.** *Arts of the Amazon.* London: Thames & Hudson, 1995.

**Brown, Percy.** *Indian Paintings under the Mughals, A.D. 1550 to A.D. 1750.* New Delhi: Cosmos Publications, 2003.

**Brusatin, Manlio.** "Pierre et ligne d'azur," in *Azur* exhibition catalogue, May 28–September 12, 1993. Ghent: Fondation Cartier pour l'art contemporain, 1993.

———. *History of Colors.* Boston: Shambala Publications, 1991.

**Bühler, Alfred.** "Ikats, colorants et méthodes de teinture," in *Cahiers Ciba*, vol. 3, no. 36. Basel, Switzerland, July 1951.

———. "Plangi," in *Cahiers Ciba*, no. 55. Basel, Switzerland, 1954.

**Burnham, Dorothy K.** *To Please the Caribou: Painted Caribou-Skin Coats Worn by the Naskapi, Montagnais, and Cree Hunters of the Quebec–Labrador Peninsula.* Toronto: Royal Ontario Museum, 1992.

**Buxbaum, David C.** *Chinese Family Law and Social Change.* Seattle: University of Washington Press, 1978.

**Calon, Olivier.** "Jaune soleil," in *Jaune.* Paris: Éditions Du May, 1994.

———. "Visage pâle" and "Blanche église," in *Blanc.* Paris: Éditions Du May, 1995.

**Cardon, Dominique.** *Guide des teintures naturelles. Plantes, lichens, champignons, mollusques et insectes.* Yverdon-les-Bains, Switzerland: Delachaux et Niestlé, 1990.

**Carrasco, David, and Eduardo Martos Moctezuma.** *Moctezuma's Mexico: Visions of the Aztec World* (Revised Edition). Boulder: University Press of Colorado, 2003.

**Caruana, Wally.** "De la figuration à l'abstraction, une histoire vieille comme le monde," in *Peintres aborigènes d'Australie: Établissement public du parc et de la grande halle de la Villette, Paris, 28 novembre 1997 au 11 janvier 1998* by Sylvie Crossman and Jean-Pierre Barou. Montpellier, France: Indigène Editions, 1997.

**Caso, Alfonso.** *The Aztecs, People of the Sun.* Norman: University of Oklahoma Press, 1958.

**Cazenave, Michel, ed.** *Encyclopédie des symboles.* Paris: Le Livre de Poche, 1998.

Cennini, Cennino. *The Craftsman's Handbook (Il librio dell'arte)*. New York: Dover Publications, 1954.

Cézanne, Paul, cited by Paul Eluard. *Anthologie des écrits sur l'art*. Paris: Éditions Cercle d'art, 1987.

Chapman, Anne. *Drama and Power in a Hunting Society: The Selk'nam of Tierra del Fuego*, Cambridge: Cambridge University Press, 1982.

Chatwin, Bruce. *The Songlines*. New York: The Viking Press, 1987.

Chaussonnet, Valérie, and Bernadette Driscoll. "The Bleeding coat: The art of North Pacific ritual clothing: Joint marks, ochre, and alder dyeing: Athapaskan clothing," in *Anthropology of the North Pacific Rim*. Washington, D.C.: Smithsonian Institution Press, 1994.

Chawaf, Chantal. *Rougeâtre*. Paris: Jean-Jacques Pauvert Éditeur, 1978.

Chenciner, Robert. *Kaitag: Textile Art from Dagestan*. London: Textile Art Publications, 1993.

Chidiac, Hana, Oleg Grabar, and Muhammed El-Kholi. *Châteaux omeyyades de Syrie* exhibition catalogue, Institut du monde arabe, Paris, September 16, 1990–March 17, 1991. Paris: Éditions IMA, 1990.

Cipriani, Lidio. "Hygiene and medical practices among the Onge (Little Andaman)," in *Anthropos*, vol. 56. Fribourg, Switzerland: Anthropos-Institut, 1961.

Claisse-Dauchy, Renée. *Médecine traditionnelle au Maghreb: Rituels d'envoûtement et de guérison au Maroc*. Paris: L'Harmattan, 1996.

Clébert, Jean-Paul. *Les Tziganes*. Paris: Arthaud, 1962.

Clottes, Jean. *Les Cavernes de Niaux*. Paris: Éditions du Seuil, 1995.

Cobbi, Jane. *Pratiques et représentations sociales des Japonais*. Paris: L'Harmattan, 1993.

Colinart, Sylvie, Élisabeth Delange, and Sandrine Pagès. "Couleurs et pigments de la peinture de l'Égypte ancienne," in *Techné*, no. 4. Paris, 1996.

Collinder, Bjorn. *The Lapps*. Princeton: Princeton University Press for the American Scandinavian Foundation, 1949.

Colwin, Laurie. *Passion and Affect*. New York: Viking Press, 1974.

Connors, Mary F. *Lao Textiles and Traditions*. New York: Oxford University Press, 1996.

Conway, Susan. *Thai Textiles*. London: British Museum Press, 1992.

Coquet, Michèle. *Textiles africains*. Paris: Société nouvelle Adam Biro, 1993.

Cormack, J. G. *Chinese Birthday, Wedding, Funeral and Others Customs* (Second Edition). Taipei: Ch'eng Wen Publishing Company, 1974.

Courtney-Clarke, Margaret. *Ndebele: The Art of an African Tribe*. New York: Rizzoli, 1986.

Cousin, Françoise. *Tissus imprimés du Rajasthan*. Paris: L'Harmattan, 1986.

Culas, Michel. *Grammaire de l'objet chinois*. Paris: Éditions de l'Amateur, 1997.

Dams, Lya. *Les Peintures rupestres du levant espagnol*. Paris: Picard, 1984.

Danco, Juliana, and Dimitru Danco. *La Peinture paysanne sur verre de Roumanie*. Bucharest: Éditions Méridiane, 1975.

Danforth, Loring M. *The Death Rituals of Rural Greece*. Princeton: Princeton University Press, 1982.

Dean, Jenny. *Wild Colour, How to Grow, Prepare and Use Natural Plant Dyes*. London: Mitchell Beazley Ltd., 1999.

D'Harcourt, Raoul. "Les textiles dans l'ancien Pérou," in *Cahiers Ciba*, no. 86. Basel, Switzerland, February 1960.

De Hamel, Christopher. *A History of Illuminated Manuscripts*. Boston: David R. Godine, 1986.

De la Soudière, Martin. *L'Hiver, à la recherche d'une morte saison*. Lyon, France: La Manufacture, 1987.

Deguillaume, Marie-Pierre. *Secrets d'impression*. Paris: Syros, 1994.

Delacroix, Eugène. *Œuvres littéraires*, Volume 1. Paris: G. Crès & Cie., 1923.

Delamare, François, and Bernard Guineau. *Colors: The Story of Dyes and Pigments* (Discoveries). New York: Harry N. Abrams, Inc., 2000.

Delcambre, Anne-Marie. *Mahomet: La parole d'Allah* (Découvertes). Paris: Gallimard, 1987.

Dempsey, Hugh A. "Arts primitifs des Indiens des Prairies canadiennes," in *Chefs-d'œuvre des arts indiens et esquimaux du Canada*, exhibition catalogue, March–September 1969. Paris: Société des amis du musée de l'Homme, 1969.

Densmore, Frances. *Chippewa Customs*. Smithsonian Institution, Bureau of American Ethnology, Bulletin no. 86. Washington, D.C.: Government Printing Office, 1929.

**Deruisseau, L. G.** "Les couleurs sous la Renaissance," in *Cahiers Ciba*, no. 20. Basel, Switzerland, November 1948.

**Després, Denise, and Jean-Michel Kirsch.** *L'Ocre: Peindre et décorer aux couleurs du soleil.* Paris: Flammarion, 1998.

**Desproges, Pierre.** *Dictionnaire superflu à l'usage de l'élite et des biens nantis.* Paris: Éditions du Seuil, 1985.

**Doumet, Jospeh.** "De la teinture en pourpre des Anciens par l'extraction du produit colorant des *Murex tronculus, Brandaris* et des *Purpura haemastoma,*" in *National Museum News*, Spring 1999.

**Doxiadis, Euphrosyne.** *The Mysterious Fayum Portraits.* New York: Harry N. Abrams, Inc., 1995.

**Dumont, Louis.** *A SouthIndian Sub-caste: Social Organization and Relgion of the Pramalai Kallar.* New York: Oxford University Press, 2006.

**Dunn, Charles J.** *Everyday life in Traditional Japan.* Boston: Charles E. Tuttle Company, 1972.

**Dusenbury, Mary.** "The art of color," in *Beyond the Tanabata Bridge, Traditional Japonese Textiles.* London: Thames & Hudson, 1993.

**Dutilleux, Jean Pierre.** *Raoni and the First World / Raone et le monde premier* (bilingual edition). Paris: Au même titre, 2000.

**Eberhard, Wolfram.** *The Local Cultures of South and East China.* Leiden, The Netherlands: E. J. Brill, 1968.

——. *A Dictionary of Chinese Symbols.* London: Routledge, 1988.

**Emmons, George Thorton.** *The Basketry of the Tlingit*, Part. II, vol. III (American Museum of Natural History, Memoirs). New York: Knickerbocker Press, 1903.

**Étienne-Nugue, Jocelyne.** *Artisanats traditionnels en Afrique noire: Bénin.* Paris: Institut culturel africain/L'Harmattan, 1984.

——. *Artisanats traditionnels en Afrique noire: Togo.* Paris: Institut culturel africain/L'Harmattan, 1992.

**Étienne-Nugue, Jocelyne, and Élisabeth Laget.** *Artisanats traditionnels en Afrique noire: Côte d'Ivoire.* Paris: Institut culturel africain/L'Harmattan, 1973.

**Étienne-Nugue, Jocelyne, and Mahamane Saley.** *Artisanats traditionnels en Afrique noire: Niger.* Paris: Institut culturel africain/L'Harmattan, 1987.

**Evans Schultes, Richard, and Siri von Reis.** *Ethnobotany: Evolution of a Discipline.* Portland, Oregon: Dioscondes Press, 1995.

**Faber, G. A.** "La teinturerie en Grèce," in *Cahiers Ciba*, no. 18. Basel, Switzerland, June 1948.

——. "La teinturerie chez les Romains," in *Cahiers Ciba*, no. 18. Basel, Switzerland, June 1948.

**Fagot, Philippe.** "Cosmochromie, l'univers de la couleur," in *Les Cahiers de Terres et Couleurs*, no. 4. Paris, May 2000.

**Falgayrettes-Leveau, Christiane, and Lucien Stéphan.** *Formes et couleurs, sculptures de l'Afrique noire.* Paris: Musée Dapper, 1993.

**Ferchiou, Sophie.** *Technique et Sociétés, exemple de la fabrication des chéchias en Tunisie.* Paris: Université Paris-VIII/ Musée de l'Homme (Mémoire de l'Institut d'ethnologie), 1971.

**Fettweis, Martine.** *Cobá et Xelhá: Peintures murales mayas.* Paris: Institut d'ethnologie, 1988.

**Figue-Henric, Éric.** *Connaissance des teintures végétales.* Paris: Dessain et Tolra, 1980.

**Firth, Raymond.** *We, the Tipokia: A Sociological Study of Kinship in Primitive Polynesia.* London, George Allen and Unwin Ltd., 1936.

——. *Primitive Polynesian Economy.* London, George Routledge and Sons Ltd., 1939.

——. *The Work of the Gods in Tikopia.* London: The London School of Economics and Political Science, 1940.

——. *Symbols: Public and Private.* Ithaca, New York: Cornell University Press, 1973.

**Fleurquin, Véronique.** "Lait blanc," in *Blanc.* Paris: Éditions Du May, 1995.

**Foskett, Daphne.** *Miniatures: Dictionary and Guide.* Woodbridge, U.K.: Antique Collectors' Club, 1990.

**Frédéric, Louis.** *Dictionnaire de la civilisation indienne* (Bouquins). Paris: Laffont, 1987.

**Fruzzetti, Lina M.** *The Gift of a Virgin: Women, Marriage and Ritual in a Bengali Society.* New Brunswick, New Jersey: Rutgers University Press, 1990.

**Furetière, Antoine, with Cécile Wajsbrot.** *Les Couleurs.* Mayenne, France: Zulma, 1997.

**Gagey, Anne.** "Des couleurs dans un hôpital," in *Journées AEC*, 1997.

**Galloti, Jean.** "Tissage, tapisserie et teinture en Afrique du Nord (Maroc et Algérie)," in *Cahiers Ciba*, no. 21. Basel, Switzerland, 1949.

**Ganseer, A.** "La teinture du cuir dans l'Antiquité," in *Cahiers Ciba*, no.34. Basel, Switzerland, March 1951.

**Garcia, Michel (text) and Marie-Françoise Delarozière (watercolors).** *De la garance au pastel: Le jardin des teinturiers.* Aix-en-Provence, France: Editions Édisud, 1996.

———. *Bleu indigo: Des plantes et des couleurs: Indigotier, Polygonum, Pastel.* Lauris, France: Cahiers de l'association Couleur Garance, 1998.

———. *Les Encres végétales: Histoire, fabrication.* Lauris, France: Cahiers de l'association Couleur Garance, 1988.

———. *La Garance: De la racine à la couleur.* Lauris, France: Cahiers de l'association Couleur Garance, 1998.

———. *Les Lichens.* Lauris, France: Cahiers de l'association Couleur Garance, 1998.

———. *De la plante à la couleur: Fabriquer des couleurs avec les enfants.* Lauris, France: Cahiers de l'association Couleur Garance, 1999.

———. *Fibres et Couleurs végétales: Teintures: Nuancier et recettes* (dossier Chanvre). Lauris, France: Cahiers de l'association Couleur Garance, 1999.

**Geis-Tronich, Gudrun.** *Les Métiers traditionnels des Gulmance.* Stuttgart: Steiner Verlag Wiesbaden, 1989.

**Germain Georges-Herbert.** *Inuit: Peuples du froid.* Paris: Solar, 1996.

**Goldman, Irving.** *The Cubeo: Indians of the Northwest Amazon.* Urbana: University of Illinois Press, 1963.

**Gonda, Jan.** *Les Religions de l'Inde. L'Hindouisme récent,* Volume 2. Paris: Payot, 1965.

**Goswamy, B. N.** "Colour: South Asia," in *The Dictionary of Art,* edited by Jane Turner. New York, Oxford University Press, 1996.

**Gousset, Marie-Thérèse, and Patricia Stirnemann.** "Indications de couleur dans les manuscrits médiévaux," in *Pigments et Colorants: De l'Antiquité au Moyen Âge.* Paris: Éditions du CNRS, 1990.

**Green, Miranda, ed.** *The Celtic World.* London: Routledge, 1996.

**Griaule, Marcel.** *Folk Art of Black Africa.* New York: Tudor Publishing Co., 1950.

———. *Conversation with Ogotemmeli: An Introduction to Dogon Religious Ideas.* London: Oxford University Press, 1965.

**Griaule, Marcel, and Germaine Dieterlen.** *Signes graphiques soudanais.* Paris: Hermann et Cie, 1951.

**Grimal, Pierre.** *Dictionary of Classical Mythology.* London: Blackwell Publishing, Inc., 1996.

**Groenen, Marc.** "Colorants et symbolique au paléolithique," in *La Couleur.* Brussels: Éditions Ousia, 1993.

**Gröning, Karl.** *Body Decoration: A World Survey of Body Art.* New York: Vendome Press, 1998.

**Gualupi,G., and G. Stocchi.** *La Chine: Les Arts et la Vie quotidienne d'après le père Matthieu Ricci et d'autres missionnaires jésuites.* Milan: Franco Maria Ricci, 1982.

**Gudin, Claude.** *La Langue de bois, suivie de Nique ta botanique.* Lausanne, Switzerland: Éditions Âge d'homme, 1996.

**Guiart, Jean.** *The Arts of the South Pacific.* New York: Golden Press, 1963.

**Guild, Tricia.** *Tricia Guild on Color: Decoration, Furnishing, Displays.* New York: Rizzoli, 1993.

**Guillemard, Colette.** *Le Dico des mots de la couleur* (Point-Virgule). Paris: Éditions du Seuil, 1998.

**Gunasinghe, Siri.** *La Technique de la peinture indienne d'après les textes du Silpa.* Paris: Presses universitaires de France, 1957.

**Gusinde, Martin.** *The Selk'nam on the Life and Thought of a Hunting People of the Great Island of Tierra del Fuego.* New Haven: Human Relations Area Files, 1934.

**Gutmann, A. L.** "Techniques du tissage et de la teinture en Flandre," in *Cahiers Ciba,* no. 11. Basel, Switzerland, September 1947.

**Halpern, Joel M.** *A Serbian Village.* New York: Columbia University Press, 1958.

**Hamayon, Roberte.** *La Chasse à l'âme: Esquisse d'une théorie du chamanisme sibérien.* Nanterre, France: Société d'ethnologie, 1990.

**Hansen, Henny Harald.** *The Kurdish Woman's Life: Field Research in a Muslim Society, Iraq.* Copenhagen: Copenhagen Ethnographic Museum Record, 1961.

**Harrison, Daniel Kulp.** *Country Life in South China: The Sociology of Familism,* Volume 1 (Second Edition). Taipei: Ch'eng Wen Publishing Company, 1966.

**Harva, Uno.** *Die religiosen Vorstelleingen der altaischen Volker.* Helsinki: Soderstrom, 1938.

**Harvey, Janet.** *Traditional Textiles of Central Asia.* London: Thames & Hudson, 1996.

**Hauser-Schäublin, B., Marie-Louise Nabholz-Kartaschoff, and Urs Ramseyer.** *Balinese Textiles.* London: British Museum Press, 1991.

**Hejzlar, Jospeh.** *Aquarelle chinoise: L'école de Chang-Hai.* Paris: Éditions Cercle d'art, 1979.

**Hemmet, Christine.** "Mode et esthétique chez les minorités du Viêt Nam," in *Le Viêt Nam des royaumes* by Jean-François Hubert, et al. Paris: Éditions Cercle d'art, 1995.

**Hendry, Joy.** *Wrapping Culture: Politeness, Presentation and Power in Japan and Other Societies.* Oxford: Clarendon Press, 1993.

**Henry, Victor.** *La Magie de l'Inde antique,* Paris: Dujarrie, 1904.

**Herring, Eillen.** "Tatu," in *Dimensions of Polynesia* by Jehanne Teilhet. Fine Arts Gallery of San Diego, October 7–November 25, 1973.

**Hersak, Dunja.** "Couleurs, stries et saillies: réflexions sur le travail de terrain et certaines enigmes du musée," in *Trésors cachés.* Tervuren, Belgium: Musée royal de l'Afrique centrale, 1986.

**Hocart, Arthur Maurice.** "Lau Islands, Fiji," in *Bernice P. Bishop Museum Bulletin,* no. 62. Honolulu: Bishop Museum Press, 1929.

**Hodous, Lewis.** *Folkways in China.* London: Arthur Probthain, 1929.

**Hongxun, Wang.** *Chinese Kites.* San Francisco: China Books and Periodicals, Inc., 1989.

**Horn, Dr. P.** "Les textiles aux temps bibliques," in *Cahiers Ciba,* no. 2. Basel, Switzerland, 1968.

**Hose, Charles, and William McDougall.** *The Pagan Tribes of Borneo.* New York: Oxford University Press, 1993.

**Hoskins, Janet.** "Why do ladies sing the blues?" in *Cloth and Human Experience* edited by Annette B. Weiner and Jane Schneider. Washington, D.C.: Smithsonian Institution Press, 1989.

**Huyen, Nguyen van.** *The Ancient Civilization of Vietnam.* Hanoi: G101 Publishers, 1995.

**Itten, Johannes.** *The Art of Color: The Subjetive Experience and Objective Rationale of Color.* New York: Reinhold Publishing Corp. 1967.

**James, Wendy.** *The Listening Ebony, Moral Knowledge, Religion and Power Among the Udruk of Sudan.* New York: Oxford University Press, 1988.

**Jaoul, Martine.** "Des teintes et des couleurs" in *Les dossiers du Musée national des arts et traditions populaires,* no. 2. Ivry-sur-Seine, France: Réunion des musées nationaux, 1994.

**Jones, David M.** "Colour: Pre-Columbian Americas," in *The Dictionary of Art* edited by Jane Turner. New York: Oxford University Press, 1996.

**Jordan, David K.** *Gods, Ghosts and Ancestors: The Folk Religion of a Taiwanese Village.* Berkeley: University of California Press, 1972.

**Judas, A. S.** "Notes on the Munshi tribe and language," in *Journal of the African Society,* vol. XVI. London: Macmillan and Company Ltd., 1916–1917.

**Juillerat, Bernard.** *Children of the Blood: Society, Reproduction and Cosmology in New Guinea.* Oxford: Berg, 1996.

**Juliusson, Per.** *The Gonds and Their Religion: A Study of the Integrative Function of Religion in a Present, Preliterary and Preindustrial Culture in Madhya Pradesh, India.* Stockholm: University of Stockholm, 1974.

**Juvet-Michel, A.** "Teinture et tissage des anciens tapis d'Orient," in *Cahiers Ciba,* no. 17. Basel, Switzerland, 1948

———. "La technique de la toile imprimée," in *Cahiers Ciba,* no. 24. Basel, Switzerland, July 1949.

**Kaeppler, Adrienne L., C. Kaufmann, and D Newton.** *Oceanic Art.* New York: Harry N. Abrams, Inc., 1997.

**Kandinsky, Wassily.** *Concerning the Spiritual in Art and Painting in Particular.* New York: Wittenborn, Schulz Inc., 1947.

**Kapferer, Bruce.** *A Celebration of Demons: Exorcism and the Aesthetics of Healing in Sri Lanka.* Bloomington: Indiana University Press, 1983.

**Karmous, T., N. Ayed, F. Chelbi, and A. El Hili.** "Le pourpre de l'ère punique en Tunisie: Extraction et analyse de ce pigment," in *Techné,* no. 4. Paris, 1996.

**Karsten, Rafael.** *The Religion of the Samek: Ancient Beliefs and Cults of the Scandinavian and Finnish Lapps.* Leiden, The Netherlands: E. J. Brill, 1955.

**Khatibi, Abdelkebir, and Mohammed Sijelmassi.** *The Splendor of Islamic Calligraphy* (Revised and Expanded Edition). London: Thames & Hudson, 1996.

**Klein, O.** "Le travail du textile chez les Araucans," in *Cahiers Ciba,* no. 6. Basel, Switzerland, 1961.

**Kosambi, Damodar Dharmanand.** The Culture and Civilization of Ancient India in Historical Outline. London: Routledge & Kegan Paul, 1965.

**Kühn, H.** "La couleur dans la peinture," in Cahiers Ciba, no. 1. Basel, Switzerland, 1963.

**Kupka, Karel.** Peintures aborigènes d'Australie. Paris: Musée de l'Homme, 1972.

**Kyburz, Josf A.** Cultes et Croyances au Japon, Kaïda, une commune dans les montagnes du Japon central. Paris: Maisonneuve et Larose, 1987.

**Lambrecht, Francis.** The Mayawyaw Ritual. Washington, D.C.: Catholic Anthropological Conference Publications, 1936–1941.

**Lang, Luc.** Strong Ways., London: Orion Books, 2002.

**Latour, A.** "Les couleurs en France au xviiie siècle," in Cahiers Ciba, no. 2. Basel, Switzerland, March 1946.

———. "Textile Arts of the North American Indians," in Cahiers Ciba, no. 90. Basel, Switzerland, February 1950.

**Layton, Robert.** The Anthropology of Art, Second Edition. Cambridge: Cambridge University Press, 1991.

**Lechatelier, Luc.** "Drapeau blanc" in Blanc. Paris: Éditions Du May, 1995.

**Le Fur, Daniel.** "Les pigments dans la peinture égyptienne" in Pigments et Colorants: De l'Antiquité au Moyen Âge. Paris: Éditions du CNRS, 1990.

**Le Mouël, Jean-François.** Ceux des mouettes, les Eskimos Naijâmiut du Groënland Ouest. Paris: Institut d'ethnologie, Musée de l'homme, 1978.

**Legey, Dr.** Essai de folklore marocain. Paris: Librairie orientaliste Paul Geuthner, 1926.

**Leix, A.** "Les couleurs de l'ancien Orient" in Cahiers Ciba, no. 12. Basel, Switzerland, October 1947.

———. "L'Ancienne Égypte, pays des tisseurs de lin" in Cahiers Ciba, no 12. Basel, Switzerland, October 1947.

———. "Chaldée et Assyrie, pays de la laine" in Cahiers Ciba, no 12. Basel, Switzerland, October 1947.

**Lenclos, Jean-Philippe, and Dominique Lenclos.** Couleurs de l'Europe, Géographie de la couleur. Paris: Le Moniteur, 1999.

———. Colors of the World: A Geography of Color. New York: W.W. Norton & Co., 2004.

**León-Portilla, Miguel.** The Aztec Image of Self and Society: An Introduction to Nahua Culture. Salt Lake City: University of Utah Press, 1992.

**Leroi-Gourhan, Arlette and André.** Un voyage chez les Aïnous: Hokkaido-1938. Paris: Albin Michel, 1989.

**Lewis, Roy.** The Evolution Man: Or, How I Ate My Father. New York: Vintage Books, 1994.

**Lorac-Gerbaud, Andrée.** Les Secrets du laque: Techniques et historique. Paris: Éditions de l'Amateur, 1996.

**Loude, Jean-Yves, and Viviane Lièvre.** Kalash: Les derniers infidèles de l'Hindu-Kush. Paris: Berger-Levrault, 1980.

**Louis, André.** Nomades d'hier et d'aujourd'hui dans le Sud tunisien. Aix-en-Provence, France: Édisud / Mondes méditerranéens, 1979.

**Maertens, Jean-Thierry.** Le Dessein sur la peau: Essai d'anthropologie sur les inscriptions tégumentaires. Paris: Aubier Montaigne, 1978.

**Marin, Manuela.** "Beyond Taste: The Complements of Colour and Smell in the Medieval Arab Culinary Tradition" in A Taste of Thyme: Culinary Cultures of the Middle East by Sami Zubaida and Richard Tapper. New York: St. Martin's Press, 2001.

**Martiniari-Reber, Marielle.** "Textile" in Byzance by Jannie Durand. Paris: Réunion des musées nationaux, 1992.

**Mason, Otis Tufton.** American Indian Basketry. New York: Dover Publications Inc., 1988.

**Maulpoix, Jean-Michel, and Dawn Cornelio, trans.** A Matter of Blue. Rochester, New York: BOA Editions Ltd., 2005.

**McFeeley, Peggy.** "Tapa design," in Dimensions of Polynesia, Fine Arts Gallery of San Diego, October 7–November 25, 1973 by Jehanne Teilhet-Fisk. San Diego, 1973.

**McNair, Amy.** "Colour: East Asia," in The Dictionary of Art, edited by Jane Turner. New York: Oxford University Press, 1996.

**Meade, Marie, trans., and Ann Fienup-Riordan, ed.** Our Way of Making Prayer. Anchorage Museum of History and Art, 1996.

**Mediavilla, Claude, et al.** Calligraphy: From Calligraphy to Abstract Painting. Wommelgem, Belgium: Scirpus Editions, 1996.

**Merian, Sylvie L., et al.** "The Making of an Armenian manuscript," in Treasures in Heaven: Armenian illuminated Manuscripts. New York: The Pierpont Morgan Library, 1994.

**Messaoudi, Mohammed.** Fiche Technique sur les teintures végétales (II). Casablanca: Fondation Konrad Adenauer / Ministère de l'Artisanat et des Affaires sociales, 1989.

**Mollard-Desfour, Annie.** *Le Dictionnaire des mots et des expressions de couleur: Le bleu.* Paris: Éditions du CNRS, 1998.

——. *Le Dictionnaire des mots et des expressions de couleur: Le rouge.* Paris: Éditions du CNRS, 2000.

**Morabia, A.,** "Lawn (color)" in *Encyclopedia of Islam* (Second Edition), edited by P. J. Bearman, et al. Leiden, The Netherlands: E. J. Brill, 1960–2005.

**Morphy, Howard.** "From Dull to Brilliant: The Aesthetics of Spiritual Power among the Yolngu," in *Antropology, Art, and Aesthetics,* edited by Jeremy Coote and Anthony Shelton. New York: Oxford University Press, 1992.

**Murphy, Veronica, and Rosemary Crill.** *Tie-dyed Textiles in India, Tradition and Trade.* New York: Rizzoli, 1991.

**Nencki, Lydie.** "Teintures végétales," manuscript, 1973.

**Neumayer, Erwin.** *Prehistoric Indian Rock Painting.* Oxford: Oxford University Press, 1983.

**Neuville, Virginie, and Pauline Clermont.** *Le Langage des couleurs.* Paris: Marabout, 1996.

**Newman, Geoffrey.** "Colour: Western world," in *The Dictionary of Art,* edited by Jane Turner. New York: Oxford University Press, 1996.

**Nicolas, Guy.** *Dynamique sociale et appréhension du monde au sein d'une société haussa.* Paris: Institut d'ethnologie, 1975.

**Okediji, Moyo.** "Colour: Africa," in *The Dictionary of Art,* edited by Jane Turner. New York: Oxford University Press, 1996.

**Paine, Melanie.** *Embroidered Textiles: Traditional Patterns from Five Continents With a Worldwide Guide to Identification.* New York: Rizzoli, 1990.

**Painter, L.** "Techniques anciennes de la peinture hindoue," in *Peinture-Pigments-Vernis,* vol. 42, no. 8. August 1966.

**Pagès-Camagna, Sandrine, and Sylvie Colinart.** "Le bleu et le vert égyptiens," in *Pour la science,* special edition. Paris, April 2000.

**Pal, Pratapaditya.** *Art of Tibet.* New York: Harry N. Abrams, Inc., 1990.

——. *Idoles du Népal et du Tibet: Arts de l'Himalaya.* Paris: Éditions Findakly / Paris-Musées, 1996.

**Pallottino, Massimo.** *Etruscan Painting.* Geneva: Skira, 1985.

**Pâques, Viviana.** *L'Arbre cosmique dans la pensée populaire et la vie quotidienne du Nord-Ouest africain.* Paris: L'Harmattan, 1995.

——. *Peintures de sable des Indiens Navajo, la voie de la beauté: Établissement public du parc et de la grande halle de la Villette, 11 février–21 mars 1996,* edited by Sylvie Crossman and Jean Pierre Barou. Paris: Actes Sud, 1996.

**Parramón, José M.** *The Book of Color: The History of Color, Color Theory, and Contrast; The Color of Forms and Shadows; And the Practice of Painting with Color.* New York: Watson Guptill Publications, 1993.

**Pastoureau, Michel.** "La couleur et l'historien," in *Pigments et Colorants: De l'Antiquité au Moyen Âge.* Paris: Éditions du CNRS, 1990.

——. *Dictionnaire des couleurs de notre temps: Symbolique et société.* Paris: Éditions Bonneton, 1992.

——. "Entre vert et noir. Petit dictionnaire historique de la couleur bleue" in *Azur* exhibition catalogue, May 28–September 12, 1993. Ghent: Fondation Cartier pour l'art contemporain, 1993.

——. *Jésus chez le teinturier: Couleurs et teintures dans l'Occident médiéval.* Paris: Le Léopard d'Or, 1998.

——. "Bleu protestant," in *Libération.* Paris: September 18–19, 1999.

**Pavlovic, Jeremija M.** *Folk and Customs in Kragujevac Region of the Jasenica in Sumadija.* New Haven: Human Relations Area Files (1973), 1921.

**Pelletier, Jean-Claude.** "Ocres et terres, secrets d'ateliers...," in *Les Cahiers de Terres et Couleurs,* no. 4. Paris, 1999.

**Pelt, Jean-Marie.** *La Cannelle et le Panda: Les grands naturalistes explorateurs autour du monde.* Paris: Fayard, 1999.

**Penney, David W.** *Native American Art Masterpieces.* New York: Hugh Lauter Levin Associates, Inc., 1996.

**Perego, François.** "Des pigments à la peinture," in *Pour la science,* special edition. Paris, April 2000.

**Petit, Jean, Jacques Roire, and Henri Valot.** *Des liants et des couleurs.* Puteaux, France: Éditions EREC, 1995.

**Phillips, Barty.** *Tapestry.* London: Phaidon Press Ltd., 1994.

**Picq, Pascal, Jean-Pierre Digard, Boris Cyrulnik, and Karine Lou Matignon.** *La Plus Belle Histoire des animaux.* Paris: Éditions du Seuil, 2000.

**Pignet, François, ed.; Michel Boyer, Dominique Cardon, Maurice Chastrette, and Annick Méary.** *Le Secret des couleurs* (La science pour tous), CD-ROM. Chinagora Multimédia, Paris: 1997.

**Pimpaneau, Jacques.** *Chine: Cultures et traditions.* Arles, France: Éditions Philippe Picquier, 1990.

**Polakoff, Claire.** *African Textiles and Dyeing Techniques.* London: Routledge & Kegan Paul, 1982.

**Pomiès, Marie-Pierre.** "Les terres colorantes, comment et où les produit-on," in *Terres et Couleurs*, no. 3. Paris, February 1998.

**Popova, O.** *La Miniature russe: xɪᵉ-début du xvɪᵉ siècle.* St. Petersburg: Aurora, 1984.

**Pouqueville, F.C.H.L.** *Voyage de la Grèce.* Paris: Firmin-Didot Père et Fils, 1826.

**Propp, Valdimir.** *Les Fêtes agraires russes.* Paris: Maisonneuve et Larose, 1987.

**Radcliffe-Brown, A.R.** *The Adaman Islanders: A study in Social Anthropology.* Cambridge: Cambridge University Press, 1922.

**Régnier, Jacqueline.** *Les Couleurs.* Paris: Éditions Volets Verts, 1994.

**Reichel-Dolmatoff, Gerardo.** *Los Kogi: Une tribu de la Sierra Nevada de Santa Marta, Colombia.* Bogotá: Editorial Iqueime, 1950–1951.

**Reinach, Adolphe.** *Textes grecs et latins relatifs à l'histoire de la peinture ancienne.* Paris: Macula, 1985.

**Rémy, Jean-Philippe.** "La saga des pigments," in *Science et vie Junior*, no. 23, Paris: January 1996.

**Renaud, Philippe.** "Vert malachite" in *Vert.* Paris: Éditions Du May, 1994.

——. "Introduction" in *Blanc.* Paris: Éditions Du May, 1995.

**Rendourn, R.T.** "L'habit fait le moine: La psychologie de l'habillement" in *Cahiers Ciba*, no. 4. Basel, Switzerland, 1964.

**Reswick, Irmtraud.** *Traditional Textiles of Tunisia and Related North Africa Weavings.* Los Angeles: Craft and Folk Museum, 1985.

**Riefenstahl, Leni.** *Last of the Nuba.* New York: Harper & Row, 1974.

**Rivers, W.H.R.** *The History of Melanesian Society.* Cambridge: Cambridge University Press, 1914.

**Roche-Bernard, Geneviève,and Alain Ferdière.** *Costumes et Textiles en Gaule romaine.* Paris: Éditions Errance, 1993.

**Rockhill, W. Woodville.** "Notes on Some of the Laws, Customs, and Superstitions of Korea" in *American Anthropologist.* Washington, D.C., 1891.

**Rodee, Marian E.** *Old Navajo Rugs: Their Development from 1900 to 1940.* Albuquerque: University of New Mexico Press, 1991.

**Roire, Jacques.** "Les noms des couleurs," in *Pour la science*, special edition. Paris: April 2000.

**Roque, Georges, Bernard Bodo, and Françoise Viénot.** *Michel-Eugène Chevreul: un savant, des couleurs!* Paris: Muséum national d'histoire naturelle; Puteaux, France: Étude et réalisations de la couleur, 1997.

**Roque, Georges, and Claude Gudin.** *La vie nous en fait voir de toutes les couleurs.* Lausanne, Switzerland: L'Âge d'homme, 1998.

**Rufino, Patrice Georges.** *Le Pastel: Or bleu du pays de Cocagne.* Panayrac, France: Éditions Daniel Briand, 1992.

**Schramm, H.** "Le monde des nomades," in *Cahiers Ciba*, no. 3. Basel, Switzerland, 1968.

**Seaman, Gary.** "The Sexual Politics of Karmic Retribution," in *The Anthropology of Taiwanese Society*, by Emily Martin Ahern and Hill Gates. Stanford: Stanford University Press, 1981.

**Sennelier, Gustave.** *Chimie des couleurs: Fabrique de couleurs fines pour les arts*, catalogue no. 31. Paris: Gustave Sennelier, 1912.

**Silva Alcionilio Bruzzi Alves da.** *The Indigenous Civilization of the Uaupés / A civilisação indegena do Uaupés.* New Haven: Human Relations Area Files, 197-.

**Speiser, Felix.** *Ethnology of Vanuatu.* Bathurst, Australia: Crawford House Press, 1990.

**Spencer, Sir Baldwin, and Francis James Gillen.** *The Arunta: A Study of a Stone Age People.* London: Macmillan, 1927.

**Spier, Leslie.** *Klamath Ethnography.* Berkeley: University of California Press, 1930.

**Stahl, Paul Henri.** *Ethnologie de l'Europe du Sud-Est: Une anthologie.* Paris / The Hague: Mouton, 1974.

**Steinman, Brigitte.** *Les Tamang du Népal: Usages et religion, Religion de l'usage.* Paris: Éditions Recherche sur les civilisations, 1987.

Stephen, Alexander M. *Hopi Journal of Alexander M. Stephen.* New York: Columbia University Press, 1936.

Talayesva, Don C. *Sun Chief: The Autobiography of a Hopi Indian.* New Haven: Yale University Press, 1942.

Tamisier, Jean-Christophe. *Dictionnaire des peuples: Sociétés d'Afrique, d'Amerique, d'Asie et d'Oceanie.* Paris: Larousse, 1998.

Tavernier, Irène. "Vivre la couleur," in *Communiquer par la couleur,* edited by Irène Tavernier et al. Paris: Éditions 3C Conseil, 1994.

Taylor, Roderick. *Ottoman Embroidery.* Northampton, Massachusetts: Interlink Publishing Group, 1993.

Tornay, Serge. "Perception des couleurs et pensée symbolique," in *Voir et nommer les couleurs,* edited by Serge Tornay. Nanterre, France: Laboratoire d'ethnologie et de sociologie comparative, 1978.

Toromura, K. "Matières colorantes et pigments" in *Cahiers Ciba,* no. 4. Basel, Switzerland, 1967.

Tromeur, Riwan. "L'Ocre exactement?" in *Les Cahiers de Terres et Couleurs,* no. 3. Paris, November 1998.

Troyanovitch, Sima. "Manners and Customs," in *Servia by the Servians,* edited by Alfred Stead. London: William Heinemann, 1909.

Turner, W. "Le symbolisme hindou des couleurs," in *Cahiers Ciba,* no. 3. Basel, Switzerland, May 1946.

Urner, Hildegard. "Le noir dans les traditions populaires," in *Cahiers Ciba-Geigy,* no. 2. Basel, Switzerland, 1973.

Varron, A. "La sériciculture dans l'ancien Orient et dans l'Antiquité classique," in *Cahiers Ciba,* no. 8. Basel, Switzerland, April, 1947.

Verdier, Yvonne. *Façons de dire, façons de faire: La laveuse, la couturière, la cuisinière.* Paris: Gallimard, 1997.

Verhecken, A. *Les Fresques mobiles du Nord: Tapisseries de nos régions, $xvi^e$–$xx^e$ siècle.* Antwerp, Belgium: Martial & Snoeck, 1994.

Vernant, Jean-Pierre. *The Universe, the Gods, and Men: Ancient Greek Myths.* New York: Harper Collins, 2001.

Verswijver, Gustaaf, et al. *Kaiapó: Amazonie: plumes et peintures corporelles.* Ghent: Musée royal de l'Afrique centrale, 1992.

Vialou, Agueda Vilhena, Hélène Badu, Francesco d'Errico, and Denis Vialou. "Les colorants rouges de l'habitat rupestre de Santa Elina, Mato Grosso (Brésil)," in *Techné,* no. 3. Paris, 1996.

Vignaud, Colette, Marie-Pierre Pomiès, and Michel Menu. "La peinture préhistorique," in *Pour la science,* special edition. Paris, April 2000.

Vogt, Émile. "Vanneries et tissus à l'âge de pierre et du bronze en Europe," in *Cahiers Ciba,* no. 15. Basel, Switzerland, 1948.

Vrignaud, Gilberte. *Vêture et parure en France au dix-huitième siècle.* Paris: Éditions Messene / Jean de Cousance, Editeur, 1995.

Wacker, Nicolas. *La Peinture à partir du matériau brut et le rôle de la technique dans la création d'art.* Paris: Allia, 1997.

Walter, Annie. "L'art féminin de la vannerie: Les nattes à Pentecôte," in *Vanuatu: Océanie: Arts des îles de cendre et de corail,* Musée des Arts africains et océaniens, September 30, 1997–February 2, 1998. Paris: Réunion des musées nationaux, 1996.

Walter, Philippe, Christiane Ziegler, Pauline Martinetto, and Jocelyne Talabot. "Quand la couleur soulignait l'œil dans l'Égypte ancienne," in *Techné,* no. 9–10. Paris, 1999.

Weinber-Thomas, Catherine. *Ashes of Immortality: Widow-Burning in India.* Chicago: University of Chicago Press, 2000.

Weir, Shelagh. *Palestinian Costume.* London, British Museum Press, 1994.

Wescher, H. "Les grands maîtres dans l'art de la teinturerie en France au $xviii^e$ siècle," in *Cahiers Ciba,* no. 2. Basel, Switzerland, March 1946.

Wheeler, William. "Blanc albinos," in *Blanc.* Paris: Éditions Du May, 1995.

Wizinger, R. "Noir de tannin et noir campêche," in *Cahiers Ciba-Geigy,* no. 2. Basel, Switzerland, 1973.

Wolf, Arthur P., and Chieh-shan Huang. *Marriage and Adoption in China, 1845–1945.* Stanford: Stanford University Press, 1980.

Yvel, Claude. *Le Métier retrouvé des maîtres: La peinture à l'huile.* Paris: Flammarion / Arts et Métiers graphiques, 1991.

THE DYE RECIPES WERE INSPIRED BY THE
FOLLOWING KEY WORKS, AND WERE CREATED
DURING AN APPRENTICESHIP ON DYEING
TECHNIQUES UNDER THE INSTRUCTION OF
KARIN DELAUNAY IN GOULT, VAUCLUSE.

Cardon, Dominique. *Guide des teintures
naturelles. Plantes, lichens, champignons,
mollusques et insects.* Yverdon-les-Bains,
Switzerland: Delachaux et Niestlé, 1990.

Dean, Jenny. *Wild Colour: How to Grow,
Prepare and Use Natural Plant Dyes.* London:
Mitchell Beazley Ltd., 1999.

Figue-Henric, Éric. *Connaissance des
teintures végétales.* Italy: Dessain et Tolra,
1980.

Garcia, Michel. *Les Encres végétales: Histoire,
fabrication.* Lauris, France: Cahiers de
l'association Couleur Garance, 1988; *La
Garance: de la racine à la couleur.* Lauris
[(France):] Cahiers de l'association
Couleur Garance, 1998; *Les Lichens.*
Lauris [(France):] Cahiers de l'association
Couleur Garance, 1998; *De la plante à
la couleur: Fabriquer des couleurs avec les
enfants.* Lauris [(France):] Cahiers de
l'association Couleur Garance, 1999;
*Fibres et Couleurs végétales. Teintures:
nuancier et recettes* (dossier Chanvre).
Lauris [(France):] Cahiers de l'association
Couleur Garance, 1999.

Nencki, Lydie. "Teintures végétales."
manuscript, 1973.

THE PAINT AND INK RECIPES WERE INSPIRED
BY THE FOLLOWING KEY WORKS:

Cennini, Cennino. *The Craftsman's
Handbook (Il libro dell'arte).* New York:
Dover Publications, 1954.

Després, Denise and Jean-Michel Kirsch.
*L'Ocre: Peindre et décorer aux couleurs du
soleil.* Paris: Flammarion, 1998.

Garcia, Michel. *Les Encres végétales: Histoire,
fabrication.* Lauris, France: Cahiers de
l'association Couleur Garance, 1988.

——. *De la plante à la couleur: Fabriquer des
couleurs avec les enfants.* Lauris, France:
Cahiers de l'association Couleur Garance,
1999.

Pelletier, Jean-Claude. "Ocres et terres,
secrets d'ateliers…," in *Les Cahiers de Terres
et Couleurs,* no. 4. Paris, 1999.

Petit, Jean, Jacques Roire, and Henri Valot.
*Des liants et des couleurs.* Dijon-Quetigny,
France: Éditions EREC, 1995.

Wacker, Nicolas. *La Peinture à partir du
matériau brut et le rôle de la technique dans la
création d'art.* Courtry, France: Allia, 1997.

Yvel, Claude. *Le Métier retrouvé des maîtres:
La peinture à l'huile.* Paris: Flammarion, Art
et Métiers graphiques, 1991.

# TABLE
# OF
# CONTENTS

## PHOTOGraPHIC CreDITS

Akg/Paris: 13, 39, 192, 205, 227, 228; Henning bock: 36.
Alinari/Giraudon: 179.
Archives Musée Dapper, Paris: Photo Massimo Listri: 267.
Artephot: Cercle d'Art: 109, 163; A. Meyer: 140;
R. Percheron: 141.
Bibliothèque centrale, MNHN, Paris, 2005: 79, 81, 122,
151, 153, 155, 185, 187, 263, 265.
Philippe Blet: 170.
The Bridgeman Art Library: 145, 148, 196.
Bridgeman/Giraudon/©British Library: 215.
Corbis: Keren Su: 32.
Cosmos: G. Buthaud: 266; Pascal Maitre: 106; Cary
Wolinsky: 246.
Dagli Orti: 14, 52, 55, 90, 101, 113, 190, 202, 206, 233.
Explorer: A. Evrard: 95; J. Joffre: 252.
Fotogram-Stone images: P. Chesley: 84; O. Franken: 17.
Hoa-Qui: Y. Arthus-Bertrand: 25; V. Audet: 10; Bravo:
128; M. Bruwier: 103; Courtney Clark: 165; V. Durruty:
19, 57, 71; A. Evrard: 139; M. Huet: 47; C. et J. Lénars: 225;
J.-L. Manaud: 88, 91, 93; C. Pavard: 94; T. Perrin: 69;
L. Pozzoli: 35; Reimbold: 92; X. Richer: 158; Treal/Ruiz:
20; C. Valentin: 200; E. Valentin: 60; P. de Wilde: 63, and
back cover); X. Zimbardo: 96–97, [front cover].
Karbine-Tapabor: 72, 249.
J.-L. Nou: 117, 194–195, 259.
Yannick Perrin: 66.
Pix/Giraudon: 45, 183, 213, 229, 236–237.
Rapho: Roland and Sabrina Michaud: 58, 64–65, 110, 176,
211, 224, 243; Ch. Monty: 147; Sazo: 218; Bill Wasmann: 28.
Réunion des Musées Nationaux: 134, 143, 162, 220, 239;
D. Arnaudet: 132, 137, 166–167; M. Bellot: 160, 230;
J.-G. Berizzi: 115, 197; H. Lewandowski: 112; R. G. Ojeda:
31, 144.
Jacques Vasseur: 44, 46, 48, 76, 80, 120, 124, 126, 150,
152, 154, 173, 182, 184, 186, 210, 212, 214, 254, 256, 258,
260, 264.

The pigment samples presented in this book were
created on rag paper by Laurence Jean-Bart and the
author. The textiles were dyed by the author, except for
the illustration of walnut hull brown which was made by
Betty Goldberg.

PROJECT MANAGER, ENGLISH-LANGUAGE EDITION: AIAH WIEDER

DESIGNER, ENGLISH-LANGUAGE EDITION: SHAWN DAHL

COVER DESIGNER, ENGLISH-LANGUAGE EDITION: E.Y. LEE

PRODUCTION MANAGER, ENGLISH-LANGUAGE EDITION: MICHELLE MARCANO

LIBRARY OF CONGRESS CONTROL NUMBER:
2006935953

ISBN 13: 978-0-8109-9292-4
ISBN 10: 0-8109-9292-2

COPYRIGHT © 2006 EDITIONS DU SEUIL, PARIS
ENGLISH TRANSLATION COPYRIGHT © 2006
ABRAMS, NEW YORK

PUBLISHED IN 2006 BY ABRAMS, AN IMPRINT OF
HARRY N. ABRAMS, INC.

PRINTED AND BOUND IN SINGAPORE
10 9 8 7 6 5 4 3 2 1

HNA
harry n. abrams, inc.
a subsidiary of La Martinière Groupe

115 WEST 18TH STREET
NEW YORK, NY 10011
WWW.HNABOOKS.COM